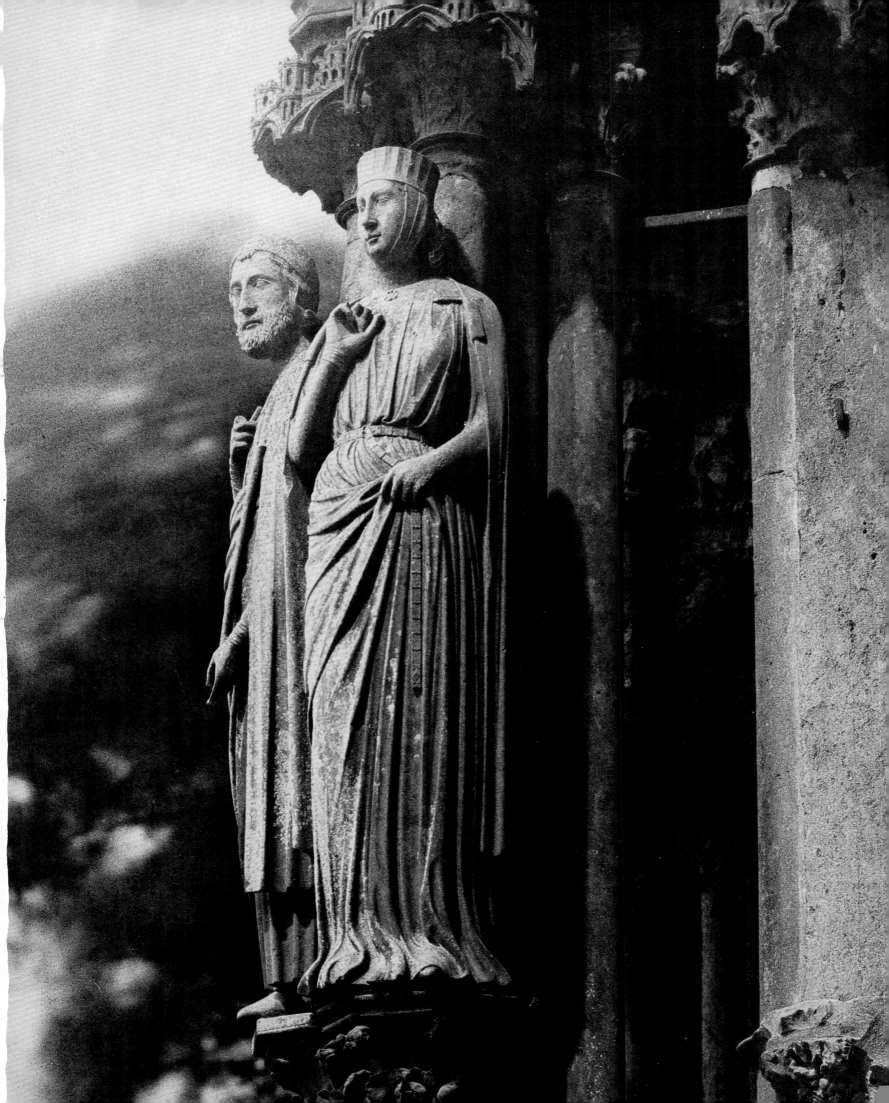

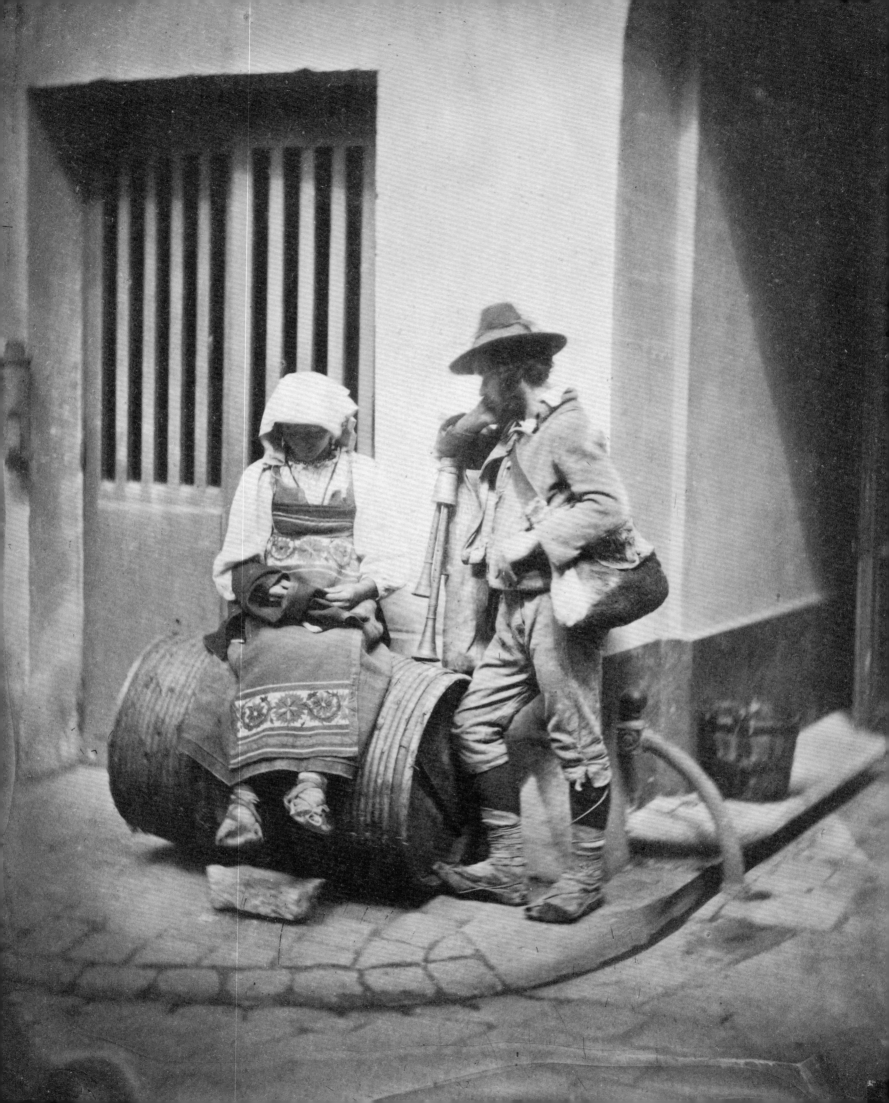

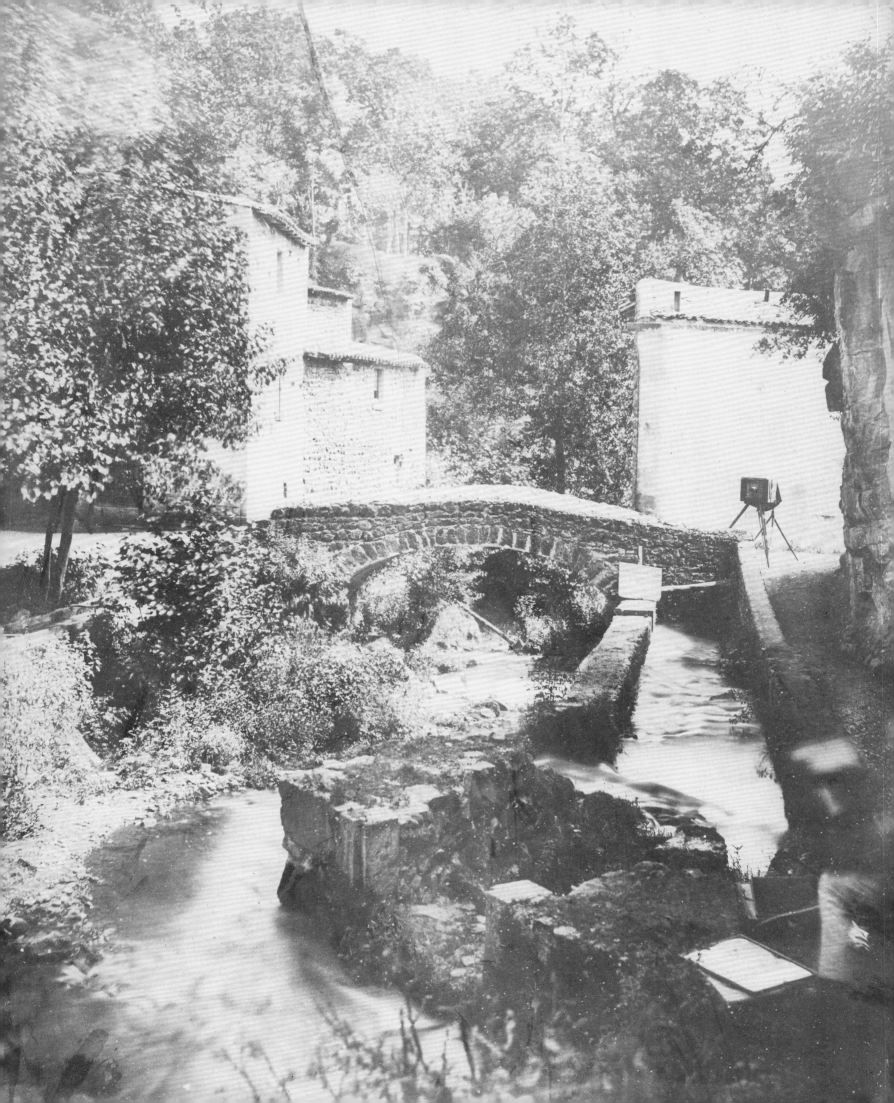

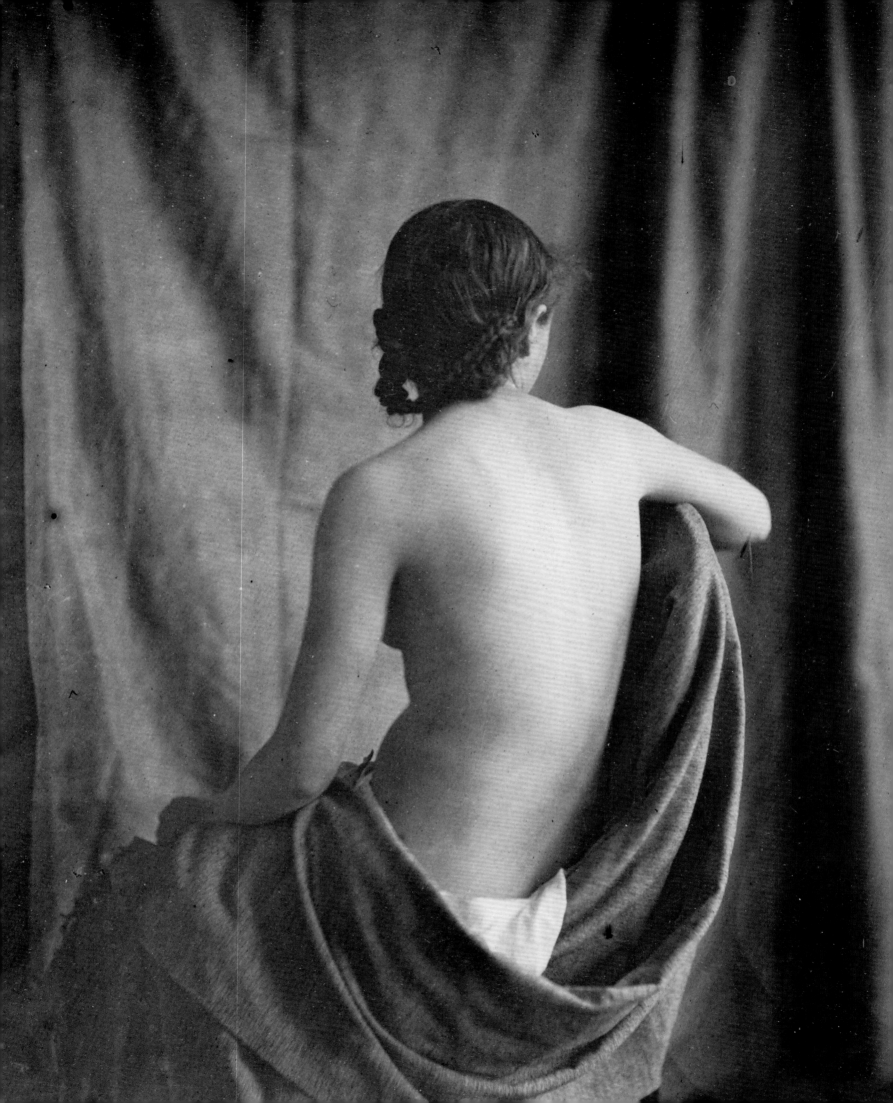

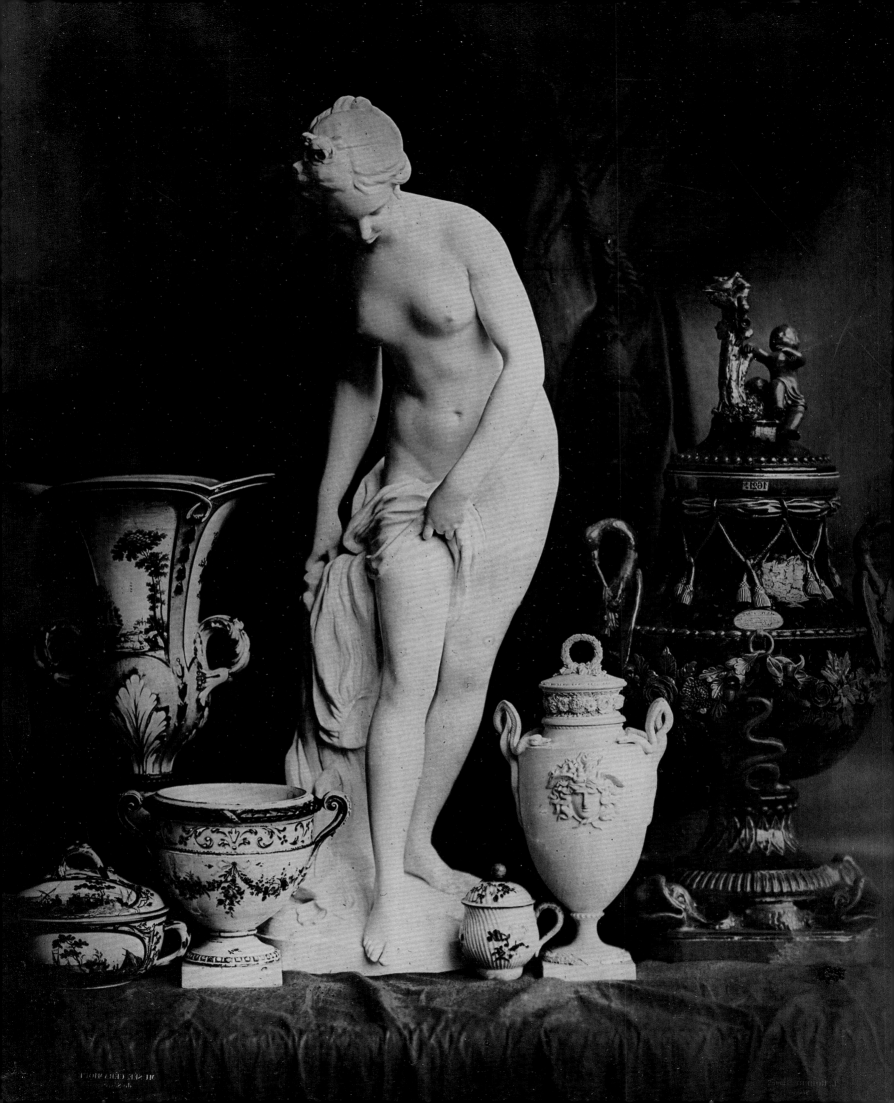

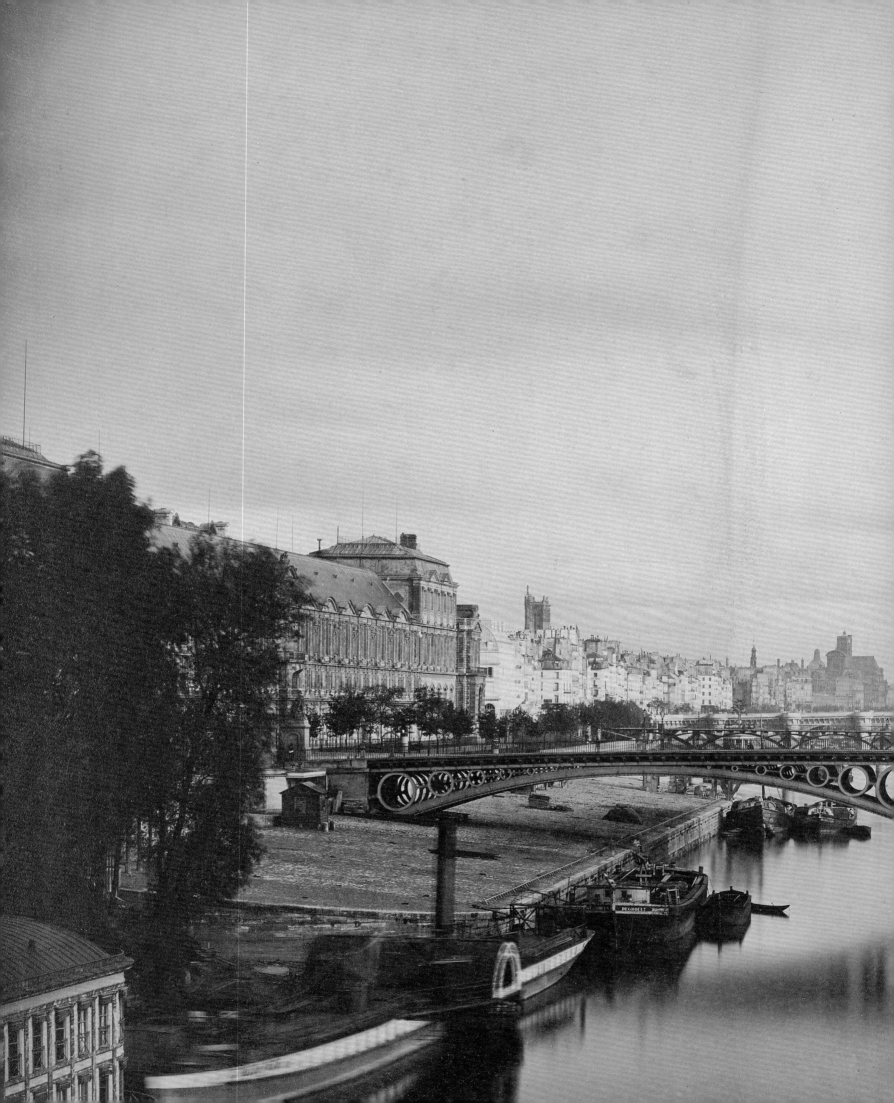

REAL

Photography in Mid-Nineteenth-Century France

IDEAL

Edited by Karen Hellman

with contributions by
Sylvie Aubenas, Sarah Freeman, Anne de Mondenard,
Karlyn Olvido, and Paul-Louis Roubert

The J. Paul Getty Museum, Los Angeles

This publication is issued on the occasion of the exhibition *Real/Ideal: Photography in France, 1847–1860*, on view at the J. Paul Getty Museum at the Getty Center, Los Angeles, from August 30 to November 27, 2016.

© 2016 J. Paul Getty Trust

Published by the J. Paul Getty Museum, Los Angeles
Getty Publications
1200 Getty Center Drive, Suite 500
Los Angeles, CA 90049–1682
www.getty.edu/publications

Ruth Evans Lane, *Project Editor*
Jane Bobko, *Manuscript Editor*
Jeffrey Cohen, *Designer*
Amita Molloy, Stacy Miyagawa, *Production*
John McElhone, *Translator*

Distributed in the United States and Canada by the University of Chicago Press
Distributed outside the United States and Canada by Yale University Press, London

Printed in Hong Kong

Library of Congress Cataloging-in-Publication Data
Names: J. Paul Getty Museum, host institution, author. | Hellman, Karen, editor. | Aubenas, Sylvie, writer of added commentary. | Freeman, Sarah, 1971– writer of added commentary. | Mondenard, Anne de, writer of added commentary. | Roubert, Paul-Louis, writer of added commentary.
Title: Real/ideal : photography in mid-nineteenth-century France / edited by Karen Hellman, with Sylvie Aubenas, Sarah Freeman, Anne de Mondenard, Karlyn Olvido, and Paul-Louis Roubert.
Other titles: Real ideal
Description: Los Angeles : J. Paul Getty Museum, [2016] | ©2016 | Includes index. | "This publication is issued on the occasion of the exhibition Real/Ideal: Photography in France, 1847–1860, on view at the J. Paul Getty Museum at the Getty Center, Los Angeles, from August 30 to November 27, 2016."—Provided by publisher.
Identifiers: LCCN 2016008951 | ISBN 9781606065105 (hardcover)
Subjects: LCSH: Calotype—France—History—19th century—Exhibitions. | Photography—France—History—19th century—Exhibitions. | Photograph collections—California—Los Angeles—Exhibitions. | J. Paul Getty Museum—Photograph collections—Exhibitions.
Classification: LCC TR395 .J53 2016 | DDC 770.74/79494—dc23
LC record available at http://lccn.loc.gov/2016008951

Illustration Credits
Every effort has been made to contact the owners and photographers of objects reproduced here whose names do not appear in the captions or in the illustration credits as listed below. Anyone having further information concerning copyright holders is asked to contact Getty Publications so this information can be included in future printings.

Plates 12, 13; fig. 17: © RMN-Grand Palais / Art Resource, NY
Plates 16, 17; figs. 3, 42: © BnF, Dist. RMN-Grand Palais / Art Resource, NY
Plate 23: © Gustave Le Gray / BHVP / Roger-Viollet / The Image Works
Plate 69: © The Israel Museum, Jerusalem by Ofrit Rosenberg Ben Menachem
Plate 97: © National Gallery of Canada
Plate 104; figs. 21, 24, 35: www.metmuseum.org
Plates 52, 55, 88, 89, 121; figs. 8, 14: Bibliothèque des arts décoratifs, Paris
Figs. 10, 22, 27, 34, 37, 38, 39, 43: Bibliothèque nationale de France
Fig. 9: Los Angeles, Getty Research Institute (1377-054)
Figs. 11, 12: © Musée Carnavalet / Roger-Viollet / The Image Works
Fig. 16: Los Angeles, Getty Research Institute (2850-401)
Fig. 18: Ardi Photographies
Fig. 19: Swiss National Museum (LM-117298-24 à 34)
Fig. 20: © Daniel Blau Munich, Courtesy Daniel Blau

Contents

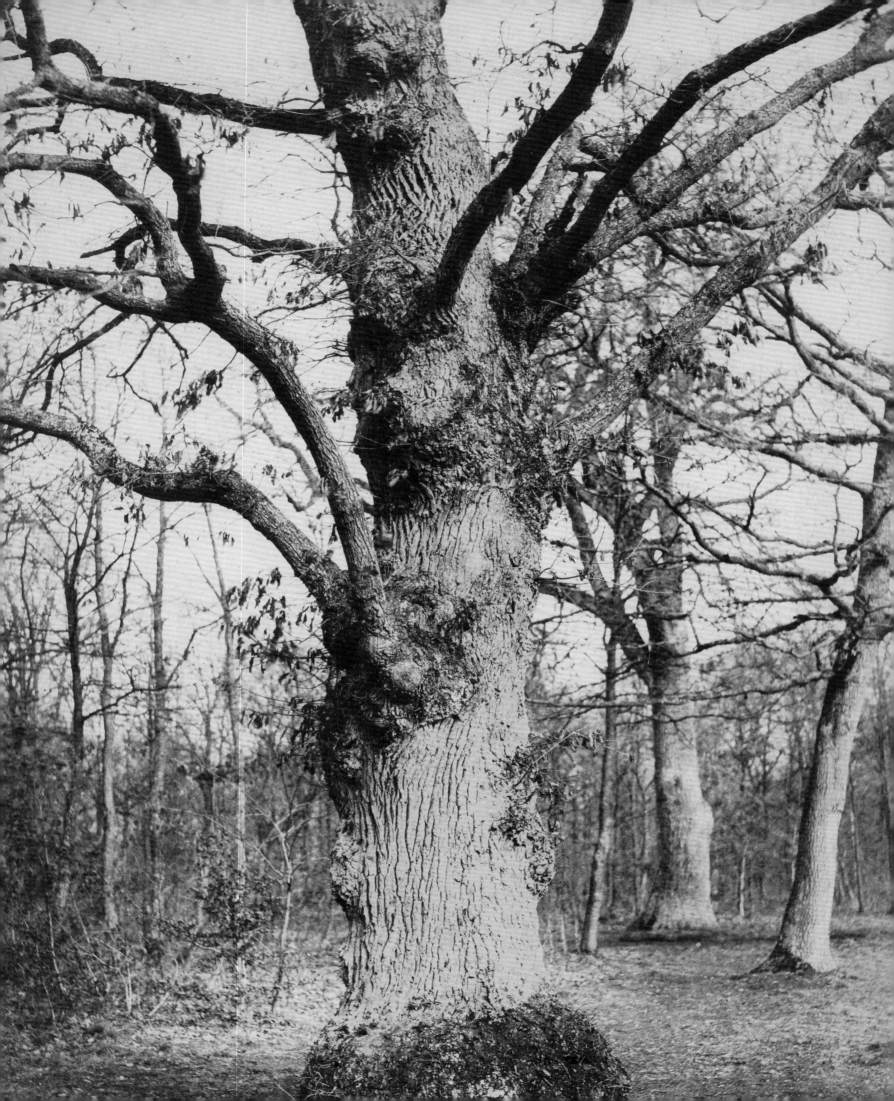

Foreword

In the years following the announcement of the invention of photography in 1839, practitioners in France gave shape to this exciting new medium through experimental printing techniques and innovative compositions. The rich body of work they developed proved foundational to the establishment of early photography, from the introduction of the paper negative in the late 1840s to the proliferation of more standardized equipment and photomechanical technology in the 1860s. The works in the exhibition *Real/Ideal: Photography in France, 1847–1860* were created during a period in this early history of the medium when the ambiguities inherent in the photograph were ardently debated. The dialogue between notions of real and ideal has been critical to understanding and even defining the character of photography from its beginnings. Photography's status as either (or both) fine art or industrial product, its repertoire of subject matter, its ideological functions, even the ever-experimental photographic process itself are issues that occupy practitioners still today.

Real/Ideal explores these themes in their various manifestations by focusing on French photographers who worked with paper negatives, especially the key figures Édouard Baldus, Gustave Le Gray, Henri Le Secq, and Charles Nègre. The catalogue serves as the first publication of a large number of the J. Paul Getty Museum's nineteenth-century paper prints made from paper and glass negatives, highlighting our especially strong holdings of early French photography. It includes several key prints and negatives acquired in 2015 from the collection of Jay McDonald of Santa Monica, which also form a cornerstone of the exhibition.

We are grateful to Karen Hellman, assistant curator in the Department of Photographs, who conceived the exhibition and catalogue. The project has been further enhanced by generous loans from institutional and private collectors. We are pleased to thank them here: the Bibliothèque national de France, Bibliothèque des arts décoratifs, Musée d'Orsay, Médiathèque de l'architecture et du patrimoine, Société française de photographie, Bibliothèque historique de la Ville de Paris, Galerie de Bayser, Paris; the Wilson Centre for Photography, London; the National Gallery of Canada, Ottawa; Robert Hershkowitz, Sussex, England; Paul Sack, San Francisco; the San Francisco Museum of Modern Art; Gary Sokol, San Francisco; Manfred and Hanna Heiting, Malibu; and the Getty Research Institute.

Timothy Potts
Director, J. Paul Getty Museum

Acknowledgments

Karen Hellman

o delve into the photography of mid-nineteenth-century France is to witness a vibrant dialogue sparked by material and philosophical exchange between people from every discipline. A similar exchange of ideas between curators and conservators, and photography historians and collectors, was essential to the making of this publication and exhibition. I particularly thank the French authors who contributed essays—Sylvie Aubenas, Anne de Mondenard, and Paul-Louis Roubert—as well as Sarah Freeman for her essay and coordination of analyses of the negatives in the Getty collection. Their scholarship and writing, as evidenced in this book, continues to be at the forefront of work on this period in French photography.

I thank the institutions that lent to the exhibition and publication. I am grateful to Sylvie Aubenas and Thomas Cazentre, in the department of prints and photographs at the Bibliothèque nationale de France, for allowing access to their masterpieces; Béatrice Krikorian at the Bibliothèque des arts décoratifs, who made it possible for me to make several visits to view their extraordinary holdings of salted paper prints and cyanotypes by Henri Le Secq; Luce Lebart and Paul-Louis Roubert at the Société française de photographie; Thomas Galifot, Fabrice Golec, and Marie Robert at the Musée d'Orsay; Carole Gascard at the Bibliothèque historique de la ville de Paris; Françoise Reynaud at the Musée Carnavalet; Gilles Désiré dit Gosset at the Médiathèque de l'architecture et patrimoine; Lori Pauli at the National Gallery of Canada, Ottawa; and Matthieu de Bayser at the Galerie de Bayser in Paris. I thank the generous private collectors who have shared their treasures: Manfred and Hanna Heiting, Robert Herschkowitz, Jay McDonald, Paul Sack, Gary Sokol, and Michael and Jane Wilson. I am indebted to individuals outside of the Getty who provided helpful access during the research stage: Marie-Sophie Corcy, Shelley Dowell, Polly Fleury, Michel Frizot, Laure Haberschill, Lisa Hostetler, Serge Kakou, Hope Kingsley, Ross Knapper, Hans Kraus, Baudoin Lebon, Anne McCauley, Jay McDonald, Ella Naef, Françoise and Michel Paviot, Stephanie Smith, and Isabelle Taillebourg.

At the Getty Museum, many thanks to Timothy Potts, director, and Thomas Kren, former associate director for collections and senior curator emeritus, Manuscripts, for their support of the project. Many people around the Getty have contributed to this exhibition and its catalogue: in the Registrar's Office, my gratitude to Cherie Chen and Leigh Grissom for coordinating images for the plates and handling all rights and reproduction issues for the publication; to Amy Weiss for masterfully arranging all incoming loans; and to Carole Campbell and Marit Coyman-Myklebust for tracking everything internally and externally. My great thanks to the Exhibitions Department, particularly Quincy Houghton, Amber Keller, and Kirsten Schaefer for coordinating every detail of a loan exhibition such as this, and to the exhibition designers, Michael Lira, Amanda Ramirez, Stephanie Yaeger, and Tristan Telander. I thank associate editor Ruth Evans Lane and am grateful for the exceptional work of the Getty Publications staff, including book design by Jeffrey Cohen, production coordination by Amita Molloy and Stacy Miyagawa, image coordination by Pam Moffat, and editorial support by Rachel Barth and graduate intern Nicole Kim. My thanks to expert copyeditor Jane Bobko for her fine-tuning of the text and to John McElhone for the translation of the French essays. The leadership of publisher Kara Kirk and editor in chief Karen Levine made it possible for such a book with multiple authors and images from three continents to be achieved. Thanks as well to Michael Smith and his Imaging Services team, particularly Stacey Rain Strickler for her skill in photographing such light-sensitive objects as paper negatives and salted paper prints and Gary Hughes for preparing images for publication. At the Getty Research Institute, Marcia

Reed, Frances Terpak, and the staff of Special Collections were extremely helpful. Other individuals who were essential to the project are Tuyet Bach, Erik Bertellotti, Anne Martens, Alexandria Sivak, Sahar Tchaitchian, Peter Tokofsky, and Karen Voss.

In the Department of Photographs, I extend my appreciation to Virginia Heckert and Judith Keller for their encouragement and guidance; Karlyn Olvido for her incredible organization and drafting of the chronology; Miriam Katz for her cataloguing supervision and collection management; and Mazie Harris, Arpad Kovacs, Corey Mack, Amanda Maddox, Paul Martineau, and Marisa Weintraub for their advice. In the Department of Paper Conservation, I am grateful to Sarah Freeman for her sensitive conservation work for both publication and exhibition, to Marc Harnly, and to Stephen Heer and David McDaniel Jr. for their expert work with the mounting and framing for the exhibition. Thanks as well to Kevin Marshall and Tracy Witt in the Preparations Department for their talent in devising the illumination of fragile and rarely exhibited waxed paper negatives.

Out of this project developed a collaboration on the study of the French waxed paper negative, and so I thank Marc Harnly and Sarah Freeman in the Department of Paper Conservation at the Getty Museum for their expertise and support in establishing a project with the Centre de recherche et de restauration des musées de France (C2RMF) at the Louvre and the Centre de recherche sur la conservation des collections (CRCC), Paris, particularly with the support of Anne de Mondenard and Bertrand Lavédrine, who spearheaded this pioneering study. Sylvie Aubenas and Patrick Lamotte at the BnF generously supplied rare paper negatives for analysis. The joint initiative, still in its early stages, would not be possible without the scientists at the Getty Conservation Institute, including Tom Learner, Jim Druzik, Michael Schilling, Art Kaplan, and Vincent Beltran.

Photographie

Recueil

de

Dessins positifs

obtenus

à l'aide de négatifs sur papier.

Souvenirs.

Introduction

Karen Hellman

rare group of 167 photographs from paper and glass negatives by the innovative French photographer Hippolyte Bayard (1807–1887) and others has been a part of the J. Paul Getty Museum's collection since the establishment of the Department of Photographs in 1984 (fig. 1). Originally assembled in an album (now disbound), which was titled by an unknown hand *Photographie: Recueil de dessins positifs obtenus à l'aide de négatifs sur papier* (Photography: Collection of positive prints obtained from paper negatives), the works are predominately by Bayard. Bayard's prints in the album date from about 1842 to 1849 and include depictions of Bayard and his garden (plates 27, 28), portraits, still lifes, posed everyday scenes, and vistas of his native Paris. These prints offer rare insight into both this photographer and this period in the history of photography, shortly after the calotype, or paper, negative had been developed in England, in the mid-1830s, by William Henry Fox Talbot (1800–1877).[1] Inspired by Bayard's early experiments, this book and exhibition are devoted to paper photography in mid-nineteenth-century France and provide an overview of the Getty's holdings. The focus is on the era between 1847, when the first French treatise on the paper negative was published, and the 1860s, when more streamlined, mechanical means were sought for photography.[2]

Real/Ideal: Photography in Mid-Nineteenth-Century France explores a period in the development of photography that overlapped with a change in practice among novelists and painters, who were abandoning "ideal"—mythological or biblical—subjects for "real" people and objects of everyday life. The photographers included here explored the medium through depictions of architecture, genre scenes, studies of nature, and still lifes. Each photographer's work with the paper negative, the specific ways in which each treated the "real" material of the medium in order to create an image that might be deemed "ideal" in its execution, will be examined in the contexts of the critical reception of photography and of photography's complex relationship to Realism and to art in 1850s France.

The work of four French photographers—Édouard Baldus (1813–1889), Gustave Le Gray (1820–1884), Henri Le Secq (1818–1882), and Charles Nègre (1820–1880)—is highlighted, primarily through examples from the Getty Museum's collection. These photographers were what the Parisian portrait photographer Nadar (Gaspard-Félix Tournachon, 1820–1910), in his 1899 memoir *Quand j'étais photographe* (When I was a photographer), called "primitives" ("les primitifs de la photographie"): they explored the medium in France before there were any established practices or schools.[3] Exhibited alongside their work are photographs by some of their contemporaries who made paper photographs and also portraits, made between 1853 and 1865, by Nadar's studio (though he did not practice the paper negative) that capture the photographers' artistic and literary coevals in Second Empire Paris.[4]

The Getty Museum's Department of Photographs was founded following a surge of studies on the French calotype in the early 1980s, and one year after three exhibitions of French paper photography were held in the United States, including *Masterpieces of the French Calotype* (1983), at the Princeton University Art Museum, whose accompanying catalogue was *The Art of French Calotype*.[5] Since then, the calotype (when the process was imported to France, the word *calotype* was often used to describe both the paper negative and the positive print, and the practitioner was known as a *calotypiste*) and early French photography have been a particular strength of the Getty's collection.[6] Many of these works have been included in exhibitions about paper photographers in the United States, Canada, and Europe, including the 2002 exhibition at the Getty Museum *Gustave Le Gray, Photographer (1820–1884)*, organized with the Bibliothèque nationale de France, Paris[7]; *Primitifs de*

Fig. 1.
Title page of *Photographie: Recueil de dessins positifs obtenus à l'aide de négatifs sur papier*, ca. 1842–60. Los Angeles, J. Paul Getty Museum, 84.XO.968

la photographie: Le calotype en France (1843–60), at the Bibliothèque nationale de France, Paris (2010); *Nineteenth-Century French Photographs from the National Gallery of Canada*, Ottawa (2010); and *Modernisme ou modernité: Les photographes du circle de Gustave Le Gray (1850–60)*, at the Petit Palais, Paris (2012). In addition to Le Gray, Baldus and Nadar have been given careful monographic attention in American exhibitions in recent decades.[8]

"Real" and "ideal" are problematic terms within aesthetics even aside from further complication by the invention of photography, but here they are critical to an understanding of the historical and artistic domains of these photographs. Each of the essays in this book addresses a different aspect of these contexts. My essay points to key works in the Getty's collection and to the ways the "real" is utilized or purposefully neglected by the photographer, depending on the subject. Anne de Mondenard focuses on the French government's part in the development of paper photography. Paul-Louis Roubert's essay examines the role of the Salon and art criticism in France in paper photography's evolution. Sylvie Aubenas takes up the idea of the "physiology" of the artist-photographer, or *calotypiste*, in France, and its influence on paper photography and artists' definition of themselves as photographers. Sarah Freeman looks closely at some of the recipes and techniques developed by photographers to create their paper negatives, discusses the recent examination of paper negatives in the Getty's collection, and determines some of the main issues in the conservation and display of these rare and light-sensitive objects. Finally, Karlyn Olvido has compiled a chronology of some of the key photographic, literary, historic, and artistic events of the period.

NOTES

1. Bayard's 1839 invention of a direct-positive paper photograph was overshadowed by the government-promoted daguerreotype.

2. It might have been possible for paper-negative photography to flourish in France as it was beginning to do in England in the early 1840s. However, the combination of Talbot's restrictive patents on his process and the initial saturation of the market by the daguerreotype, the dominant photographic process in France, slowed the evolution of a working "school" of paper-photography practitioners.

3. Nadar, *Quand j'étais photographe* (Paris: Flammarion, 1899), 191–245.

4. The "primitives" switched to glass-plate negatives and albumen prints in the mid-1850s, and several of those photographs are also part of this exhibition.

5. André Jammes and Eugenia Parry Janis, *The Art of French Calotype*, exh. cat. (Princeton: Princeton University Press, 1983). This exhibition and catalogue were the impetus to Abigail Solomon-Godeau's essay "Calotypomania: The Gourmet Guide to Nineteenth-Century Photography," in *Photography at the Dock: Essays on Photographic History, Institutions, and Practices* (Minneapolis: University of Minnesota Press, 1991): 4–27. Since then, studies, particularly in the form of monographs, have been written on this period in French photography and on some early French photographers: Baldus, Bayard, Louis Désiré Blanquart-Evrard (1802–1872), André Adolphe-Eugène Disdéri (1819–1889), Le Gray, Charles Marville (1813–1879), Nadar, and Henri-Victor Regnault (1810–1878).

6. Significant works made in France between the mid-1840s and the early 1860s came to the Getty Museum through four of the major collections whose purchase established the Department of Photographs: the collection of the Swiss art dealer Bruno Bischofberger (more than 1,700 works), that of the Chicago collector Arnold Crane (more than 1,500 works), that of the French collector André Jammes (more than 4,000 objects, including more than 1,300 individual prints), and that of the New York–based collector Samuel Wagstaff Jr. (more than 7,000 works). The Getty's holdings of Le Gray number about 180 objects. Baldus and Nadar are also well represented, with the Baldus holdings numbering about 100 loose prints and more than 700 prints in albums; there are about 900 works by Nadar. The Getty collection currently includes 26 prints by Le Secq, whose work is less well represented in the United States (the largest collection is that of the George Eastman Museum in Rochester, New York), and 40 works by Charles Nègre. The largest holdings of Nègre outside France are those of the National Gallery of Art in Ottawa and the Centre for Canadian Architecture in Montreal.

7. See Sylvie Aubenas, *Gustave Le Gray, 1820–1884*, with contributions by Anne Cartier-Bresson et al., ed. Gordon Baldwin, exh. cat. (Los Angeles: J. Paul Getty Museum, 2002).

8. See Malcolm R. Daniel, *The Photographs of Édouard Baldus*, exh. cat. (New York: Metropolitan Museum of Art; Montreal: Canadian Centre for Architecture, 1994); Maria Morris Hambourg, Françoise Heilbrun, and Philippe Néagu, eds., *Nadar*, with contributions by Sylvie Aubenas et al., exh. cat. (New York: Metropolitan Museum of Art, 1995).

Real/Ideal: Photography in Mid-Nineteenth-Century France

Karen Hellman

pic tales of ordinary citizens, towering canvases depicting everyday subjects—such were the creations of many French Realist novelists and painters in the mid-nineteenth century. The creations of Honoré de Balzac (1799–1850), Gustave Courbet (1819–1877), Gustave Flaubert (1821–1880), the brothers Edmond (1822–1896) and Jules (1830–1870) de Goncourt, Jean-François Millet (1814–1875), Émile Zola (1840–1902), and others brought ordinary people to the forefront of the artistic imagination. Despite the widespread turn away from academic, mythological, or biblical subjects, which coincided with a new attention to the drastic divide between the aristocracy and the working class, Realism was not a clearly defined movement in either literature or painting. Even one of its advocates, the writer Champfleury (1821–1889), resisted its definition, writing in 1857 in *Le réalisme* (fig. 2): "I don't like schools, I don't like flags, I don't like systems, I don't like dogmas; it is impossible to place myself in the small church of Realism."[1] By that time, Realism derived from several sources rather than from one point of origin or manifesto and had been a force in literature and painting for over a decade.

The "real," rather than "ideal," subject became increasingly important for writers, painters, and critics in mid-nineteenth-century France, appearing in a range of media. *The Human Comedy* (1842–49), the multivolume lifework of Balzac (fig. 3), was divided among scenes of various kinds, including scenes of private life, Parisian life, political life, and provincial life. Conceived in the early 1830s, shortly after the July Revolution of 1830 had put

Fig. 2.
Title page of Champfleury, *Le réalisme* (Paris: M. Lévy, 1857). Los Angeles, Getty Research Institute, 86-B6590

Fig. 3.
Nadar (Gaspard-Félix Tournachon) (French, 1820–1910), *Honoré de Balzac*, 1850s. Charcoal and gouache, 31 × 23.2 cm (12³/₁₆ × 29 in.). Paris, Bibliothèque nationale de France, Département des estampes et de la Photographie, RESERVE BOITE FOL-NA-88

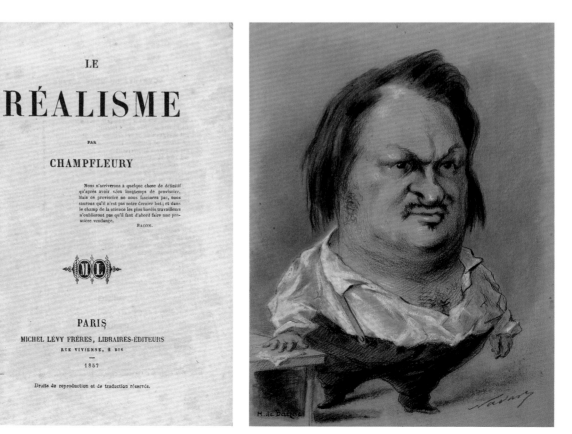

Louis-Philippe (r. 1830–48) on the throne, *The Human Comedy* was Balzac's attempt to create a comprehensive account of the multifaceted character and situations of French society, starting from the French Revolution. This was the era of the author as observer, of the Goncourts' *Journal* (1851–70), of Flaubert's *Madame Bovary* (1856), and of Victor Hugo's *Les misérables* (1862).

During this same period, Courbet exhibited *The Stone Breakers* (1849; destroyed) and *A Burial at Ornans* (1849; Paris, Musée d'Orsay)—two large-scale depictions of rural life—at the Salon, in 1850 and 1851, respectively, and Millet showed his worshipful paintings of workers, a subject to which he was devoted throughout his career (figs. 4, 5). In 1855, Champfleury wrote a pamphlet to accompany Courbet's private exhibition at the so-called Pavillon du réalisme, across the street from that year's Exposition universelle (from which several of Courbet's paintings, including *A Burial at Ornans*, had been rejected), while Courbet himself proclaimed his goal in a brochure written for the occasion: "To record the manners, ideas, and aspect of the age as I myself saw them—to be a man as well as a painter, in short to create living art."[2] For contemporary art critics such as Théophile Thoré (1807–1869), the subject and painting styles of Courbet and Millet provided an opposition to the decadence of Paris under Napoléon III (r. 1852–70): "the singularity of Millet and Courbet, amid the affectation of contemporary artists, is that they began to look at nature, deserted [by contemporary artists] for vague and misleading ideals. It is always returning to the natural truth that has regenerated the arts in all epochs."[3]

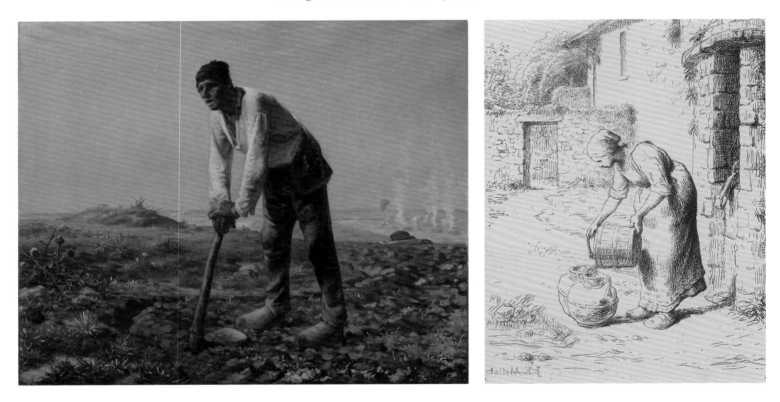

Fig. 4.
Jean-François Millet (French, 1814–1875), *Man with Hoe*, 1860–62. Oil on canvas, 80 × 299 cm (31½ × 239 in.). Los Angeles, J. Paul Getty Museum, 85.PA.114

Fig. 5.
Jean-François Millet (French, 1814–1875), *Woman Emptying a Bucket*, 1862. Cliché verre, 28.4 × 222 cm (11³⁄₁₆ × 28¹¹⁄₁₆ in.). Los Angeles, J. Paul Getty Museum, 84.XO.702.317.38

Such distinctions between "real" and "ideal" are also relevant to a generation of photographers active in France during this period. In connection with photography, the term *realism* is problematic for many reasons, not least because many mid-nineteenth-century French Realist writers and artists dismissed the medium of photography as mechanical, and did not comment on any substantive connection to or motivation for their work. The poet and art critic Charles Baudelaire (1821–1867), though a supporter of his friend Courbet's paintings, voiced despair about realism and its potential influence on art in general in his unfinished essay "Puisque réalisme il y a" (Since realism is there), in which he argued that all "true" artists *were* realists, it was just that their reality was of another realm, and therefore realism, and any medium that made it precious (photography) spoiled true art.[4] Champfleury also wrote disapprovingly about photography: "Ten *daguerréotypeurs* meet up in the countryside and subject the scenery to the action of light. Beside them, ten students of landscape painting set to copying the same site. Once the chemical operation is complete, the ten plates are compared: they depict exactly the same landscape, without variation. On the other hand, after two or three hours at work, the ten pupils...lay their sketches out next to each other. There is not a single similar one among them."[5]

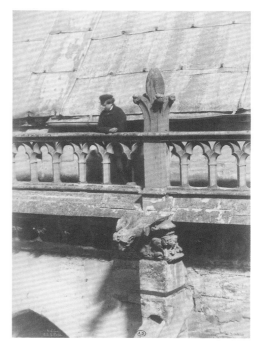

Certainly photography complicated a novel's or a painting's claim on "reality." But how Realist writers and painters related to photography (or didn't) is not the concern of this essay. Rather, my intention is to apply the dialectic of realism and idealism to photography. A discussion of the "real" versus the "ideal" is as critical to the photographic medium as it was to the literature and painting of the period. At the same time that French writers and artists were debating a new art for the economic era in which they lived, photographers were contending with their medium's unprecedented "realism." Thus, a consideration of the opposition of realism and idealism brings a fuller understanding of the photographs presented in this exhibition and of this period in photographic history. France from the late 1840s to the 1860s was not the only place or period in which the terms *realism* and *idealism* were debated, but the debate there and then was particularly passionate when it came to photography's purpose as a medium.

Four Photographers

Like many of their generation, Édouard Baldus (1813–1889) (see fig. 35), Gustave Le Gray (1820–1884) (fig. 6, see also fig. 34), Henri Le Secq (1818–1882) (see fig. 38), and Charles Nègre (1820–1880) (see fig. 8) moved to Paris to study painting in the 1830s. Le Gray, Le Secq, and Nègre met in the studio of the academic history painter Paul Delaroche (1797–1856), who was also Millet's mentor. Nègre, having moved to Paris from the provincial town of Grasse, entered Delaroche's studio in 1839, while Le Secq, born in Paris, and Le Gray, from Villiers-le-Bel (a suburb of Paris), entered in 1840 and 1842, respectively. Baldus had moved to Paris from Prussia in 1838. Each artist met with varying degrees of success at the Salons in the 1840s and, by the middle of that decade, each had been drawn toward the intriguing experimental potential of photography. Le Gray and Nègre both started making daguerreotypes as early as 1843 or 1844 (fig. 7), whereas Baldus, who appears not to have worked with the daguerreotype, turned to paper photography in 1848 or 1849.[6] Both Le Gray and Le Secq are known to have been working with paper photography in 1848. Not only did they practice the process together, often using each other as a model, but they also lived and worked near each other in Paris. Paper negative and positive portraits of Le Secq by Nègre, and of Nègre by Le Secq, on one of the towers of Notre-Dame, in Paris, in the early 1850s are in the collection of the Musée d'Orsay and the Bibliothèque des arts décoratifs (fig. 8). Le Gray published his first treatise on the waxed-paper negative, *Traité pratique de photographie sur papier et sur verre* (Practical treatise on photography on paper and on glass), in June 1850 (fig. 9), and Baldus published his own paper-negative method (which included soaking the paper in a sensitizer bath that contained gelatin) in May 1852 (fig. 10).[7] Le Gray's 1851 edition of his treatise (the second of four), entitled *Nouveau traité théorique et pratique de photographie sur papier et sur verre* (New theoretical and practical treatise on photography

Fig. 6.
Gustave Le Gray (French, 1820–1884), *Self-Portrait*, ca. 1855. Albumen silver print, 29.5 × 221.9 cm (11⅝ × 28⅝ in.). Los Angeles, J. Paul Getty Museum, 84.XP.218.73

Fig. 7.
Charles Nègre (French, 1820–1880), *Hellenistic Sculpture*, ca. 1847. Daguerreotype, 9.2 × 27 cm (3⅝ × 2¾ in.). Los Angeles, J. Paul Getty Museum, 92.XT.54

Fig. 8.
Henri Le Secq (French, 1818–1882), *Cathedral of Notre-Dame (Portrait of Charles Nègre)*, 1853. Salted paper print, 33 × 24 cm (13 × 9¼ in.). Paris, Bibliothèque des arts décoratifs

Fig. 9.
Cover of *Photographic Manipulation: The Waxed Paper Process of Gustave Le Gray*, 3rd ed. (London: George Knight and Sons, 1855). Los Angeles, Getty Research Institute. Le Gray's treatise was printed in several editions in English translation as well as in the original French.

Fig. 10.
Title page of Édouard Baldus, *Concours de photographie: Mémoire déposé au secrétariat de la Société d'encouragement pour l'industrie nationale* (Paris: Victor Masson, 1852). Paris, Bibliothèque nationale de France

Fig. 11.
Louis Désiré Blanquart-Evrard (French, 1802–1872), *Blanquart-Evrard's Daughter*, ca. 1847. Salted paper print, 20.7 × 15.7 cm (8 × 6 in.). Paris, Musée Carnavalet, C.91.195

Fig. 12.
Louis Désiré Blanquart-Evrard (French, 1802–1872), *Blanquart-Evrard's Wife*, ca. 1847. Salted paper print, 20.7 × 15.7 cm (8 × 6 in.). Paris, Musée Carnavalet, C.91.194

on paper and on glass)—the word "theoretical" had, significantly, been added to the title—also described his experiments with glass negatives, which were based on work with albumen-coated glass by Claude-Félix-Abel Niépce de Saint-Victor (1805–1870).[8] Although French photographers were using both paper and glass negatives relatively early on, and although Le Gray, Nègre, and Baldus stopped making paper negatives and turned to collodion-on-glass negatives after the mid-1850s, it was through the paper negative, though short-lived, that these practitioners found their early expressive potential as photographers.

In June 1847, a paper-negative process by the Lille-based businessman and cloth merchant Louis Désiré Blanquart-Evrard (1802–1872) (see fig. 33), originally sent to Paris the previous year, was presented and tested by a commission assembled from the Académie des sciences and the École des beaux-arts in the capital (figs. 11, 12).[9] The report stated that the French process was visually clearer than the English process and allowed for more variance in manipulation and effects. The report also stated: "We will not insist on the beauty of these prints, since they are under the eyes of the [Académie des sciences]."[10] This contrast between the science of the specimens (chemistry on ordinary paper) and their beauty underscores the immediate contradiction with which photographers with artistic ambitions struggled. Both Le Gray and Baldus adopted versions of the label "artist-photographer" (Le Gray described himself as a "peintre et photographiste"—painter and photographist—and Baldus referred to himself as a "peintre photographe"—painter-photographer).[11] Artistic ambitions are evident in the paper negatives of these four photographers. A negative by Le Gray from Balzac's birthplace of Tours (plate 13), made with Le Gray's student Auguste Mestral (1812–1884) for the Mission héliographique (discussed below) in 1851, depicts the glorious, towering facade of the cathedral of Saint-Gatien, but also the modern road and buildings leading up to it. A camera on a tripod is positioned to take a view of the edifice, and two ghostlike traces—the photographers—sit in a horse-drawn cart to the left of the camera. Differences in contrast, tonality, and thickness of paper become apparent when this negative is compared with one of Chartres Cathedral by Le Secq (plate 14), where the contrast between the darks and the lights is much higher. Even more telling is a comparison with Nègre's paper negative *Tarascon*, from 1852 (plate 15), to which he applied gouache to create a dynamically clouded sky.

A Society and a Mission for Photography

In 1851, while each of these four photographers was developing his individual techniques with the paper-negative process, each also played a role in one or both of two major photographic organizations in Paris—the Société héliographique and the Mission héliographique.[12] The Société héliographique, of which Baldus, Nègre, Le Gray, and Le Secq were founding members, was the first photographic society in the world. In formation and in membership, the society was a microcosm of the wide range of artistic, scientific, commercial, and industrial practices and applications embraced by the medium.[13] In addition to the photographers comte Olympe Aguado (1827–1894) (plate 112; see fig. 39), Jean-Louis-Marie-Eugène Durieu (1800–1874) (plate 102), and Joseph, vicomte Vigier (1821–1894), the membership included the Realist Champfleury (fig. 13); the Romantic painter Eugène Delacroix (1798–1863); the physicist and photographic experimenter Edmond Becquerel (1820–1891); the archaeologist, art historian, and bureaucrat Léon de Laborde (1807–1869); and the engraver Désiré-Albert Barre (1818–1878). By contrast, the Mission héliographique was established by the government-sponsored Commission des monuments historiques to photograph hundreds of key historical monuments in France in order to record them before they were transformed through restoration under Napoléon III.

In both organizations, photography's relationship to industry and to art, its "real" and its "ideal" dimensions, was integral to the photographers' choice of subjects and how they depicted them. In an early issue of *La lumière*, the journal of the Société héliographique, Nègre proposed that, in photography, "where science ends, art begins." In other words, the artist picks up where the scientist leaves off. Nègre continued: "When the chemist prepares the paper, the artist directs the lens, and by means of the three beacons that guide him ceaselessly in the study of nature—observation, feeling, and reasoning—he reproduces the effects that make us dream, the simple patterns that move us, and the sites with powerful and bold silhouettes that surprise us and frighten us."[14] The study of nature, observation, and reproduction are transformed via the medium of photography into dream, surprise, and fear. The tangible is transformed into the intangible.

Fig. 13.
Nadar (Gaspard-Félix Tournachon) (French, 1820–1910), *Champfleury (Jules-François-Félix Husson)*, ca. 1855–59. Salted paper print, 35.4 × 24.4 cm (13¹⁵⁄₁₆ × 9⅝ in.). Los Angeles, J. Paul Getty Museum, 84.XM.436.455

That a mechanical device was capable of effecting such a transformation was also a point of discussion for members of the Société héliographique in assessing the medium's purported realism. In the first issue of *La lumière*, critic and contributor Francis Wey (1812–1882) marveled at the various ways in which a photographer could, as Nègre did, alter a photographic image by improving the negative, stating: "Photography translates perfectly, but to surpass this, it must not only translate but *interpret*."[15]

The question of "real" versus "ideal" was equally significant in determining the photographs created for the Mission héliographique. Although the mission was a documentary one, each photographer developed distinctive compositional and aesthetic techniques in his paper and glass negatives. The five photographers selected for the mission—Baldus, Hippolyte Bayard (1801–1887) (see fig. 32), Le Gray, Le Secq, and Mestral—were each assigned a different region of France to photograph. Le Gray combined his itinerary with that of his student Mestral, and the two traveled through the south and west.[16] Le Secq documented monuments in the east, while Baldus went south. Bayard photographed north and west of Paris (he was also the only one of the five photographers to use glass negatives for this project and in the end submitted no work).[17]

In creating images for the Mission héliographique, the photographers experimented with a variety of methods, which underscores the argument for photography's unconventional relationship with precise representation. To compose *West Facade, Church of Saint-Jacques, Aubeterre* (plate 31), Le Gray and Mestral placed the camera containing a paper negative aslant with respect to the church's facade. The departure from a frontal, documentary stance, together with the inclusion of a figure (likely Mestral) standing inconspicuously alongside the arching stone columns of the main entrance, creates an experience of the Romanesque facade that is at once human and monumental.

Whereas Le Gray manages to capture the scale of a monument while also endowing it—by recording the stone surface through the texture of the paper negative—with a somewhat mystical, even dreamlike appearance, Le Secq let go entirely of the need to encompass the edifice (plate 33).[18] In a rare waxed salted paper print of *Strasbourg (Bas-Rhin), Cathedral of Notre-Dame* in the Getty Museum's collection, the grand central portal of the cathedral fills the frame, leaving no vantage point and forcing closer attention on the sculptural facade (plate 34). Le Secq often climbed to heights that allowed an unprecedented proximity to the Gothic cathedral, as he did when photographing the upper stories of the cathedral at Reims, giving a perspective not attainable for the average viewer (fig. 14). That photographers wrestled with notions of the "real" and the "ideal" is particularly evident in Le Secq's photographic "fragments" of "real" details of French Gothic sculptural facades (plate 122). Not only are they highly shadowed and confronted at unattainable (that is, ideal) vantages that cannot be humanly experienced, they also deliberately move far away from a straightforward, contextual document of the structure.

Baldus's and Nègre's styles of architectural photography were distinct from that of Le Secq and Le Gray. Baldus, who left Paris for his Mission héliographique in July 1851 and traveled south, focusing on the ancient Roman and medieval constructions near Arles, Avignon, and Nîmes, often backed away from the ancient monument or cathedral in order to situate his subject in the surrounding landscape. Nègre was not selected for the Mission héliographique, but it likely inspired his own six-month project to make photographs of his native Midi region, on which he embarked in August 1852. Nègre's prints from this journey were eventually compiled into a portfolio, and a bound album of seventy-four plates, entitled *Le Midi de la France: Sites et monuments historiques photographiés par Charles Nègre, peintre* (The Midi of France: Historic sites and monuments, photographed by Charles Nègre, painter), was planned for publication (plate 86).[19] Individual images of the Roman ramparts at Arles from this project (plates 47–49) illustrate Nègre's experimentation with perfecting the perspective in the final print. A comparison of Nègre's *An Aisle of the Cloister of Saint-Trophîme, Arles*, from about 1852 (plate 41), with several images of the same cloister, from about 1851, by Baldus (plates 36–38) is helpful in pointing out the differences in Nègre's and Baldus's compositional decisions. In order to create a cohesive, more "realist" view not possible in one frame, Baldus was adventurous with his paper negatives, often combining several to make a single positive print. In *Arles (Bouches-du-Rhône)—Amphitheater, Interior View* (plate 12), for example, he combined four negatives. For his image of the cloister of Saint-Trophîme, Baldus constructed a final print of the hallway and arcade of the cloister from ten different negatives. Nègre chose instead to focus on the vertical patterning of the arcade, composing his photograph as a dynamic segment of the passageway rather than attempting to encompass the whole corridor (plate 41).

In Baldus's photograph of the facade of the church of Saint-Trophîme (plate 43) and Nègre's *Church of Saint-Gabriel, near Arles* (plate 44), the photographers' approaches are again quite different. Whereas Baldus placed his camera at some distance from the church, and in a somewhat elevated position, to create a more symmetrical perspective of the entire facade, Nègre positioned his camera at a shorter distance and angled it upward, so that the church appears to be rising dramatically from deeply shadowed forms of trees in the foreground. The critic Henri de Lacretelle (1815–1899) wrote about this photograph by Nègre in *La lumière* in 1853, admiring the fine detail and remarking that the facade of the church of Saint-Gabriel appears to be reconstructed "stone by stone."[20] Looking closely, one notices the adjustments the artist made by hand (with two different values of black ink, as well as graphite and gouache) in the sky, the stairs, and the shadows of the negative to enhance the final positive image. In the same article, Lacretelle discussed Nègre's 1852 *Papal Palace, Avignon* (plate 50), about which he said: "The lens has obeyed the artist like a canvas and it has, if one may put it his way, been filled with its inspiration."[21] In 1852, Ernest Lacan (1828–1879), the editor of *La lumière*, commented on Baldus's ability to capture so much of the same Papal Palace within the confines of paper fifty centimeters high, concluding that

Baldus "has enough talent and faith in his art to achieve even better than the beautiful."[22]

Although more than three hundred negatives were produced for the Mission hélio-graphique, the albums of positive prints that were originally planned were never realized. Once Napoléon III established himself as emperor in 1852, government interest, and money, was given over to new commissions to photograph edifices and events important to the empire.[23]

"The Details We Wrongly Call Small"

Nègre's *A Street in Grasse* (plate 84), one of his most celebrated images of his native town in Provence, depicts a hillside of houses and olive presses layered along an upwardly wind-ing road. While the photograph is authentic in its depiction of a scene of olive-oil produc-tion, the composition also balances the placement of villagers at work with the light and shadow of the structures and the movement of the road.[24] "Being a painter myself," Nègre commented, "I have kept painters in mind by following my personal tastes.... Wherever I could dispense with architectural precision, I have indulged in the picturesque."[25] Although the "sacrifice of details" was a strategy not only for photographers but also for artists, it is important to recognize that photographs inevitably found details that could not be avoided. Victor Hugo lamented that "history neglects these particularities, and cannot do otherwise; infinity would invade it. And yet these details that we wrongly call small...are useful. It is the face of years that makes up the figure of centuries."[26] While Hugo was not strictly a Realist writer, his concerns for the working class and his political support for universal suffrage aligned him with the Realist movement. "Details" can be interpreted on many levels (in Hugo's case, political and historical), but at the time that he was writing, photography had access to unprecedented "real" details and photographers struggled to include or not include them, depending on the aesthetic—photographic, really—intention of the maker.

Nègre focused on the subject of the worker. Of the four photographers on whom this essay focuses, Nègre was the most devoted to continuing his practice as a painter alongside his photography and often used his photographs as references for paintings (plates 67–69).[27] These were typically genre scenes of working-class Paris—candle sellers, chimney sweeps, and organ-grinders, posed to give the impression of being in the midst of typical everyday activity (plates 64–66). Even Baudelaire, who included street merchants and entertainers in his writings as symbols of an irretrievable bygone era, might have approved of Nègre's series of photographs of an organ-grinder, made sometime before May 1853, when an oil painting from one of the prints was exhibited in the Salon.

Around 1855, Le Secq began a series of still-life compositions, making life-size prints of fruit, flowers, and various household items such as glass dishes and goblets, or a pipe and tobacco, that one might find in a well-to-do home at the time. His interest in such subjects is evident in almost forty known waxed-paper negatives and several salted paper prints and cyanotypes in public collections.[28] In one cyanotype, a glass wine bottle with a label bearing the hand-inked word *fantaisies* is propped on a table along with a large camera lens and two small, half-filled glasses (plate 121). The composition of everyday, inanimate objects would seem to mimic the eighteenth-century French still-life tradition. However, the deter-mined way in which the juxtaposition of details—an optical, manmade device with the label *fantaisies*—and the way in which the subjects are photographed close to their actual size, keeps the photographs in the present moment.[29]

Hugo's writing influenced several French photographers, particularly Le Secq, and their interest in photographing medieval French architecture in the face of Napoléon III's cam-paign to transform Paris. Baldus, Le Gray, Le Secq, and Nègre brought the concerns of the Mission héliographique to their photographic records of the demolitions (plate 55) as well as to restorations of Parisian monuments, particularly Notre-Dame (plates 24, 25), the Tour Saint-Jacques (plates 56, 57), and the bridges and banks of the Seine (plates 62, 63).

Photo-graphy/Photo-mechanical

The Société française de photographie (SFP) was formed in 1854, following the dissolution of the Société héliographique, which had split as a result of divisions between "artist-photographers" and "commercial" photographers. This new society began hosting photo-graphic exhibitions in 1855. In 1859, it organized an exhibition in the same building as the

annual Salon.[30] Baudelaire's famous review of the 1859 Salon warned against a society in which "an industry that would give us a result identical to nature would be [considered] the absolute art."[31] He saw the linking of vision with "realism" as potentially leading to devastating spiritual impoverishment. Describing both photographers and those who sat to have their portraits made by photographers, Baudelaire criticized "this unspeakable society who rushed, like a collective Narcissus, to contemplate its trivial image on the metal [daguerreotype] plate" and the "thousands of avid eyes" that looked eagerly and without autonomy into the beguiling images in the stereoscope, as if looking into "windows of the infinite."[32]

By the time of the founding of the SFP, Baldus, Le Gray, Le Secq, and Nègre all worked with photomechanical printing (plates 137–144; figs. 15, 16). What might Baudelaire think of the further mechanization of the medium (photography was always industrial and had been created in large part to make multiple reproductions) when these "artist-photographers," who had developed individual "touches" in the photographic medium, turned to the production of photomechanical prints, chiefly in the interest of preserving the images and ensuring their longevity?

When Hugo wrote in 1864, two years after the publication of *Les misérables*, that "the human soul…has still greater need of the ideal than of the real. It is by the real that we exist; it is by the ideal that we live," he maintained an argument for the Romantic ideal, even as his novel brought to life the darker reality of his own time.[33] Even if the debates surrounding photography's early years centered around the dualities of real and ideal, tangible and intangible, observation and imagination, it is clear from their coexistence in the photographs of Baldus, Le Gray, Le Secq, Nègre, and others that the medium would build on this inherent split.

Fig. 15.
Charles Nègre (French, 1820–1880), *Jean-Auguste-Dominique Ingres*, 1844. Engraving, 10.6 × 12.9 cm (4³⁄₁₆ × 5¹⁄₁₆ in.). Los Angeles, J. Paul Getty Museum, 84.XM.692.18

Fig. 16.
Cover of Honoré d'Albert, duc de Luynes, *Voyage d'exploration à la Mer morte, à Petra et sur la rive gauche du Jourdain* (Paris: Arthus Bertrand, 1874). Los Angeles, Getty Research Institute, 2850-401. The volume includes photogravures by Charles Nègre from wet-collodion negatives by Lieutenant Louis Vignes.

NOTES

1. Champfleury, *Le réalisme* (Paris: M. Lévy, 1857), 2–3.
2. Gustave Courbet, "Statement on Realism," 1855. Reprinted in *Art in Theory, 1815–1905: An Anthology of Changing Ideas,* ed. Charles Harrison, Paul Wood, and Jason Gaiger (Malden, MA: Blackwell Publishing Ltd., 1998), 398.
3. Théophile Thoré, *Salons de W. Burger, 1861 à 1868* (Paris: Librairie de Vᵉ Jules Renouard, 1870), 93.
4. Charles Baudelaire, "Puisque réalisme il y a," in *Œuvres complètes* (Paris: Gallimard, 1968), 2: 57–59. This article on Champfleury and Courbet, drafted in 1855, was never published.
5. Champfleury, *Le réalisme* (Paris: Michel Lévy Frères, Libraire-Éditeurs, 1857), 92.
6. Sylvie Aubenas, *Gustave Le Gray, 1820–1884*, with contributions by Anne Cartier-Bresson et al., ed. Gordon Baldwin, exh. cat. (Los Angeles: J. Paul Getty Museum, 2002), 25–27; Malcolm Daniel, *The Photographs of Édouard Baldus*, exh. cat. (New York: Metropolitan Museum of Art; Montreal: Canadian Centre for Architecture, 1994), 20.

7. Gustave Le Gray, *Traité pratique de photographie sur papier et sur verre* (Paris: Plon Frères, 1850); Édouard Baldus, *Concours de photographie: Mémoire déposé au secrétariat de la Société d'encouragement pour l'industrie nationale* (Paris: Victor Masson, 1852).

8. Niépce de Saint-Victor, second cousin of Joseph Nicéphore Niépce (1765–1833), had presented an albumen-on-glass process in June 1846 and October 1847. Le Gray's treatise included discussions about the art of photography and how it could be useful for artists, and about the future of photography. It was published in four editions, in 1850, 1851, 1852, and 1854.

9. See Anne de Mondenard, "Champions of Paper: The Pioneers of Negative-Positive Photography in France, 1843–1860," in this volume.

10. Isabelle Jammes, *Blanquart-Evrard et les origines de l'édition photographique française: Catalogue raisonné des albums édités, 1851–1855* (Geneva: Droz, 1981), 30. Blanquart-Evrard's "improvements" were judged by most of the audience to not be very different from Talbot's paper process in terms of the steps and chemistry used, though the result was different. The published report also noted that whereas Talbot brushed the sensitizing chemistry on the surface of the paper, Blanquart-Evrard soaked both sides of the paper, and therefore the "French" image did not just rest on the surface but was "also produced in the 'interior' [of the paper] and attained a degree of intensity that the lighter images did not achieve."

11. In his first three treatises, Le Gray referred to himself as "painter and photographer." By 1856, Le Gray was listed in the *Bottin* (the annual trade directory) as "history painter and photographer." Aubenas, *Gustave Le Gray*, 250. For Baldus, see Daniel, *The Photographs of Édouard Baldus*, 18.

12. *Héliographie* (sun drawing) was one of the first words used to describe the process in France, *hélio* being derived from the Greek *helios* (sun). Joséph Nicéphore Niépce used this term in the 1820s. Daguerre's first manual for the daguerreotype, published in 1839, included Niépce's "Notice sur héliographie" (Note on sun drawing).

13. See Paul-Louis Roubert, "A Bourgeois Ambition: Photography and the Salon des Beaux-Arts during the Second Empire," in this volume. These conversations were recorded in the minutes of the Society's meetings as well as in the weekly journal *La lumière*.

14. Charles Nègre, "Héliographie sur papier ciré et à sec," *La lumière*, no. 14 (May 11, 1851): 56.

15. Francis Wey, "De l'influence de l'héliographie sur les beaux-arts," *La lumière* 1, no. 1 (February 9, 1851): 2.

16. Because Mestral did not work independently for the Mission héliographique, and because his work is not well represented in the Getty's collection and in other public collections, Le Gray is the primary focus here.

17. As mentioned in the introduction, the focus here is on photographers who used paper negatives in the early 1850s. Bayard used albumen-on-glass negatives for his Mission héliographique assignment.

18. This was not new to architectural photography—Joseph-Philibert Girault de Prangey (1804–1892) had already made daguerreotype close-ups of sculpture in the 1840s.

19. Although the album was unfinished, some public institutions own intact versions of the project, and loose prints from the negatives are in the Getty's collection. The photographs were initially sold in installments of ten images, printed by the firm H. de Fonteny, which collapsed in 1854. Only twenty albums were published.

20. Henri de Lacretelle, "Albums photographiques: No. 1—M. Nègre," *La lumière* 3, no. 7 (February 12, 1853): 26.

21. Ibid.

22. Ernest Lacan, "Réunion photographique," *La lumière* 2, no. 17 (April 24, 1852): 71–72.

23. See Mondenard, "Champions of Paper."

24. This print is unique in that it was burnished with beeswax, a possible indication of the photographer's intent to transfer the image to another surface, or to prepare a photogravure plate and reproduce the image in ink. However, no other plates or impressions are known.

25. From an unpublished manuscript, possibly for an introduction to *Le Midi de la France*, 1854. Reprinted in James Borcoman, *Charles Nègre, 1820–1880* (Ottawa: National Gallery of Canada, 1976), 7.

26. Victor Hugo, *Les misérables, Œuvres complètes de Victor Hugo*, Vol. 1 (Paris: Nelson, 1900), 182.

27. Francis Wey, "Album de la Société héliographique," *La lumière*, no. 14 (May 11, 1851): 58.

28. The George Eastman Museum collection has a waxed-paper negative of *Fantasies*, from about 1856.

29. Eugenia Parry Janis and Josiane Sartre, *Henri Le Secq, photographe de 1850 à 1860*, exh. cat. (Paris: Flammarion, 1986), 27.

30. See Roubert, "A Bourgeois Ambition." Members of the Société française de photographie included comte Olympe Aguado (1827–1894), Auguste-Rosalie (1826–1900) and Louis-Auguste (1814–1876) Bisson, Eugène Cuvelier (1837–1900), Baron Louis-Adolphe Humbert de Molard (1800–1874), Achille Devéria (1800–1857), André Adolphe-Eugène Disdéri (1819–1889), Jean-Louis-Marie-Eugène Durieu (1800–1874), comte Jean-François-Charles-André Flachéron (1813–1883), André Giroux (1801–1879), John Beasly Greene (1832–1856), Charles-Victor Hugo (1826–1871), Charles Marville (1813–1879), Nadar (Gaspard-Félix Tournachon, 1820–1910), Henri-Victor Regnault (1810–1878), Louis-Rémy Robert (1811–1882), Félix Teynard (1817–1892), Lieutenant Louis Vignes (1831–1896), and Julien Vallou de Villeneuve (1795–1866).

31. Baudelaire, "Salon de 1859, II, The Modern Public and Photography," *La revue française* (June–July, 1859). 264.

32. Baudelaire, ibid., 264.

33. Victor Hugo, *Œuvres complètes de Victor Hugo: William Shakespeare* (Paris: Hetzel-Quantin, 1864), 238.

Champions of Paper:
The Pioneers of Negative-Positive
Photography in France, 1843–60

Anne de Mondenard

hose age-old rivals France and England each had a part in the invention of photography. In France, the matter was handled through the political power of the Académie des sciences, which in 1839 arranged for the public disclosure of the process invented by Louis-Jacques-Mandé Daguerre (1789–1851). The daguerreotype process produced a highly precise, detailed, and unique image on a plate of silver-coated copper. Left aside in favor of the daguerreotype was the direct-positive-on-paper process of Hippolyte Bayard (1801–1887); like the daguerreotype, this was a unique image, but with much more blurred delineations. Across the channel, William Henry Fox Talbot (1800–1877) had developed a paper-based process that allowed multiple prints to be made from a negative image. He obtained patent protection for his calotype process in 1841. Daguerreotypy was widely—some might say frenetically—practiced for years among all sectors of French society, from the aristocracy to the working class, until the photographic negative, which had initially been ignored in France, progressively came to a position of dominance.

A few enthusiasts such as Bayard and Henri-Victor Regnault (1810–1878) (plates 2–4) and, subsequently, Amélie Guillot-Saguez (1810–1864) and Baron Louis Adolphe Humbert de Molard (1800–1874) (plate 5) were trained in Talbot's method, despite the restrictive patent. We do not have the full list of those who were given lessons in Paris, in May 1843, by Talbot (and his assistant, Nicolaas Henneman [1813–1898]), following the assignment of Talbot's patent in France to the entrepreneur Hugues Antoine Joseph Eugène Maret, marquis de Bassano (1806–1889).[1] Bassano not only intended to start producing pre-sensitized papers but also saw the possibilities of marketing photographic views of various sites and monuments. Talbot convinced Bassano that he could, "in two or three weeks, train good calotypists in sufficient numbers to start operations. We do not require people of anything more than ordinary intelligence,"[2] and no particular knowledge of chemistry was required. Talbot was, in fact, so confident of his process that he made this prediction: "I believe that ten days of lessons will suffice to train a number of calotypists who can begin activities and proceed to instruct others."[3] Bassano found a studio close to the place du Carrousel, facing the Tuileries; he recruited young participants and purchased cameras, lenses, and processing chemicals. He committed to holding the patent rights for a period of ten years, and the contract with Talbot was signed on June 26, 1843.[4] Following Talbot's return to England, he was sent several photographs—of uneven quality—that had been made by his French students, notably views of the château de Fontainebleau by unnamed photographers. But the Société calotype (or Société calotypique) did not succeed in producing the hoped-for production of photographs. From this abandoned enterprise we have only a few surviving images that bear the mark "Sté Cpe" (fig. 17).[5] Bassano gave up the effort at the end of 1843, leaving Talbot without any further avenue to exploit his patent in France. The patent rights were formally returned to Talbot on July 15 and 17, 1845, but he was unaware of this until the end of 1846.[6]

By that time it was too late. Louis Désiré Blanquart-Evrard (1802–1872), a cloth manufacturer from Lille who had received some photographic instruction from a former student of Talbot's, sent two examples of his process for photography on paper to the Académie des sciences in September 1846. His process incorporated several improvements on Talbot's in terms of ease of manipulation and improved definition of the final image. A communication describing the process and pointing out its usefulness to historians, archaeologists, and artists—but neglecting to mention Talbot's name—was read by François Arago (1786–1853) on January 25, 1847, and subsequently appeared in the proceedings of the Académie des

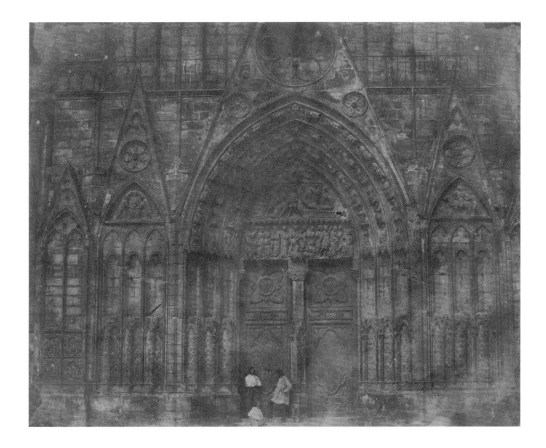

sciences.[7] The Blanquart-Evrard process was published soon after by Edmond de Valicourt and then by the optician Charles Chevalier in December 1847. Even though paper photography did not have the same sensitivity or precision as the daguerreotype, it was considered ideal for travelers who could now prepare their negative sheets days in advance and store and carry them in portfolios. The support of the Académie des sciences led to the widespread publication of paper-negative photography. This happened on the eve of the February Revolution of 1848, a period of political instability that did not provide a favorable climate for the adoption of the new method by disrupted state institutions; new leaders were emerging while old ones withdrew. But the historians, archaeologists, and artists of all political stripes—those who had first been addressed by Blanquart-Evrard—found themselves at liberty to evaluate the characteristics of the process.

Following a short period of quiescence, the Blanquart-Evrard process found its first champion in Honoré d'Albert, duc de Luynes (1802–1867), art lover and archaeologist, who had been first elected to the Académie des inscriptions et belles-lettres in 1830. A collector and philanthropist as well as a political actor, Luynes was elected deputy in the Seine-et-Oise constituency as a moderate republican supporting the policies of General Cavaignac; he supported the banishment of the Orléans royal family in a vote on May 26, 1848. A photography enthusiast, Luynes was convinced that the new paper-photography process would replace drawing as the best means of recording historic buildings, artifacts, and monuments, and moved to convince his colleagues on the Comité des arts et monuments (of the Ministry of Public Instruction) by showing them, on March 12, 1849, photographic prints of various English and French subjects: "[The committee] examined with particular interest the proofs that reproduce an object in silver, two subjects from the bronze doors of the Madeleine, an interior of the Sainte-Chapelle. These are transfers obtained from the original, which can furnish a dozen excellent proofs. M. d'Albert de Luynes will publish the instructions for this process, which promises to be so valuable to archaeologists and so simple to use."[8]

The discovery of some items from Luynes's dispersed collection gives clues as to its makeup. The collection included many prints by Bayard from different periods, among which is one from the late 1840s that represents a large silver vase (*Neptune and Galatea*, 1843) made by the silversmith Antoine Vechte (1799–1868) on commission from Luynes.[9] The J. Paul Getty Museum owns a variant of the print, from its Bayard Album (see fig. 1).[10] That album includes another subject Luynes showed to his colleagues—an image of a bas-relief sculpture on a bronze door of the church of the Madeleine representing two of the Ten Commandments ("Thou shall not kill" and "Thou shall not commit adultery").[11]

In order to convince the Comité des arts et monuments to employ photography, Luynes recorded instructions for the process.[12] He reproduced Blanquart-Evrard's published instructions, added his own notes, and summarized the advantages of the paper process over the daguerreotype. These included cost savings, the possibility of preparing sensitized material well in advance of the actual exposure, the ability to make multiple prints from a single negative, and the opportunity for each of the committee members to retain his own copies of the image, with the convenience of being able to mount them together in an album.[13]

The published proceedings do not mention how these suggestions were received by the committee members. Among these we find listed Prosper Mérimée (1803–1870), inspector of historic buildings, and his friend the archaeologist Léon de Laborde (1807–1869), a supporter of King Louis-Philippe (r. 1830–48) who had been fired from his position as curator of antiquities at the Louvre but who retained his positions on the committee and on the Commission des monuments historiques. Also on the committee was the painter Philippe-Auguste Jeanron (1808–1877), who had been named director of national museums by the Second Republic administration.[14]

Laborde and Mérimée were members of the committee but chose not to attend its meetings, preferring to act through the Commission des monuments historiques. It was this group that issued the first photographic commission, in August 1849. The project was modest; Bayard was hired to "execute six daguerreotype views."[15] The list of subjects was to be decided in consultation with Laborde. It seems that the views were never completed, and so we do not know whether Bayard would have chosen to work with daguerreotypes or with paper negatives. (The word *daguerreotype* in this context could refer simply to a photographic camera rather than to any particular photographic process.) But we can see that within the commission, Laborde was clearly considered the expert on photography. The choice of Bayard may have been influenced by the duc de Luynes's presentation, but Laborde would also have favored Bayard. In Laborde's capacity as a member of the main jury for the eleventh Exposition nationale des produits de l'industrie, in 1849, he sat on the exhibition's Commission des beaux-arts as rapporteur for heliography—a term used generally at the time to describe photography, whether produced on plates or on paper—and was involved in judging the work of the exhibitors.[16] Although Laborde was convinced by the relative advantages of the paper-negative process in terms of ease of manipulation and lower cost, he remained aware of its imperfections; he preferred the precise resolution of the images obtained by Bayard using albumen-on-glass negatives, even though this process required very long exposure times. Based on Laborde's report, Bayard received a silver medal from the national exhibition jury. Laborde was also impressed by reproductions of paintings and other art objects made from paper negatives by Gustave Le Gray (1820–1884); Le Gray was awarded a bronze medal.

Despite Laborde's relative obscurity today, he seems to be a pivotal figure who invested tremendous efforts throughout the year 1849 in promoting photography. He began his archaeological career as a member of an expedition to Petra that he organized with Adolphe Linant de Bellefonds; in 1830, he published his drawings of the site as *Voyage de L'Arabie petrée* (Journey through Arabia Petrœa to Mount Sinai and the Excavated City of Petra, the Edom of the Prophecies). In 1842, he was elected to the Académie des inscriptions et belles-lettres (where he replaced his father) and was named to the Commission des monuments historiques in the same year. Laborde was also a talented photographer who had been making daguerreotypes at least since 1842.[17] His engagement with many influential institutions and commissions, aided by his affable qualities, contributed to his ability to promote photography. It is worth following his activities through these early years of the adoption of photography on paper.

In the first days of August 1849, when the Exposition nationale had just closed, Laborde made an ambitious proposal to Jeanron, director of national museums and a fellow member of the Comité des arts et monuments; Laborde's proposal was to employ photography to record the works of art housed in the Louvre. Jeanron and Laborde present a curious conjunction of personalities: one a painter named director by the Second Republic authorities, and the other a curator and supporter of the Orléans family who had only just, in May, been reintegrated into the department of sculpture at the Louvre. There is no record of the substance of their discussion in the Archives des musées nationaux, in the Archives nationales (Pierrefitte-sur-Seine),[18] but family descendants still have drafts of letters from Laborde and the responses received from Jeanron. Laborde expresses his concern that the Louvre relied entirely on written inventories to document and identify its collections. He suggested that each object be photographed. Today this may seem an obvious step, but at the time the

idea was visionary. Laborde planned to make no fewer than twelve thousand exposures over eighteen months at a cost of fifteen thousand francs. He even planned to subsidize the cost of production by the commercial sale of prints made from the negatives.[19]

In his proposal, Laborde encloses a note titled "Budget for the preparation, copying, and production of approximately twelve thousand prints for the general inventory," in which he details a list of equipment and materials to be purchased: lenses, printing frames, processing trays, processing chemicals, and large quantities of paper. He includes funding to employ two operators, and, familiar with the current commercial environment for photographers, bases his salary estimate on the earnings of a well-known portraitist. Laborde met with Jeanron on August 10. Laborde excused himself in advance for being unable to present photographic reproductions of as many different types of objects as he would have planned, owing partly to a shortage of time and also because he was "experiencing some difficulty in rendering the antique ceramic vessels with all of the desired clarity, the red becomes confused with the black through the heliogenic action."[20]

This proposal for a photographic inventory was ahead of its time and was overambitious; in the event, it was not undertaken. Photography on paper still required long and complex manipulations. And, beyond the technical difficulties, authorities at the Louvre were not convinced of the proposal's utility, and Jeanron would not in any case have time to closely examine the question; on December 25, he was replaced as director general by the comte de Nieuwerkerke (1811–1892) (see fig. 23) by order of Louis-Napoléon Bonaparte, recently elected president of the Republic. Laborde's project was shelved.

Nieuwerkerke was conservative in his taste, and his interests were focused on historic art and academicism. An unconditional supporter of Louis-Napoléon—the future Napoléon III (r. 1852–70)—he was helped in winning his new position by his well-known relationship with Louis-Napoléon's cousin Princess Mathilde. Laborde found that his relations with the new director general were difficult; Nieuwerkerke mistrusted him and, eventually, pushed him to take an extended leave from the Louvre near the end of 1853.[21] In addition, the new director was not particularly interested in photography; he did not support any of the various photographic projects that were proposed to him. For instance, in 1852 the painter Alcide Joseph Lorentz (1813–1891) proposed a "museum of masterpieces" for the Louvre that would "cost the state nothing and would honor the donors, who were also the creators."[22] These were French photographers who had recorded "all corners of the known world, from nature to architecture and archaeology," and who would contribute, wrote Lorentz, to the "creation of a . . . photographic museum." Nieuwerkerke was somewhat welcoming of the idea but finally responded that there was not sufficient space in the Louvre. Later he rejected the idea of having photographs placed in the Salon des beaux-arts exhibition. Instead, he offered, from 1859, a separate space for photography at the same location occupied by the Salon, on the Champs-Élysées.[23] In a note written in 1867 to the emperor's minister of fine arts regarding the nomination of Benjamin Delessert (1817–1868)—a photographer related to Laborde—to the Légion d'honneur, Nieuwerkerke clearly expressed his disinterest in photography: "The fine-arts administration has consistently refused to propose giving honors to photographers."[24] So photographers had little to expect from the Louvre, except for the plentiful official permission that was granted during the 1850s to externally commissioned photographers to work in the Louvre's galleries.[25]

As for Laborde, the setbacks he experienced at the Louvre did not discourage him from advocacy for the photography-on-paper process. As a member of the Académie des inscriptions et belle-lettres, he was chosen to be the rapporteur for a committee that would instruct the photographer Maxime Du Camp (1822–1894) prior to his expedition to Egypt (fig. 18). Going beyond a simple list of sites and important texts that were to be recorded, Laborde's instructions are a defense of "this remarkable mode of recording,"[26] and its suitability for this enterprise: "The particular nature of photography, its indisputable exactitude and meticulous precision, down to the most incidental details, give value to all it produces."[27]

At the time, Laborde was himself developing his skills as a photographer, taking lessons in Le Gray's studio alongside Delessert, nephew of the famous banker of the same name. Laborde was related to Delessert by the marriage, in 1824, of Laborde's sister to another Delessert uncle, Gabriel, and the two were part of Le Gray's first group of students. Le Gray had been making daguerreotypes and exploring photography on paper with his close friends Henri Le Secq (1818–1882) and Auguste Mestral (1812–1884). After the arrival of Laborde and Delessert as students, followed by Du Camp, Le Gray gradually converted his studio into a photography school that was to be frequented by many who wished to master the paper processes.[28]

Fig. 18.
Maxime Du Camp (French, 1822–1894), *General View, Grand Temple of Isis at Philae, Nubia*, April 14, 1850. Salted paper print, 17.6 × 23.3 cm (6¹⁵⁄₁₆ × 9³⁄₁₆ in.). Caen, Association régionale pour la diffusion de l'image, Gift of Jean-Pierre Pénault, ARDI 29.00047

Le Gray's students went on to share their knowledge with others, much as Talbot had predicted would happen. Delessert had achieved such a level of refinement in his photographs by August 1849 that, at least among his family members, his portraits were compared favorably to those made by Le Gray.[29] Laborde involved his friend and colleague Merimée in his photographic experiments and shared these with Valentine, his sister: "My portrait, which I attach here, was made in ten seconds in the shade and that of Merimée, which I will send you tomorrow, in one and a half minutes because it's on English paper, which acts more slowly."[30] He shared his passion for photography widely within his family: with his other sisters, Aline Bocher and Mathilde Odier, and his brothers-in-law, Gabriel Delessert, Édouard Bocher, and Édouard Odier, and with their children, Édouard Delessert, Emmanuel Bocher, and Cécile de Valon and her husband, Alexis de Valon. The Revolution of 1848 had shaken the family, but it had also strengthened it in important ways. Laborde himself lost his position as a curator at the Louvre; Édouard Bocher left his post as prefect of Calvados in Caen; Gabriel Delessert, formerly prefect of police under Louis-Philippe, was for several months forced to exile himself and his family to England; and Édouard Odier, an amateur painter and a recipient of royal commissions, made no effort to conceal his contempt for the new government. Eventually, the family reunited at Passy, where Édouard Bocher summarized the family's situation: "Along with all the political problems, we have the pleasures of life in our own utopian colony."[31] The families occupied adjacent houses that Gabriel Delessert had inherited from his brother, the banker Benjamin Delessert, who had died in 1847. The photographer Benjamin Delessert lived close by on the hills of Passy. On the slopes leading down to the Seine, bathed in a generous natural light, a shared passion for photography developed. Merimée christened them the colonie de Passy (Passy Colony).[32] It was while staying here during the summer of 1849 that Laborde sought to prove the usefulness of photography to institutions such as the Louvre, the Commission des monuments historiques, and the Académie des inscriptions et belles-lettres, while at the same time practicing his own photographic skills *en famille* (fig. 19).

The members of the Passy Colony were not the only supporters of Louis-Philippe to get involved in photography during these unsettled times; the emerging art form provided an occupation to fill the void created by the forced withdrawals brought on by political upheaval. Le Gray's studio was frequented by a number of friends of the Laborde-Delessert family who shared their politics. Among these were the comte Olympe Aguado (plate 112);[33] Raymond de Bérenger, marquis de Sassenage; Joseph Othenon Bernard de Cléron, comte

Figs. 19a, 19b.
Léon de Laborde (French, 1807–1869) and colonie de Passy (1849–1862). Two pages from the Adrien Constant de Rebecque album. Zurich, Musée national Suisse, LM-117298-31-34, LM-117298-24-28

a. Four salted paper prints from paper negatives (left to right): *Amédée Bocher,* ca. 1850, 13.5 × 9.5 cm (5⁵⁄₁₆ × 3¾ in.); *Portrait d'homme,* ca. 1850, 13.6 × 9.7 cm (5³⁄₈ × 3⁷⁄₈ in.); *Léon de Laborde (Self-Portrait),* ca. 1849, 11.9 × 7.1 cm (4¹¹⁄₁₆ × 2¾ in.); *Cécile de Valon,* ca. 1850, 11.6 × 7.4 cm (4⁵⁄₈ × 2¹⁵⁄₁₆ in.)

b. Five salted paper prints from paper negatives (left to right): *Édouard Delessert,* ca. 1851–52, 10.3 × 8.3 cm (4¹⁄₁₆ × 3¼ in.); *Benjamin Delessert (?),* ca. 1850, 9.5 × 7.4 cm (3¾ × 2¹⁵⁄₁₆ in.); *Gabriel Delessert,* ca. 1850, 6.2 × 4.9 cm (2³⁄₁₆ × 1¹⁵⁄₁₆ in.); *Cécile de Valon,* ca. 1850, 11.5 × 8.4 cm (4½ × 3¼ in.); *Alexis de Valon,* ca. 1850, 11.5 × 8.4 cm (4½ × 3¼ in.)

d'Haussonville; and the vicomte Joseph Vigier. Le Gray's studio itself, however, espoused no particular political brand, and its students made up a varied spectrum of personalities, including the lawyer Émile Pécarrère, the magistrate Eugène Le Dien, the art collector Eugène Piot, the engineer Gabriel Tranchand, the artists Léon Delaporte, Adrien Tournachon, and Lodoïsch Crette, the architect Eugène Méhédin (who would begin to write a history of the reign of Napoléon III), and the archaeologists John Beasly Greene and Auguste Salzmann. Le Gray himself moved smoothly from one political milieu to another; by the end of the 1840s, he had made a daguerreotype of a young girl close to the Orléans family (a print of this image is found in the album of Queen Marie-Amélie at the Musée Condé, Chantilly), and had produced a portrait of the prince-president in 1849. He also made a series of portraits of Félix Avril, who was briefly the Republican prefect of Calvados in 1848, following the Orléanist ouster of Édouard Bocher.[34] Evidently photography—and particularly Le Gray, its master practitioner—had a certain unifying capacity.

Eighteen forty-nine, we see, was an unsettled year during which many institutional projects (at the Comité des arts et monuments, the Commission des monuments historiques, and the Louvre, for instance) failed to proceed to completion. But the times also favored interchange. Networks were formed between the adepts of the new art who had the ambition to see photography spread throughout society. This was the purpose of the Société héliographique, founded in early 1851, the first association in France dedicated to photography. The society was conceived to serve the interests both of fine art and science, and this dual role was personified in the profiles of its early members. Baron Jean-Baptiste Louis Gros (1793–1870), chosen as the first president, was a diplomat, and renowned for the quality of his daguerreotypes. He assembled around himself men who were primarily interested in the paper processes: photographers (Baldus, Bayard, Le Gray, Le Secq); amateurs—many of them with training from Le Gray (Aguado, Haussonville, Mestral, Montesquiou, Montléart, Pécarrère); painters (Eugène Delacroix, Jules Claude Ziegler); writers (Champfleury, Francis Wey); and scientists (the optician Charles Chevalier), including several scientist-academicians of the Institut de France (Edmond Becquerel, Henri-Victor Regnault), as well

as members of the political administration (Jean-Louis-Marie-Eugène Durieu, Frédéric Bourgeois de Mercey). Léon de Laborde and Benjamin Delessert were named, along with Bayard, to the nine-member executive committee. The society immediately started to publish a journal, *La lumière*, which tracked the progress of the new photographic processes in the worlds of art and science.

As the Société héliographique was beginning, the Commission des monuments historiques restarted its photographic commission that had come to naught in 1849. Two strong personalities were participants in both of these institutions: Laborde and Frédéric Bourgeois de Mercey (1805–1860), head of the Office of Fine Arts in the Ministry of the Interior. Adding his support was Jean-Louis-Marie-Eugène Durieu (1800–1874), who had sat on the Commission des monuments historiques as director of religious affairs from 1848 to 1850. This time the photographic commission was widely supported, and, in less than six months, five photographers had been selected and a list was established of 175 historic structures that were to be recorded.[35] In a first round, the Commission chose Baldus, Le Secq (see fig. 14), and Mestral; later, Mestral was replaced by Bayard. In a report authored by Laborde, these choices are explained: "The commission is of the opinion that Mssrs. Baldus, Lessec [*sic*], and Bayard have produced the finest heliographs of historic buildings."[36] The term *héliograph* is used in a general sense here, and does not indicate which process was to be used—paper negatives or Bayard's favored process, albumen on glass. Bayard's inclusion in the group may have stemmed from a wish to see him complete the project that had been abandoned in 1849—a setback that, by the way, seemed not to have distanced him from his patrons at Passy. Bayard was, indeed, making photographs of the family's holdings at Passy around 1850–51. One image shows the view from Benjamin Delessert's house, while another, made from a high terrace, shows the Delessert greenhouses and a smokestack, probably part of the family's sugar factory (fig. 20).[37]

More puzzling is the question of why Laborde neglected to include Le Gray from the start. Perhaps because he was better known for making portraits and reproductions of works of art. But it was just at this moment that Le Gray was perfecting his waxed-paper–negative process, a revolutionary step forward for photography on paper. Compared to the existing paper-negative processes, this innovation provided greater sensitivity and resulted in images with more translucency; most important, it allowed photographers to prepare their sensitized sheets up to fifteen days in advance of the camera exposure and gave them several days to complete the development of the negative image following exposure. It was

Fig. 20.
Hippolyte Bayard (French, 1801–1887), *Greenhouses, Passy*, 1851. Coated salted paper print, 26 × 22.4 cm (10¼ × 8³⁄₁₆ in.). Munich, Galerie Daniel Blau

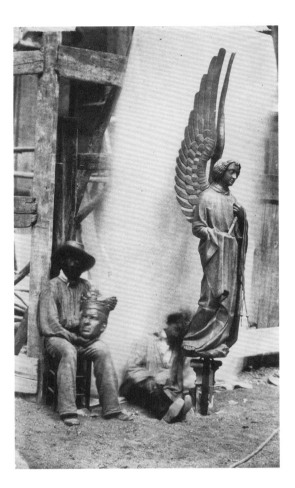

a tool perfectly suited for the traveling photographer and so was ideal for the purposes of the Mission héliographique. Le Gray was eventually included on the list of selected photographers, along with Mestral (plate 31). The commission was launched on June 26, 1851, and was uniquely ambitious at the time: five photographers sent out simultaneously across France. In retrospect it seems clearly to be the successful achievement of the projects that had first been formulated in 1849 by two archaeologists—the duc de Luynes, followed by Laborde.

The photographs that resulted from the Mission héliographique exceeded expectations. The negative-positive paper process had proved itself to be ideally suited for the purpose. All the commissioned photographers—with the exception of Bayard, who finally submitted no work—soon received additional orders for photographs from the administration. All of them chose to continue to use the paper-negative process. This was an individual technical preference, not one imposed by the sponsors, who were concerned only that their commissions yield large-format positive prints.

Le Secq was most likely approached by the prefecture of Paris to record the first of the changes that would soon transform the appearance of the city during the Second Empire (plate 55).[38] Le Gray recorded several rooms at the Salon of 1852 on a commission from Philippe de Chenevières, who in January had been named inspector of regional museums and inspector general in charge of the annual exhibitions of the works of living artists (plate 99).[39] In 1853, Mestral was paid by the Service des bâtiments civils (of the Ministry of the Interior) to photograph Victor Geoffroy-Dechaume's sculptures (*Angel of the Passion*, and the apostles James and Thomas) prior to their permanent placement on the restored Sainte-Chapelle (fig. 21).[40] But it was Baldus who established the strongest link to the administration. In 1852, he proposed that the Office of Fine Arts sponsor his project *Villes de France photographiées* (Photographs of the cities of France). The sponsorship arrangement resulted in orders for photographs that continued through 1858 and for which Baldus supplied many views of historic buildings, each delivered as a set of twenty prints (plate 56).[41] The landscape painter and art critic Frédéric Bourgeois de Mercey had been named head of the Office of Fine Arts in 1853; Baldus was his close friend.[42] Bourgeois de Mercey sent Baldus to photograph the flooding of the Rhône in Lyon and Avignon in 1856 (plate 132). Baldus took with him large sheets of paper, but the precise resolution of these images suggests that he may have used glass-plate negatives. While at the Office of Fine Arts, Bourgeois de

Mercey acquired many photographs, including a number of portraits of the prince-president by Le Gray (certainly including the 1849 portrait mentioned previously), views of the Sainte-Chapelle by Bisson, maritime subjects by Jean Victor Macaire-Warnod (1812–after 1886) and Louis Cyrus Macaire (1807–1871), views of the Italian countryside and of Egypt by Méhédin, in addition to photographically illustrated books such as *Egypte, Nubie, Palestine et Syrie*, by Du Camp; *L'Italie monumentale*, by Piot; *Le Midi de la France: Sites et monuments historiques photographiés* (The Midi of France: Historic sites and monuments photographed), by Charles Nègre (plate 86); *Jérusalem* by Salzmann; *Voyage au Soudan* by Pierre Trémaux (1818–1895); and numerous reproductions of engravings and other works of art by Bisson.[43] The commissions did not state any preference regarding the negative process to be used—glass plate or paper—but in the latter years of the 1850s it became clear that the glass-plate negative was replacing the paper negative, just as earlier the paper negative had replaced the daguerreotype. The photographic commissions initiated by the emperor were intended to record particular moments or events critical to the empire, so the faster and more sensitive wet collodion-on-glass–negative process was more often chosen for these. They include the *Camp de Châlons* images (1857) (plate 133) made by Le Gray and the *Asile impérial de Vincennes* series (1859) of Nègre's. In 1856, concerned with assuring the permanence of all these photographic records, the duc de Luynes financed and gave his name to two concurrent competitions administered by the Société française de photographie, which had been founded in 1854. The first, for a "permanent" photographic process, was awarded in 1862 to Alphonse-Louis Poitevin (1819–1882), for carbon printing. In 1867, Poitevin's photolithography process won the second competition, which aimed to find the best photomechanical reproduction process.[44]

By the early 1860s, the Office of Fine Arts had slowed its acquisition of photographs; this despite the fact that Henry Courmont (1813–1891), who had succeeded Bourgeois de Mercey following his death in 1860, had formerly been on the Commission des monuments historiques and had studied photography with Le Gray. A new era in photography was beginning: it was becoming industrialized and commonplace; large-format images, which required much time and effort to produce, were seen less. The duc de Luynes, however, remained a faithful supporter of the processes that he believed were of such value in the service of archaeological study. In 1864 (plate 144), and again in 1866, he financed expeditions to the Dead Sea region. On the first, he himself accompanied Lieutenant Louis Vignes (1831–1896); for the second, he sent Henry Sauvaire (1831–1896). Laborde praised the resulting images of Petra, which confirmed the accuracy of his own drawings of the site published in 1830 and that he had probably made using a camera obscura: "The duc de Luynes has this year photographed the Khazneh of Petra, and his reproduction, by its nature a true representation, has proven my own."[45]

NOTES

1. Paul-Louis Roubert, "Cendrillon ranimée: Émergence de la photographie sur papier en France," in *Primitifs de la photographie: Le calotype en France, 1843–1860*, ed. Sylvie Aubenas and Paul-Louis Roubert, exh. cat. (Paris: Gallimard, Bibliothèque nationale de France, 2010), 35–51.
2. William Henry Fox Talbot to Amélina Petit de Billier, February 28, 1843, British Library, London, Talbot Collection. Talbot's letter is in French.
3. Talbot to Petit de Billier, March 2, 1843, British Library, London, Talbot Collection. Talbot's letter is in French.
4. Alfred François Bouard to William Henry Fox Talbot, December 22, 1846, British Library, London, Talbot Collection.
5. See also two views of Fontainebleau attributed to Bassano, from the Brewster Codex, at the J. Paul Getty Museum, Los Angeles, 84.XZ.574.34 and 84.XZ.574.178.
6. Bouard to Talbot, December 22, 1846.
7. "Procédés employés pour obtenir les épreuves de photographie sur papier, par M. Blanquart-Evrard de Lille," *Comptes rendus hebdomadaires des séances de l'Académie des sciences* 23 (September 28, 1846): 639; 24 (January 25, 1847): 117–23.
8. Meeting of March 12, 1849. *Bulletin du Comité historique des arts et monuments: Archéologie—Beaux-arts* 1 (1849): 71.
9. *Épreuves choisies*, sale catalogue, Paris, Binoche Renaud Giquello, June 25, 2010, lot 27.
10. The Getty variant has the accession number 84.XO.968.130, not 84.XO.968.30, as was indicated in the auction catalogue cited in note 9 above.
11. J. Paul Getty Museum, *Photographie: Recueil de dessins positifs obtenus à l'aide de negatifs sur papier*, 84.XO.968.146.
12. Meeting of April 13, 1849. *Bulletin du Comité historique des arts et monuments: Archéologie—Beaux-arts* 1 (1849): 99.
13. "Documents: Des papiers photographiques," *Bulletin du Comité historique des arts et monuments: Archéologie—Beaux-arts* 1 (1849): 101–6.

14. Jeanron was named to the committee on February 6, 1849, and was present at the meetings held on March 12 and April 13, 1849. See *Bulletin du Comité historique des arts et monuments: Archéologie—Beaux-arts* 1 (1849): 33, 68–69, 98–99.

15. "The commission determines that M. Bayard will be asked to execute six daguerreotype views; a payment of one hundred francs should be allocated for this work. M. Bayard should consult with M. Delaborde on the choice of subjects." Minutes of the Commission des monuments historiques, August 17, 1849, 311, Charenton-le-Pont, Médiathèque de l'architecture et du patrimoine, 80/15/06.

16. *Rapport du jury central sur les produits de l'agriculture et de l'industrie exposés en 1849* (Paris: Imprimerie nationale, 1850), 1: xvii, xxiii. Laborde was named rapporteur for billiards manufacture, mirror manufacture, heliography on metal plates, heliography on paper, heliography with coloring, and cabinetmaking applied to heliography.

17. See Anne de Mondenard, "La colonie de Passy: Un cercle d'amateurs aux origines de la photographie" (PhD diss., Université Paris-Sorbonne, 2013).

18. Series *AA of the Archives des musées nationaux contains no correspondence of directors (minutes or summaries) from this period.

19. Sender's copy of a letter from Laborde to the director general of museums [before August 9, 1849], Archives of Carlos Muñoz de Laborde Rocatallada, comte de la Viñaza, Documents de la famille, IX.14, Léon de Laborde, Fonctions administratives au Louvre et aux Archives, TB5.

20. Sender's copy of a letter from Laborde to the director general of museums, August 9, 1849, Archives of Carlos Muñoz de Laborde Rocatallada, comte de la Viñaza, Documents de la famille, IX.14, Léon de Laborde, Fonctions administratives au Louvre et aux Archives, TB5.

21. Archival file, M. le comte Léon de Laborde, Pierrefitte-sur-Seine, Archives nationales, F⁷⁰ 357.

22. Joseph Lorentz to the comte de Nieuwerkerke, February 23, 1852, with a note added by Nieuwerkerke, February 28: "This museum cannot be installed at the Louvre where there is already a lack of space. Otherwise, the idea is very good. Replied as such, 28th instant." Pierrefitte-sur-Seine, Archives des musées nationaux, K 19.

23. Paul-Louis Roubert, "1859, Exposer la photographie," *Études photographiques* 8 (November 2000): 4–21.

24. Archival file, Benjamin Delessert, note dated May 15, 1867, Pierrefitte-sur-Seine, Archives nationales, F⁷⁰ 116.

25. Numerous requests related to obtaining photographic reproductions can be found in several files at the Archives des musées nationaux, in Pierrefitte-sur-Seine: A 17, A 18, C 17, D 17, I 19, T 18, Z 17, and Z 18.

26. Edmé François Jomard, Joseph Toussaint Reinaud, Félicien de Saulcy, and Léon de Laborde (rapporteur), "Rapport de la commission nommée par l'Académie des inscriptions pour rédiger les instructions du voyage de Maxime Du Camp," read September 7, 1849, Paris, Bibliothèque de l'Institut de France, MS 3720, vol. 1, file 1, fols. 19–23.

27. Cited in Sylvie Aubenas, *Gustave Le Gray, 1820–1884*, with contributions by Anne Cartier-Bresson et al., ed. Gordon Baldwin, exh. cat. (Los Angeles: J. Paul Getty Museum, 2002), 29.

28. See Anne de Mondenard, "La barrière de Clichy," in Anne de Mondenard and Marc Pagneux, *Modernisme ou modernité: Les photographes du cercle de Gustave Le Gray*, exh. cat. (Arles: Actes Sud, 2012), 31–49.

29. Ibid., 37.

30. Laborde to Valentine Delessert (née Laborde), Monday [September 1849], Archives of Carlos Muñoz de Laborde Rocatallada, comte de la Viñaza, manuscript letter, no. 206 [removed], cited in Mondenard, "La colonie de Passy," 213.

31. *Mémoires de Charles Bocher (1816–1907), précédés des Souvenirs de famille (1760–1816)*, vol. 2 (Paris: Flammarion, 1909), 70.

32. Mondenard, "La colonie de Passy."

33. See J. Paul Getty Museum, 84.XP.457.6 and 84.XM.358.10.

34. The portrait of Louis-Napoléon was exhibited at the Valenciennes city hall in September 1849. See Marc Pagneux, "Le photographique," in Mondenard and Pagneux, *Modernisme ou modernité*, 100. For the archival file on the prefect Félix Avril, see Pierrefitte-sur-Seine, Archives nationales, F1bI/155/12.

35. See Anne de Mondenard, *La mission héliographique: Cinq photographes parcourent la France en 1851* (Paris: Monum, 2002).

36. Minutes of Commission des monuments historiques, February 28, 1851, 163–64. Charenton-le-Pont, Médiathèque de l'architecture et du patrimoine, 80/15/07.

37. Copies of this image are found at two locations: Paris, Société française de photographie, 24.283, salted paper print from a glass-plate negative, 26.5 × 19.3 cm; and Munich, Galerie Daniel Blau. Reproduced in *Hippolyte Bayard* (Munich: Daniel Blau Photography, 2010).

38. See Anne de Mondenard, "Une place au sein des beaux-arts," in Mondenard and Pagneux, *Modernisme ou modernité*, 225–40.

39. Philippe de Chennevières, *Souvenirs d'un directeur des beaux-arts* (Paris: Arthena, 1979), 46. This volume is a facsimile reproduction of the installments originally published in *L'artiste* between 1883 and 1889.

40. Invoice (Mestral, photographer, 380 francs, eight negatives at forty francs each, the ninth at twenty francs, and forty francs for retouching the backgrounds), May 17, 1854, no. 3186 (exercise 1853), Pierrefitte-sur-Seine, Archives nationales, F⁴ 2800.

41. See, for example, J. Paul Getty Museum, 84.XP.218.21 and 84.XM.348.4.

42. See James A. Ganz, *Édouard Baldus at the Château de la Faloise* (Williamstown, MA: Sterling and Francine Clark Art Institute, 2007).

43. Pierrefitte-sur-Seine, Archives nationales, summary of series F⁴ 22763-2800 and F⁷⁰ 196-217.

44. Sylvie Aubenas, *D'encre et de charbon: Le concours photographique du duc de Luynes, 1856–1867* (Paris: Bibliothèque nationale de France, 1994).

45. *Les Nabathéens: Pétra* (Paris: Lemercier, [1864]). This four-page leaflet is in personal files of Léon de Laborde, Pierrefitte-sur-Seine, Archives des musées nationaux, O30 53.

A Bourgeois Ambition: Photography and the Salon des Beaux-Arts during the Second Empire

Paul-Louis Roubert

Photography emerged in France and England at the very moment that the large public exhibition of industrial products and fine art—the so-called universal exhibition or world's fair—came into being. It was inevitable that photography would play a part in the enthusiasm for such exhibitions, which the writer Gustave Flaubert (1821–1880) described, satirically, as "frenz[ies] of the nineteenth century."[1] Photography—seductive in form, mysterious in its operational details, powerful in the scope of its application—was introduced to the public as a prodigy born of three modern activities: art, science, and technology. It was a symbol, at once commonplace and transcendent, of Europe's entry into a new era of industrialism, in which merchandise was presented to the urban masses for their contemplation and the fulfillment of their wishes. And among these modern appetites, photography unexpectedly opened a new horizon that disrupted old hierarchies and standards. The ambiguities inherent in the photograph were soon evident, and these appealed to those artists who were committed to an aesthetic reading of photography rather than to the industrial model represented by the daguerreotype. The extent of this artistic ambition—which practitioners chose to fulfill by practicing photography on paper (using first the paper-negative process, and later collodion on glass)—found a physical locus in a great cultural event, the annual Salon des beaux-arts, and especially so when the Salon adopted as its new home the Palais de l'industrie, which had been built in Paris for the Exposition universelle of 1855. Alternatively defensive at photography's association with the commercial daguerreotype and hungry for praise of photography of high quality executed on paper, the proponents of photography supported the ambitions of a number of practitioners and critics to achieve institutional and academic recognition through two symbolically powerful activities: organizing exhibitions and developing an art-critical vocabulary.

The Salon: A Frontier to Be Conquered

Reviewing the Salon of 1852, the critic Henri de Lacretelle (1815–1899) wrote: "In the galleries devoted to engravings, lithographs, and drawings we deplore the decision to exclude photography from the Palais-royal. We compare what we see in these galleries to what we recall of the photographic prints we have seen—of historic buildings, of landscapes, of portraits, and of genre scenes by Messrs. [Jules Claude] Ziegler, [Henri] Le Secq, [Gustave] Le Gray, [Friedrich von] Martens, [Charles] Nègre, [Édouard] Baldus, [Victor] Plumier, and so many others—and we find no deficiency in them, in neither hue nor accuracy, nor even composition."[2] In this comment Lacretelle summarizes the elements of the debate that had been gathering steam in the French photographic world in the early 1850s. He recognizes clearly that "photography is neither drawing nor painting," but states that "no longer should darkness and silence cloak this brilliant process [of photography], whose benefits are incalculable."[3] These comments were published in *La lumière* (fig. 22), at that time the only periodical devoted to photography and to defending the interests of its practitioners. From the time photography was first announced, it had been subject to prejudicial judgments that relegated the process to the most utilitarian applications and distanced it from the realm of art. Knowledge of photography, which had been made public in France in 1839, when François Arago (1786–1853), permanent secretary of the Académie des sciences, presented the daguerreotype, had been slow to spread among the general public. Although photographs could be seen in the windows of the department stores on the *grands boulevards* of

Fig. 22.
Front page of *La lumière* 1
(February 9, 1851). Paris,
Bibliothèque nationale de France

23

Paris, at the shops of merchants of optical devices and photographic supplies, and in large posters advertising the services of the portrait photographers who had been thriving since the 1840s, photography was more often shown than explained to the public, and then only with mediocre examples of daguerreotypes that tended to undermine photography's reputation. In *La lumière* we find appeals to engage in a program of public education aimed at promoting, thanks to photography on paper, appreciation of a better quality of photograph, one that was not strictly commercial in its intention, and so to encourage the integration of photography into the Salon. Since 1833, under the auspices of the Académie des beaux-arts, the Salon had made an annual public presentation of progress in current French art. Photographers had been excluded, left to put up small exhibitions themselves alongside the Salon. However, as Lacretelle noted about the 1852 Salon, "those who are the most competent and the most refined in matters of taste in art, but who are indisposed to favor photography, return from [the photographers'] exhibitions…full of admiration and praise. Before going in, they say, 'We are going to see a smudge of charcoal on the wall or a grimace in the mirror.' But on leaving, they say, 'We have seen pictures.'" "It is time," Lacretelle concluded, "that the public should be allowed to decide on these matters for themselves."[4]

A similar sense of urgency could be found in private settings. Since the beginning of 1852, Ernest Lacan (1828–1879), editor of *La lumière*, had organized a series of private "réunions photographiques" in which amateur and art-oriented photographers gathered to view and discuss the latest examples of prints produced by the most active practitioners among them. These convivial meetings, which would eventually become the "soirées photographiques" regularly chronicled in *La lumière* by Lacan, were nevertheless unsatisfactory. After a meeting in 1852, Lacan reported, those present "felt rather afflicted, thinking that all these masterpieces of photography should easily find a place in the Salon, where the crowds currently throng, and that the greater public should be able to admire such work, bringing encouragement and stimulation!"[5]

The Salon of 1852 (plates 99, 101) was the first to be organized following Louis-Napoléon's coup of December 2, 1851—and the start of his reign, as Napoléon III, over France's Second Empire (1852–70). The previous Salon, in 1850 (plate 100), had also been a missed opportunity to bring photography into the domain reserved by the Académie des arts. Then, the young Gustave Le Gray (1820–1884) had sent the selection jury nine photographic prints—views of the forest at Fontainebleau and reproductions of Fontainebleau paintings by Pierre-Antoine Labouchère (1807–1873) and Jean-Léon Gérôme (1824–1904), painters he had met years before when they all were apprentices in the studio of Paul Delaroche (1797–1856). Owing to some indecisiveness, even blindness, on the part of the jury, the prints had initially been accepted into the lithography section, but, a few days before the opening, they were rejected. This incident, fully recounted in the pages of *La lumière*, shows that a photographer of Le Gray's standing was not satisfied with showing his work at an exhibition of industrial products, such as the one that took place in Paris in 1849 and where he had been awarded a bronze medal. In the 1852 edition of his treatise on photography (a work, first published in 1850, that offers a vigorous defense of photography on paper), he appeals for photography's inclusion in the Salon:

> Photography has made rapid progress since its beginnings, especially with regard to its operational manipulations. What remains to be done will be achieved when all those involved attain a higher state of refinement of taste. This task, in my opinion, belongs to the administration of our museums. By accepting good photographic prints into the Salon, to be seen alongside the works of artists, the authorities will encourage those who practice this new art to persevere in their efforts.…The fine-arts administration owes this nurturing encouragement to photography as it does to all branches of art. We regret deeply that the authorities have, up to now, refused to take this path. But we are generally optimistic that this will change in the future and that the museum administration, better informed regarding the breadth and the usefulness of photography, will next year give photography its legitimate place.[6]

Lacretelle had made a direct appeal, the same year, to the benevolence of the powerful comte de Nieuwerkerke (1811–1892) (fig. 23), a sculptor of some accomplishment and the director general of museums since 1849: "We believe that the eminent artist who heads the administration has ignored the hostile ideas that still circulate through some ateliers, and that he is willing to include photographs in many of the Louvre's galleries."[7] Notwithstanding all this, the Salon of 1853 showed no photographs.

Fig. 23.
Gustave Le Gray (French, 1820–1884),
Émilien de Nieuwerkerke, 1859.
Albumen silver print from a
collodion-on-glass negative, 24.8 ×
18.2 cm (9¾ × 7⅛ in.). Paris, Société
française de photographie, Gift of
Le Gray, 243/014

What photography in France needed was a group dedicated to bringing pressure to bear on the fine-arts authorities and to resolving these grievances. The year 1851—the year in which the Mission héliographique had been launched[8]—also saw the creation of the Société héliographique, which brought together photographers such as Baldus, Hippolyte Bayard (1801–1887), Le Gray, and Le Secq; painters such as Eugène Delacroix (1798–1863) and Jules Claude Ziegler (1804–1856); critics such as Étienne-Jean Delécluze (1781–1863) and Francis Wey (1812–1882); and a number of dedicated amateurs. All were involved in the practice and support of photography on paper. In the spring of 1851, immediately following the society's founding, it initiated a publishing project, an album to which members were asked to contribute copies of their best photographs. The album would serve as a kind of exhibition, inasmuch as it would assemble photographs before the public and create an ad hoc forum for critical discussion. Wey described the project thus in *La lumière*: "From one season to the next, journals devote their pages to detailed analyses of paintings seen in exhibitions. Our albums are our exhibitions; they furnish theory with novel points of view concerning art and provide valuable insights with regard to science; they offer to the descriptive imagination scenes that are stimulating and satisfying, all the more so since they border so closely on the true appearance of things; they are, in fact, the most immediate translation of nature possible."[9] The preoccupation of the supporters of the new medium was both to give a voice to the defenders of photography and also to develop public taste with regard to photography. Like the painters whose works hung in the Salon, they were as much concerned

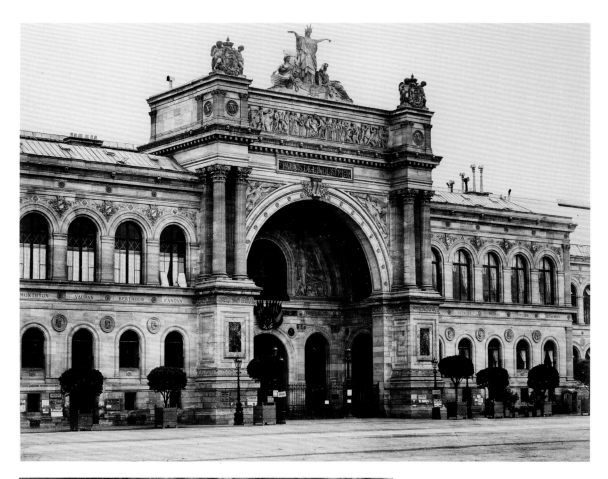

with enabling the public to see new art as they were with the selling of it. (If what we today know as the Album of the Société héliographique ever existed, it has yet to be found.)

The Société héliographique was unable to withstand the tensions that were stirred in this new community, notably between the advocates of the paper negative and the proponents of the new process of wet collodion on glass, and the group was disbanded by the end of 1851.[10] But before it disappeared, it had laid valuable groundwork: to provide a means of communication, it created *La lumiére*, whose continued existence was assured by the publisher Alexis Gaudin, to whom the journal was sold in November 1851; it facilitated personal exchange and social forums within the photography community; and, through the production of exhibitions and alternate means of diffusion, such as its album, it encouraged emulation, educated public taste, and stimulated the interest of collectors.

The 1855 Exposition Universelle

After the disbanding of the Société héliographique, the French photography community made several attempts to form a new association; these efforts succeeded in 1854 with the creation of the Société française de photographie (SFP).[11] Reuniting several of the most active members of the Société héliographique, the new group took up the essential mission of the old one—to defend and promote photography on paper—but adopted statutes that established it along the lines of an academic learned society, and were similar to the organizing principles of the Photographic Society in London, which had been founded a year earlier. The SFP began publishing the *Bulletin de la Société française de photographie* in early 1855, as a monthly forum for members to share their work and engage in discussions. And the founders included in the statutes of the SFP a requirement that the organization put on periodic public exhibitions of photographs.[12] The first such exhibition was announced in February 1855, alongside some nineteen regulations regarding SFP exhibitions, among which we find that "nude studies, generally and without exception," would be refused; that prints were to be submitted accompanied by the original negatives; and that the exhibition would be open to the public at the offices of the SFP, on rue Drouot, on Sundays, Wednesdays, and Fridays.[13] The SFP exhibition was meant to open on June 1, but this was delayed by two months because of the inauguration in Paris, on May 15, 1855, of the much larger Exposition universelle, the second such ambitious world's fair, following the Great Exhibition of 1851 in London.

Held in the brand-new Palais de l'industrie on the Champs-Élysées (fig. 24), the Exposition universelle was arranged by nation, as the London exhibition had been. Although photography seems to have been well represented—unfortunately, we have no precise numbers—the dispersal of photographs (most of them paper prints) throughout the exhibition prevented the interested visitor from forming an overall impression of the state of photographic art. The painter and photographer Jules Claude Ziegler (fig. 25) wittily complained that "the thousand turnings incorporated in this vast city of exhibits, which is promised to be finished from one day to the next, will form a path that will be beyond the capacities of human locomotion, and that the only way to see all will be by train.... To gather together in one bundle all the scattered branches of heliographic art we were obliged to roam through the vast distances—squares, streets, alleyways, dead ends, kiosks, storerooms—of this immense capital of industrial nations. And yet we were still uncertain of having seen all."[14]

The Exposition universelle marked the first time a display dedicated to the fine arts was included in a world's fair. The art exhibition was located in a separate building, on the avenue Montaigne, and showed works made since the beginning of the century, along with separate retrospective displays of paintings by Delacroix and Jean-Auguste-Dominique Ingres (1780–1867). Photographs, however, remained classified among the products of industry. The presentation produced an extremely poor impression in the French photographic community, as recorded in the comments of Paul Périer (1812–1897), vice president of the SFP, who found it both inadequate and poorly installed:

> On going through the main entrance into the Palais de l'industrie and taking one of the first corridors to the left, one finds four or five small chambers, or booths, where the most brilliant examples of French photography are crowded onto the four walls and struggle there with unreliable and dubious rays of sunlight that strike them at odd angles. While we may be proud that our art has found a place in this exhibition, it is most assuredly not because of the welcome that has been extended. One is put in mind of the infamous catacombs of the Louvre where so many painters have been buried

Fig. 26.
Nadar (Gaspard-Félix Tournachon)
(French, 1820–1910), *Self-Portrait in
Striped Coat*, 1856–58. Salted paper
print, 18.1 × 13.3 cm (7⅛ × 5¼ in.).
Los Angeles, J. Paul Getty Museum,
84.XM.436.22

alive. Many of us already feel disoriented in being surrounded by the products of cosmopolitan industry, wondrous as they may be. These beautiful and stimulating photographs—derived from a discovery that surpasses, and may even threaten the very existence of, lithography, engraving, even some aspects of painting—must surely be worthy of a dignified place among the arts.[15]

Périer, speaking for the SFP, also asserted that photography, once the wheat was sorted from the chaff, should have been accorded a place in the fine-arts section: "One could at least have expected that artistic [photographic] works would have been welcomed [into the fine-arts exhibition], where they could have been placed, modestly, below the works of great genius. As to the manufacturers of printed stuffs who [exhibit their products] under the pretext of photography,...they would have had the opportunity of showing their articles in the honorable hall where we currently find ourselves; that is to say, along with the manufactured products of the whole world."[16] And he seconded the complaints of photographers who felt that their work should be considered in the context of their own large ambitions: "One fact that is beyond question strengthens our claims to this honor: our best works are of the kind that are marked by taste and intelligence, establishing a clear and profound distinction between the purely commercial photographer and the photographic artist."[17] Photographers, wrote Périer, claimed "only the rights of the bourgeoisie, and we bow deeply to nobility; in this great feast set by the masters of art, the crumbs will satisfy our hunger. But those crumbs are ours, and we will have them."[18]

The disappointing installation at the Exposition universelle (which took the place of that year's Salon) nonetheless gave the SFP an opportunity to assert the merits of its own, delayed exhibition: "This unfavorable placement [of photographs at the exposition] is all the more striking," wrote the critic Ferdinand de Lasteyrie (1810–1879), "when one visits the charming exhibition now open at 11, rue Drouot, at the offices of the photography society."[19] The exhibition had eventually opened on August 1, 1855. It was intended to showcase the competency of the SFP in organizing such a project, albeit on a rather modest scale. The presentation at the Exposition universelle, far from occasioning unwelcome competition for the rue Drouot exhibition, forced a comparison of the two events, underlined the contrast in suitability of the rooms at each, and, in fact, contributed to the success of the SFP exhibition. Encouraged by this first positive experience in 1855, and faced with the lack of enthusiasm from state authorities, the SFP would continue to press for the inclusion of photographs in the Salon, a battle that preoccupied the association through the end of the 1850s. The SFP, establishing its credentials, took on an authoritative role in all questions relating to the exhibition of photographs. For the photography exhibition held in Brussels, as part of the Exposition universelle des arts industriels, in the summer of 1856 the SFP oversaw the selection of the French section, coordinating the proposals of each of the exhibitors. Reports published in the SFP's *Bulletin*, *La lumière*, and the *Moniteur universel* uniformly praised the quality of the Brussels presentation, the pleasant experience delivered to visitors, and the welcome provision of a catalogue.

Meanwhile, in Paris, the second SFP exhibition was in preparation. Nadar (Gaspard-Félix Tournachon, 1820–1910) (fig. 26) chose this moment in 1856, when he had yet to join the SFP, to take up the question of representation in the Salon with the group's directors: "Sirs, photography has, until now, been ignored in the program for the 1857 Salon. This oversight seems to me to be prejudicial to both the art and the interests of those whom you represent. No doubt you have already had this thought, and I confess to being tardy in drawing your attention to the great influence that an official statement from your association would have on this case. Such a collective statement will draw together the individual efforts that each one of us must make to achieve this common goal, and thereby give our arguments true force."[20] Nadar was far removed in his political stance from those most involved with the direction of the SFP, who were generally close to the imperial court of Napoléon III. But though their political interests were divergent, they shared the ambition to see photography represented in the Salon; this was clearly a concern that extended beyond the small circle of the SFP. To achieve a satisfactory outcome the SFP would have to do much more than demonstrate competence in organizing exhibitions.

The second annual exhibition of the SFP is known as that of 1857, though it opened near the end of 1856; it was scheduled to take place soon after the closing of the 1856 Brussels exhibition, so as not to overtax the small group of French photographers, most of them amateurs. Since the exhibits were too numerous to display in the SFP's rooms on the rue Drouot, they were moved to Gustave Le Gray's new studio, on the boulevard des Capucines. The

installation included 168 photographers, many of them from outside France, and a catalogue was produced listing all the works shown. The exhibition was promoted by many admiring articles in the press that focused both on the serious, edifying aspect of the works and on the high quality of the visual presentation. Critics such as Théophile Gautier (1811–1872) (plate 75), in *L'artiste*, and Delécluze, in the *Journal des débats*, wrote feature articles on the exhibition. Paul Périer was moved to make the following congratulatory remarks in a report he provided to the SFP's *Bulletin*:

> Recall the poor impression, one might say the condemnation, of photography that has generally existed among artists; for too long they have known of these works only through tawdry displays seen along the commercial boulevards. These products of the camera—dull, pale, lacking character, lifeless, everything reduced to a dreadful uniformity—were perfectly suited to inspire in artists the most profound scorn for these curious machines that seemed to obscure every trace of the operator's individuality. Today, largely owing to the exhibitions organized by our society, the public sees that those photographers who have a true claim to be artists have mastered their equipment and their processes, to the extent that they give their works an individual mark, a personal character that—even without the evidence of a signature—perfectly distinguishes the work of one from that of another.[21]

With this success the SFP attained a new level of public recognition and raised its status above that of a club of hobbyists; it gained international recognition, becoming, with regard to photography, an authoritative source of publications, discussions, and exhibitions of high-quality work. Photography could get out of the rut of being little more than a sidewalk spectacle, and finally attain respectability (fig. 27).

Critical Thinking

The exhibition of photographs was more than a simple opportunity for competition and recognition; it also made necessary the establishment of a critical framework that would have validity beyond the closed circle of insiders. The "réunions photographiques" initiated by Ernest Lacan were an early forum for engaging in the thoughtful aesthetic reflection that needed to take place before discussion of photography could move into contemporary critical debate.[22] In a summary of a "soirée photographique" that took place on May 18, 1852, the architecture critic Charles Bauchal wrote:

> In our opinion, what distinguishes art is most importantly the freedom to follow, as one pleases, whatever path one may choose to take, led by inspiration or emotion. And here we find that photography, like other branches of art, already possesses two distinct schools: one that is concerned principally with overall effect and one that concentrates on the precise reproduction of detail—the school of the fantastic and the school of the real; that of the colorists and that of the draftsmen. Which is to say that this eternal argument in art—that which considers the relative importance of line or effect, of drawing or coloring, of Michelangelo or Raphael, Rubens or Le Sueur, Girodet or Proudhon, Ingres or Delacroix, Rousseau or Aligny—exists also in photography, and has already passionately engaged its practitioners.[23]

Photography lacked its own history and was alleged to lack a style at all, since it was produced by a mechanical device. By citing the great names of art history in this brief description of alternative approaches to the aesthetic of the photograph, Bauchal associated the new art with the old and transformed these historic masters into exemplary points of reference for photographers. Photography not only faced, in Bauchal's words, the "struggle of Romanticism and Classicism…as it exists in painting, music, and literature";[24] these photographer-artists were also engaged in a dialogue with the entire history of art.

In retrospect, the most interesting feature of the push to exhibit photographic works was the need to provide a critical vocabulary for the medium. If ever there was a battle since photography made its first appearance, this was the ground on which the fight was joined. Even before associations to encourage the development of photography were created, the art critics—those whose subject was exactly the kind of art shown in the annual Salons— had seized on an attitude that systematically denigrated and indicted photography. This

Fig. 27.
Nadar (Gaspard-Félix Tournachon) (French, 1820–1910), *Exhibition at the Société Française de Photographie: A Man Photographed at the Exit.* Lithograph, from "Revue du premier trimestre de 1857," *Le journal amusant* 70 (May 2, 1857): 4. Private collection

was the case from the moment when it was suggested that photography might come to have some influence over art in general and painting in particular. Photography was seen by these critics as a kind of Trojan horse—an invasion by industry into the realm of poetry. Photography, which the critic Alphonse de Calonne (1818–1902) called the "seed of death for true art,"[25] seemed to find no acceptance in any critical framework, a situation that was described by Charles Baudelaire (1821–1867) in "Le public moderne et la photographie" (The modern public and photography) (1859), which recapped twenty years of critical hostility.[26] For photographers such as Le Gray, Le Secq (fig. 28), and Nègre, who had all been trained at the Académie des beaux-arts and who could be found exhibiting paintings in the Salon, the slandering of photography called for a fight that would be carried on not only in the pages of journals but also in the exhibition galleries.

But what would be a balanced critical approach to photographic images that took into account their mechanical origin? The problem was as difficult as it was important.

Exhibitions of photographs were occurring frequently in England, France, and Belgium. The jury for the photographic section of the 1856 Exposition universelle des arts industriels in Brussels reported the situation in this way: "Created too recently to have reached a state of decline, [photography] continues to make progress at such a rate that last night's work is surpassed by this morning's, as that will be surpassed by tomorrow's. Because of this rapid development in the art, it is essential to have frequent exhibitions of photographs; it is only in this way that one can hope to direct the student toward the goal that he should strive for; while the masters of the art will be reminded, witnessing the achievements of relative newcomers, that to stay still is to be surpassed."[27] That photography and progress are bound together by their industrial underpinnings makes this analysis all the more complicated. Poor-quality photographs made by operators with little talent certainly caused tremendous damage to the reputation of the new medium and contributed to the disdain in which it was held by the art world. But to judge photography on the basis of the distorting mirror of "grotesque prints...seen in some store windows along the boulevards" would be a mistake, Lacan wrote; that would make as much sense as "to judge painting, poetry, or music on the basis of a painted sign on a fairground stall, the motto of a confectioner, or the bitter old tune of the blind man on the pont des Arts." In his view, the best that could be said of photography's detractors was that "they speak of a subject that they have insufficiently studied, and one can only ask who it is that forces them to do so, when there are so many other sources that would lead them to useful expressions of their ideas and their knowledge."[28]

Lacan chronicled the critical texts appearing in *La lumière* and in the SFP's *Bulletin* (as well in publications aimed at a more general readership) that commented on the photographic exhibitions in Paris, London (fig. 29), Edinburgh, and Brussels. Detailed commentaries stretched over many pages (sometimes far too many), recounting the merits of this or that process or comparing the qualities of this and that photographer. In general, the choice of photographs and photographers was too limited and too tentative to impose classifications or to award medals. Such commentaries were meant to lay out and explain the range of what photography could do, and to do so in a way that, if not strictly disinterested, was at

Fig. 29.
Charles Thurston Thompson (English, 1816–1868), *Exhibition of the Photographic Society of London and the Société Française de Photographie at the South Kensington Museum*, 1858. Albumen print, 29 × 33.3 cm (11³⁄₈ × 13¹⁄₈ in.). London, Victoria & Albert Museum, Given by Alan S. Cole, 2715-1913

least not commercially motivated. The point was to be made that there were many kinds of photographs beyond the cheap examples seen on the commercial street and that a photographer who knew what it was he wished to obtain could control the process to arrive at the desired result. Additionally, the reader was guided to the distinction to be made between documentary photography (often associated with depictions of architecture) and artistic photography (associated with landscape views). "[Let us] leave aside for the moment the photographs of historic buildings, where the aim is analogous to that of a technical drawing in which clarity and extreme accuracy are valued rather than effect," the photographer Henri de La Blanchère (1821–1880) wrote, "and instead consider their more complex and difficult cousins, artistic photographs; here, we will have much to discuss." For La Blanchère, as for a number of his colleagues, the thing that was worth discussing, the thing that merited critical attention and debate, was artistic photography: "That which seeks to create, on its own and by its proper capacities, a picture; that is, a complete object, pleasing to the eye, and respecting the conditions of unity and perspective that constitute a work of art as opposed to a simple reproduction."[29]

Is photographic art possible? If so, under what conditions? These questions recur regularly in the pages of *La lumière* and the SFP's *Bulletin*, where they were no doubt intended to promote discussion and increase knowledge among readers. The author of an unsigned report on the SFP's 1857 exhibition queried: "Is it possible...that two talented artists, equipped with the means to make photographs, would not only obtain different results but would, in fact, arrive at wholly different interpretations of nature itself, simply by following their own ideas? Briefly, is photography condemned forever to be nothing but a craft...? Or can it rise to the exalted dignity of art, as we are profoundly convinced it will?"[30] Only by the careful study of actual photographs would it be possible to answer these questions. "Instead of judging photography by the results of the latest amateur or commercial production," Lacan wrote, "if we would devote some time to the examination of the works of intelligent photographers, we could finally end this recurring attention to what is the antithesis, one might even say the desecration, of art."[31] The other side of this argument required the establishment of a rhetoric of photographic aesthetics that would guide any photographer who wished to rise from the status of operator to that of artist. The photographer Jean-Louis-Marie-Eugène Durieu (1800–1874) contributed an especially significant article, in which he explained: "When one wishes to obtain a picture rather than a reproduction, when one renders an artistic effect in the view of a landscape or in a portrait; that is the moment when the photographer becomes a true creator and must meet very specific requirements."[32] These requirements included the conventional artistic concerns of "choice of a point of view, the skillful placement of the limits of the view, the ability to attract and concentrate the viewer's attention on the principal subject, the correct distribution of light." Added to these was an essential consideration derived from the photographer's detailed knowledge of the way in which sensitized photographic materials would record the scene, allowing him to "judge in advance how the image, as seen on the glass of the camera, will be transformed through the photographic process, and to predict what the final *rendering* will be, if one may use that term."[33] The photographer-artist is not ruled by technique; he masters it. To the traditional skills of good composition and ordering he adds his knowledge of photographic "transformations." "The lens is not a simple optical contrivance that responds mechanically to whoever happens by and desires to use it; instead, it is an instrument that the photographer directs and leads in accordance with his own ideas. While it is true that the lens will not show what it does not see, it is a fact that the photographer must make the lens see what he wants....That is exactly where there is art in photography."[34] Photographic art, in Durieu's formulation, is not the passive production of a detailed image of nature but, rather, an expression of the photographer's sensibilities through an image born of the transformative nature of the camera. This is the means by which "art inserts itself in photography."[35]

In such published discussions, the photographers shown in the SFP exhibitions were mentioned as often as possible in comparison with renowned artists, as a means both of enlivening the descriptions of the photographs and of reinforcing the linkages between photography and painting. Le Gray's landscapes were compared to those of the painter Narcisse Virgile Diaz de la Peña; the portraits of Nadar to those of Jusepe de Ribera; the landscape views of Paul-Marcellin Berthier (1822–1912) to those of Théodore Rousseau (fig. 30); Baron Louis Adolphe Humbert de Molard (1800–1874) to Teniers and Van Ostade; Pesme (active 1850–1870s) to Watteau. In photography, as in painting, the same rule applied, Durieu asserted: "Art relies on one condition: not to reproduce the exterior aspect of things and to

Fig. 30.
Théodore Rousseau (French, 1812–
1867), *Forest of Fontainebleau, Cluster
of Tall Trees Overlooking the Plain
of Clair-Bois at the Edge of Bas-Bréau*,
ca. 1849–52. Oil on canvas, 90.8 ×
116.8 cm (35¾ × 46 in.). Los Angeles,
J. Paul Getty Museum, 2007.13

imitate them more or less accurately but to express, to manifest, to communicate the ideas that the appearance of nature excites in our soul, each of us following his own manner of feeling. Imitation is only a method of art, not its purpose."[36]

The third exhibition of the SFP opened on April 1, 1859, in the same building—the Palais de l'industrie—and during the same weeks as that year's Salon. The *Lumière* columnist La Gavinie wrote: "The galleries that are dedicated to photography have today been opened by [the state] in its exhibition hall. Such a substantial encouragement—denied several years ago—does not in itself establish the complete return to favorable opinion of this art, for which this journal has long been the foremost advocate."[37] This exhibition was the result of many months of discussions and negotiations between the museum administration and the SFP, represented by its president, the chemist Henri-Victor Regnault (1810–1878), and aided by the archaeologist and politician Léon de Laborde (1807–1869) and the comte Olympe Aguado (1827–1894), a wealthy banker and a friend to Empress Eugénie, the wife of Napoléon III.[38] The arts administration authorized the SFP to organize an exhibition of photographs to be displayed *parallel* to, but clearly distinct from, the Salon. The entrance to the SFP exhibition, located on the second floor of the west wing of the Palais de l'industrie, was separate from the entrance to the Salon proper. Mention of the photographic exhibition was nowhere to be found either in the official program of the Salon or on the posters that were distributed throughout Paris announcing the dates and the hours of the larger exhibition. All the costs of the photographic exhibition—installation, program, catalogue—were borne by the SFP. The result was that, in 1859, photography did *not* gain entry to the Salon; it was hardly tolerated, in fact—a curiosity hidden away and visited only by some enthusiasts and a few wayward individuals who were unhappy when they found that they would be charged an entry fee substantially larger than that assessed for the main event. For the arts administration, this middling solution had all the advantages of maintaining the status quo: the SFP and its executive received the flattering message that only they were capable of organizing photographic exhibitions of refinement; meanwhile, the question of photography as art could be avoided entirely. This satisfied critics such as Maurice Aubert, who saw the arrangement as being cautiously appropriate:

> Some persons have desired that the [exhibition of photographs] not be located separately from the official exhibition of works admitted to the Salon, and have expressed the wish that such a separation be eliminated in future exhibitions. This would, no doubt satisfy a legitimate sense of pride. But would it really serve the interests of this new branch of art?...We must not make the placement of photographs in one or another part of the exhibition hall a matter that is to be decided on the basis of self-esteem;

Fig. 31.
Charles-Louis Michelez (French,
1817–?), *Fifth Exhibition of the Société
Française de Photographie, Palais
de l'Industrie, Southeast Wing*, 1863.
Albumen silver print, 23.6 × 26 cm
(9¼ × 10¼ in.). Paris, Société française
de photographie, 292-2

these questions must be taken more seriously. It is much to the advantage of photography that it be exhibited separately, and this is not in any way intended to denigrate its incontestable value. Photographs must be contemplated at leisure, in a room where the eye will not be drawn to other objects, even those of inferior artistic merit.[39]

But, in fact, was this not first and foremost a question of pride? Although the French photography community may have celebrated this flirtation with the fine arts, they were certainly the only ones who could be pleased with the 1859 edition of the Salon. Across the barrier that separated photography from fine art, things had become noxious. Since 1852, the comte de Nieuwerkerke, whom the SFP had courted in the hope that he would help to resolve their grievances, had exerted an unprecedented degree of control over the Salon. Censorship had never been so prevalent, and new ideas brought by young artists had rarely been so absent.[40] Distracted by dreams of finding artistic recognition, the French photographic avant-garde had accepted the dominant academic logic of art without remarking that this mode of thinking was at least exhausted, if not obsolete. But it was in this world that photography won its first and primordial battle—to become visible (fig. 31).

NOTES

1. Gustave Flaubert, *Le dictionnaire des idées reçues* (Paris: Louis Conard, 1913), 66.
2. Henri de Lacretelle, "Salon de 1852," *La lumière* 2 (June 5, 1852): 94.
3. Ibid.
4. Ibid.
5. Ernest Lacan, "Réunion photographique," *La lumière* 2 (April 24, 1852): 72.
6. Gustave Le Gray, *Photographie: Traité nouveau théorique et pratique des procédés et manipulations sur papier et sur verre* (Paris: Lerebours et Secretan, 1852), 2–3.
7. Lacretelle, "Salon de 1852," 94.
8. See Anne de Mondenard, *La mission héliographique: Cinq photographes parcourent la France en 1851* (Paris: Monum, 2002), and her essay in the volume, 20.
9. Francis Wey, "Album de la Société héliographique," *La lumière* 15 (May 18, 1851): 57.
10. See André Gunthert, "L'institution du photographique: Le roman de la Société héliographique," *Études photographiques* 12 (November 2002): 37–63.

11. See André Gunthert, "Naissance de la Société française de photographie," in *L'utopie photographique: Regard sur la collection de la Société française de photographie*, ed. Michel Poivert and Carole Troufléau, exh. cat. (Paris: Le Point du jour, 2004), 13.

12. "Statuts de la Société française de photographie, fondée le 15 novembre 1854," *Bulletin de la Société française de photographie* 1 (1855): 13.

13. "Première exposition publique dans les salons de la Société," *Bulletin de la Société française de photographie* 1 (1855): 40.

14. Jules Ziegler, *Compte rendu de la photographie à l'Exposition universelle de 1855* (Dijon: Douillier, 1855), 32.

15. Paul Périer, "Exposition universelle: 1ᵉʳ article," *Bulletin de la Société française de photographie* 1 (1855): 146.

16. Ibid., 147.

17. Ibid.

18. Paul Périer, "Exposition universelle: 2ᵉᵐᵉ article," *Bulletin de la Société française de photographie* 1 (1855): 172.

19. Ferdinand de Lasteyrie, "Exposition universelle: Photographie; 2ᵉᵐᵉ article," *Le siècle* (November 6, 1855): 3.

20. "Assemblée générale de la Société française de photographie, 21 novembre 1856," *Bulletin de la Société française de photographie* 2 (1856): 326.

21. Paul Périer, "Rapport sur l'Exposition ouverte par la Société en 1857," *Bulletin de la Société française de photographie* 3 (1857): 262.

22. See Ève Lepaon, "'L'art ne ferait pas mieux': Corrélations entre photographie et peinture dans *La lumière*," *Études photographiques* 31 (Spring 2014), https://étudesphotographiques.revues.org/3403.

23. Charles Bauchal, "Soirée photographique," *La lumière* 2 (May 29, 1852): 90.

24. Ibid.

25. Alphonse de Calonne, "Exposition de 1850–1851," *L'opinion publique* (February 21, 1851): 2.

26. See Paul-Louis Roubert, *L'image sans qualités: Les beaux-arts et la critique à l'épreuve de la photographie, 1839–1859* (Paris: Monum, 2006).

27. J. Renoir et al., "Rapport du jury chargé de juger la section de photographie à l'Exposition universelle des arts industriels de Bruxelles," *Bulletin de la Société française de photographie* 2 (1856): 344.

28. Ernest Lacan, "Chronique photographique," *La lumière* 9 (April 16, 1859): 64.

29. Henri de la Blanchère, "Études photographiques," *La lumière* 7 (January 31, 1857): 19.

30. "Rapport sur l'Exposition ouverte par la Société en 1857," *Bulletin de la Société française de photographie* 3 (1857): 260.

31. Ernest Lacan, "Exposition photographique de Bruxelles," *La lumière* 6 (November 29, 1856): 185.

32. "Rapport présenté par M.E. Durieu, au nom de la Commission chargée de l'examen de l'Exposition ouverte dans les salons de la Société française de photographie, du 1er août au 15 novembre 1855," *Bulletin de la Société française de photographie* 2 (1856): 63.

33. Ibid.

34. Ibid., 64.

35. Ibid., 68.

36. Ibid., 62–63.

37. La Gavinie, "Chronique," *La lumière* 9, no. 13 (March 26, 1859): 52.

38. See Paul-Louis Roubert, "1859, exposer la photographie," *Études photographiques* 8 (November 2000): 5–21.

39. Maurice Aubert, *Souvenirs du Salon de 1859* (Paris: Jules Tardieu, 1859), 349–50.

40. See Henri Loyrette, "Le Salon de 1859," in Henri Loyrette and Gary Tinterow, *Impressionisme: Les origines, 1859–1869*, exh. cat. (Paris: Réunion des musées nationaux, 1994), 7; and, more generally, Patricia Mainardi, *The End of the Salon: Art and the State in the Early Third Republic* (Cambridge: Cambridge University Press, 1994).

A "Fashionable" Art: The First Golden Age of Photography in France

Sylvie Aubenas

> From here and now, paper photography has won the admiration of artists and of all persons of taste.
>
> —EDMOND DE VALICOURT, *Nouveaux renseignements pratiques sur le procédé de photographie sur papier, de M. Blanquart-Evrard* (1847)

> A good proof on paper is like a sepia drawing made by a skilled artist.
>
> —LOUIS FIGUIER, "La photographie," *Revue des deux mondes* (1848)

The official announcement of the invention of the daguerreotype, delivered by the physicist and politician François Arago (1786–1853), and the immediate demonstration of the secrets of the process, ably orchestrated by Louis-Jacques-Mandé Daguerre (1789–1851) himself, took place on August 19, 1839, in front of an unusual joint assembly of the Académie des sciences and the Académie des beaux-arts. The French government thanked Daguerre by providing him with an annual pension of six thousand francs. Arago's announcement caused an uproar. There had already been excitement and a flurry of rumors in the months since January 7 of that year, when the daguerreotype had briefly been described to the Académie des sciences.

From that moment, both William Henry Fox Talbot (1800–1877) and Hippolyte Bayard (1801–1887) were thrown into a race to have their respective processes for photography recognized as predating Daguerre's invention, and as superior.[1] One after the other, they made appeals to the academies. Eclipsed and offended by their exclusion, even as the public was celebrating Daguerre's invention, they worked feverishly to improve their still-imperfect processes. But to no avail. In France, the conviction was solidly and deeply established that the daguerreotype—an unambiguously French invention[2]—was synonymous with photography, and Bayard's and Talbot's efforts were in vain. Arago was deliberately silent on the subject of Bayard's invention, despite the inventor's having brought it to his attention on May 20.[3] In October of the following year, Bayard was moved to compose a portrait of himself as a drowned man, driven to suicide by despair (fig. 32). This image, with its allusions to Jacques-Louis David's *The Death of Marat* (1793; Brussels, Musées royaux des beaux-arts de Belgique), was accompanied by a statement of protest written in a tragicomic style: "Although he himself found these images to be imperfect, the academy, the king, and all the others who have seen them admired them as you now admire this one. This brought him much honor but not so much as a farthing. The state, which gave M. Daguerre far too much, said it could do nothing at all for M. Bayard—and the unfortunate drowned himself."[4]

Photography on paper would not become popular, either in public opinion or in use, until the early 1850s; the daguerreotype predominated for more than a decade.[5] While recent exhibitions exploring this first photographic process have revealed a wealth of remarkable images,[6] such high-quality images were not necessarily the norm during the daguerreotype period. The free use of the process allowed by Daguerre led to an explosion of "daguerreotypomania," largely characterized by a free-for-all of commercial activity in mediocre portrait factories. The hesitations of the artistic community with regard to photography should be seen in the context of this mass production. Nonetheless, a number of artists showed some interest in the new technology. Among those were Rosa Bonheur, Eugène Delacroix, Paul Delaroche, Théodore Gudin, and Horace Vernet. Several aristocrats, such as Jean-Gabriel

Fig. 32.
Hippolyte Bayard (French, 1801–1887), *Self-Portrait as a Drowned Man (Le noyé)*, October 1840. Direct positive print on paper, 25.6 × 21.5 cm (10¹⁄₁₆ × 8⁷⁄₁₆ in.). Paris, Société française de photographie, 24.282

Eynard, Joseph-Philibert Girault de Prangey, and Baron Jean-Baptiste Louis Gros, were daguerreotype enthusiasts.

Paper Photographers in France

Paper photography came to France with a number of handicaps: it arrived after the daguerreotype; the images seemed less than perfect; and there were at least two, if not three, inventors.[7] Talbot and Bayard were left to position themselves and their processes vis-à-vis each other and in relation to the daguerreotype. This was as much a political problem as a scientific argument, summarized by Talbot in his introduction to *The Pencil of Nature* (1844): "This great and sudden celebrity [of the daguerreotype] was due to two causes: first, to the beauty of the discovery itself: secondly, to the zeal and enthusiasm of Arago, whose eloquence, animated by private friendship, delighted in extolling the inventor of this new art, sometimes to the assembled science of the French Academy, at other times to the less scientific judgment, but not less eager patriotism, of the Chamber of Deputies."[8]

The representations made by the two inventors of paper photography, and the extensive reports made to the two French academies in the early 1840s, stimulated a discussion of the nature of photography and its possible applications that would have never been elicited by the daguerreotype alone. Whether photography was indeed a branch of art was hotly debated in Paris—at that time the global center of artistic life. The controversies that surrounded photography were not unrelated to the arguments around competing schools of contemporary painting. Since the 1830s, the academic tradition had been under attack both by the partisans of plein-air painting, on the one hand, and by the Realist painters, on the other. The challengers found evidence to support their arguments in current progress in science, in modern trends in literature, and in the general upheavals that were then affecting French society. It should be kept in mind that photography appeared in France during the moderate reign of Louis-Philippe—after the July Revolution of 1830, which marked a definitive halt in the return of the ancien régime, and before the February Revolution of 1848. Later, the administration of Napoléon III (r. 1852–70) with its free-market policies would coincide with an explosion of commercial activity in photography.

We should also remember that from the moment of paper photography's modest beginnings, it benefited from a natural association with those arts that shared the same support material: drawing, watercolor painting, and engraving. Daguerreotypes, by contrast, remained for many a creation of science—a curiosity, albeit a fascinating one. The experts who were asked to evaluate the value of paper photography found themselves on familiar terrain. For example, in reporting on Bayard's process in November 1839, Raoul-Rochette (1790–1854) wrote: "One could not hope for a more satisfying effect where charm and fidelity are combined in the rendition of the image. Monsieur Bayard's drawings produce an agreeable impression, which is essentially derived from the presence of light and the modulation of tints that it produces and which is a truly delightful effect. They suggest to the artist's eye the drawings of the old masters, somewhat mellowed with age; they give an appearance remarkably similar to these and have almost all their merit."[9] This is the kind of enthusiastic praise for photography on paper that later, in the early 1850s, will be given by Francis Wey (1812–1882) and Ernest Lacan (1828–1879) in the pages of the journal *La lumière*.

The complex story of the beginnings of paper photography, capably summarized by Anne de Mondenard in her essay in this volume, has been thoroughly retraced in three recent exhibition catalogues.[10] One might say of paper photography that it was smothered in the cradle, arriving, as it did, between the daguerreotype and the collodion process. But—if we may extend the metaphor somewhat—rather than dying in infancy, it was instead subject to a very slow and frustrated maturation. In France, England, and Italy it made its way, slowly and quietly, nurtured in privileged surroundings, and protected from damaging commercial pressures.

Ultimately, it was Louis Désiré Blanquart-Evrard (1802–1872) (fig. 33), a businessman from Lille with a keen interest in both art and chemistry, who was successful in spreading the practice of paper photography throughout France.[11] He learned of Talbot's process in 1844 through contact with one of Talbot's students, a man by the name of Tanner. Blanquart-Evrard improved, completed, and simplified the existing instructions to such an extent that his paper-negative process can be described as being new and distinct from Talbot's.[12] Blanquart-Evrard asked Arago to announce his negative process to the Académie des sciences; this was done on January 25, 1847, and the process was published soon after in a short

Fig. 33.
Louis Désiré Blanquart-Evrard
(French, 1802–1872), *Self-Portrait*, 1846.
Salted paper print, 14.9 × 20.7 cm
(5⅞ × 8⅛ in.). Paris, Société française
de photographie

volume that fully outlined the procedures.[13] Edmond de Valicourt published a further developed version of the process that same year.[14]

At this early stage, even the most ardent partisans of photography on paper, such as Valicourt, struggled with the idea that a photograph could be considered a fully realized work of art; he makes a clear distinction, though, between the daguerreotype as a purely commercial product and photographs on paper that are more suited to use by travelers and artists "who are not seeking to have a definitive image, but who instead want to make interesting studies, or a collection of agreeable souvenirs, or want material to be used in the later production of works of art." "It is a serious error, and far too common," he writes, "to imagine that one can find a true work of art in a daguerreotype—as if art could be born through the agency of a machine!"[15] The artistic hesitations that greeted the introduction of the daguerreotype were also proffered with regard to photographs on paper, before a full understanding of the new possibilities offered by this medium was gained. It was up to a new generation of artists—those born around 1820 and of about twenty years of age when the daguerreotype was announced—to seize on the new technology and to demonstrate brilliantly the artistic possibilities of photography. This was the generation that would rise to the challenge set by Delacroix in 1853, when he called the photograph "art from a machine," and stated that "a man of genius will use the daguerreotype as it should be used, and will raise it to a level that we have never previously witnessed."[16]

The negative-positive system for making photographs arrived in France almost completely coincident with Blanquart-Evrard's streamlined methods for making paper negatives, though there had already been some early experiments, particularly those of Claude-Félix-Abel Niépce de Saint-Victor (1805–1870), in using glass for negatives. But glass-plate negatives would not fully emerge until the processes of Frederick Scott Archer (1813–1857) and Gustave Le Gray (1820–1884), announced in 1851, reached a stage of commercial exploitation around 1854–55. This leaves the period from about 1848 until 1855 as an exceptional interregnum. Commercial photography studios, concentrating on the production of portraits, were almost exclusively using the daguerreotype and would transition directly to the collodion wet-plate negative around 1854, signaling the beginning of an era of unprecedented activity in commercial photography.[17] This circumstance allowed photography on paper to remain in the domain of artists and of the socially elite, of writers and wealthy travelers; this unique conjunction is authoritatively described by André Jammes and Eugenia Parry Janis in their book *The Art of French Calotype* (1983).[18] During these years, photography on paper

was a recreation, a vocation, an interest, even a passion. Its incompatibility with commercial exploitation and its affinities with and similarities to existing art media and to the world of art provided license and encouragement.

Gustave Le Gray was first and foremost a painter, as evidenced by his training at Paul Delaroche's studio, which was followed by a stay in Rome that stretched from 1843 to 1847, and by his attempts to show paintings at the Salon. He was the ideal teacher for those who wished to learn the art of photography on paper; his students would have felt that they were immersed in an artistic milieu as they arrived at the large studio at 7, chemin du ronde de la barrière de Clichy (plate 29) that Le Gray shared with a number of artists, including the painter Fernand Boissard de Boisdenier (1813–1866), an intimate of the poet Charles Baudelaire (1821–1872) and the critic Théophile Gautier (1811–1872) (plate 75).[19] Some sixty students are recorded as having passed through Le Gray's studio. Many of these were from French families influential due to their fortune or their position, with surnames such as Aguado, Bocher, Delessert, Haussonville, Laborde, Montesquiou, Rothschild, and Vigier. One unique circumstance that particularly favored the adoption of photography on paper in the upper levels of French society was that in 1847, when paper photography appeared in reinvigorated form, political trouble was about to break out. The period between the fall of Louis-Philippe, in 1848, and the establishment of the Second Empire, in 1852, was one of uncertainty and of many reversals of fortune; existing systems of wealth and power were turned upside down. The interest in photography shown by members of the elite can be seen as a resort to a recreational activity that was *fashionable* (to use the vaguely exotic English word that may have been on the lips of well-educated and wealthy Parisians); one could occupy oneself with this new phenomenon while waiting for better days to come. Le Gray continued giving lessons in photography until 1855; other leading photographers, such as Bayard, Édouard Baldus (1813–1889) (fig. 34), and Blanquart-Evrard, also taught photography, though not as consistently as Le Gray (fig. 35). These opportunities for learning the techniques of photography from leading artistic practitioners are key to understanding the brilliant flowering of the process in France during these years. One of Le Gray's first pupils was Léon de Laborde (1807–1869), and he, along with members of the Delessert family and the comte Olympe Aguado (1827–1894), was certainly a key figure leading the fashion for paper photography that spread among the elites in 1849.

So photography on paper became a recreational activity for the sophisticated and well-to-do, and this exclusivity held until the vendors of carte-de-visite portraits and stereoscopic views replaced the daguerreotypists' studios on the *grands boulevards* of Paris.[20] It was practiced in several select circles: at Le Gray's studio at the barrière de Clichy; in Rome, in the so-called Caffè Greco Circle;[21] at the porcelain works at Sèvres, where Henri-Victor Regnault (1810–1894) (fig. 36) was director, and Louis-Rémy Robert (1811–1882) was the head of the painting workshop;[22] in Arras, gathered around the father and son Adalbert (1812–1871) and Eugène (1837–1900) Cuvelier, were Jean-Baptiste-Camille Corot, Charles

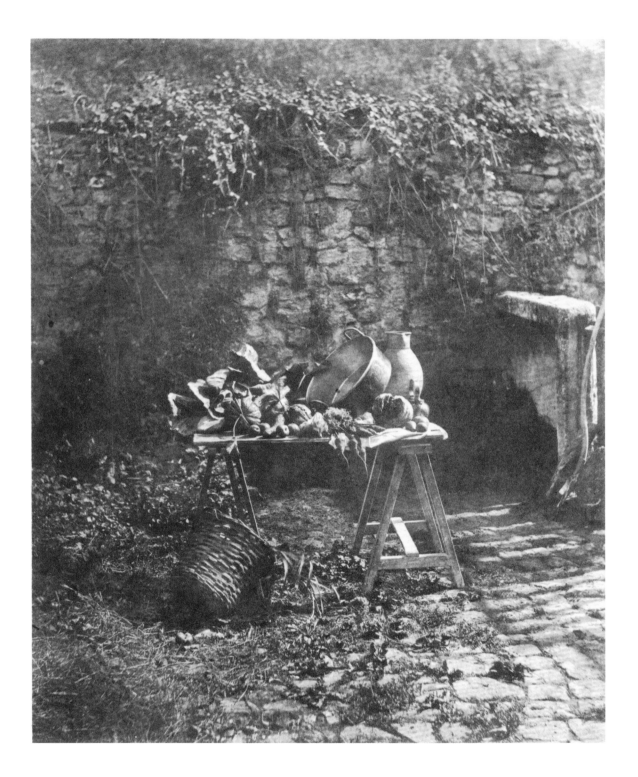

Desavary, and Constant Dutilleux. This concentrated attention on paper photography led to a remarkable flourishing, helped by the fact that many of these amateur photographers wished to unite, to work together to improve their craft through exchange, to compare their work with that of others, and to publish their discussions. These goals eventually coalesced in a number of developments during the year 1851: the formation of the Société héliographique; the appearance of the weekly review *La lumière*, whose noteworthy contributors included Lacan, Henri de Lacretelle (1815–1899), and Wey; photographic expeditions undertaken by individuals such as Maxime Du Camp (1822–1894) and Eugène Piot (1812–1890); the Mission héliographique ordered by the Commission des monuments historiques, which yielded unexpected and transcendent images made by the carefully chosen photographers; and the opening of two photographic printing establishments—the enterprise of Blanquart-Evrard in Lille and that of Elisabeth Hubert de Fonteny in Paris. And, still in this same eventful year, Le Gray made two announcements that represented decisive advancements for paper photography: first, the waxed-paper–negative process; and then, in November, a memoir presented on his behalf by Regnault, at the Académie des sciences, that is less well remembered but just as important—"Notes on Positive Proofs on Paper: New Processes for Obtaining Positive Proofs on Paper with Varied Coloration and Possessing a Greater Permanency Than Obtained Previously."[23] Le Gray emphasized the essential importance of the printing step, as he wrote in the 1851 edition of his treatise on photography: "The positive proof is the final result and it deserves the full attention of all photographers; it is impossible to put an excess of effort into trying to extend the tones and the transitions between them."[24]

The following years saw extraordinary growth in photography and the appearance of work of the highest quality, all of it occasioned by this creative environment and by practitioners armed with excellent tools, both intellectual and technical. There are so many highly talented paper photographers at work during this period—Aguado, Édouard Benecke, Henry Courmont, Cuvelier, Alphonse De Launay, William Henry Gebhard, John Beasly Greene, Firmin Eugène Le Dien, Charles Marville, Auguste Mestral, Charles Nègre, Pierre-Émile-Joseph Pécarrère, Robert, Auguste Salzmann, Félix Teynard, Joseph, vicomte Vigier—that an exhaustive list is impossible to assemble. Lacan authored a series of articles in *La lumière* during 1852 and 1853 under the rubric "Photographers—Physiological Sketches." These short biographies of photographers—artists and amateurs—give us an animated and vivid description of this milieu in which the sons of bankers rubbed shoulders with painters. "The amateur photographer," Lacan wrote, "is a man who through his love of art has become passionate about photography, much as he would be passionate about painting or sculpture or music. He has made a serious study of the subject, reasoned and with intelligence. He is determined that he will not waste time and money on useless pursuits and that he will equal, if not surpass, those who have taught him. He comes, generally, from the upper echelons of society.... Among the amateur photographers we find a duke and many counts, viscounts, and barons; diplomats, officials of the state, and magistrates."[25] In addition to Lacan's writings, we can look to the many images of the subjects themselves—portraits or self-portraits—that testify to the satisfactions of being a French paper photographer in the early 1850s. Aguado, Bayard, Blanquart-Evrard, Le Gray, Henri Le Secq (1818–1882), and Nègre all appear in images in which they are stretched out on the grass, or costumed in "Oriental" style, or dressed as elegant dandies (figs. 37–39).

This was a kind of golden age which reached its apogee in the middle of the decade with the formation of the Société française de photographie and the founding of its journal, the *Bulletin de la Société française de photographie*. The energizing effect of journals, treatises, and exhibitions; decisive technical improvements such as the waxed-paper–negative process; and, indeed, the tremendous personal influence of Le Gray himself—these led photographers to extend their ambitions to encompass new subject matter and to create images that demanded sophisticated printing techniques, where not only physical permanence but also the control of print coloration required to achieve the intended effect was sought. The image of the photographer as sophisticated amateur and world traveler persisted until the end of the decade, exemplified by amateurs such as Gustave de Beaucorps, Louis de Clercq, Léon Gérard, Victor Nau de Champlouis, and Lieutenant Louis Vignes.

The paper negative continued to be used until about 1860 (though much later examples can be found, even into the 1880s). But well before that, amateurs and artists had begun to explore the possibilities of glass-plate–negative processes, especially the collodion process, which had much greater photosensitivity and which allowed Le Gray, for instance, to create his renowned marine views (plates 115–20). The wet collodion–negative process using a glass-

plate support became widely available around 1855; it was the driving force behind the second wave of commercial photography, and it was around this time that the aristocratic amateur photographer began to be seen less frequently. Le Gray and Bisson Frères, swept up by the powerful commercial and industrial forces that accompanied the early years of the reign of Napoléon III, both opened studios on the *grands boulevards* of Paris and tried to reconcile art and commerce while avoiding a descent into the production of banal portraits. This was also the heyday of the large photographic commissions in which grants from the French state allowed photographers to undertake large-scale projects; Claude-Joseph Désiré Charnay, Baldus, Bisson Frères, Adolphe Braun, Le Gray, Léon-Eugène Méhédin, and Nègre all received such commissions and proceeded to produce bodies of work that are among the most spectacular in their respective oeuvres.[26] However, none of them managed to find financial stability through their photographic work. All of the most important professionals in paper photography declared bankruptcy, abandoned the practice, took up new vocations, or accepted jobs in institutions; the amateurs withdrew, returned to life in politics, or devoted themselves to managing their land holdings and factories. Only the wealthiest and most dedicated, such as Aguado (fig. 40) and Le Secq, continued as skilled amateur practitioners. But most of the actors in this scene exited; the felicitous and fertile tumult between professional and amateur photographers vanished.

Nadar's Balancing Act

Nadar (Gaspard-Félix Tournachon, 1820–1910) (fig. 41) is seldom associated with this movement, but his story is critical in illustrating and understanding the context. His younger brother, Adrien Tournachon (1825–1903) (fig. 42), was a painter, without much success. In 1854, Nadar sponsored his brother's lessons in photography with Le Gray, thereby bringing them both inside the inner sanctum of refined photographic sensibilities.[27] We know of

Fig. 41.
Nadar (Gaspard-Félix Tournachon)
(French, 1820–1910), *Self-Portrait*,
ca. 1855. Salted paper print, 20.5 ×
17 cm (8¹/₁₆ × 6¹¹/₁₆ in.). Los Angeles,
J. Paul Getty Museum, 84.XM.436.2

Fig. 42.
Adrien Tournachon (French,
1825–1903), *Self-Portrait* (?), 1854–55.
Wax-coated salted paper print,
22.3 × 17 cm (8¾ × 6¹¹/₁₆ in.). Paris,
Bibliothèque nationale de France,
EO-99b PET. FOL., t.1

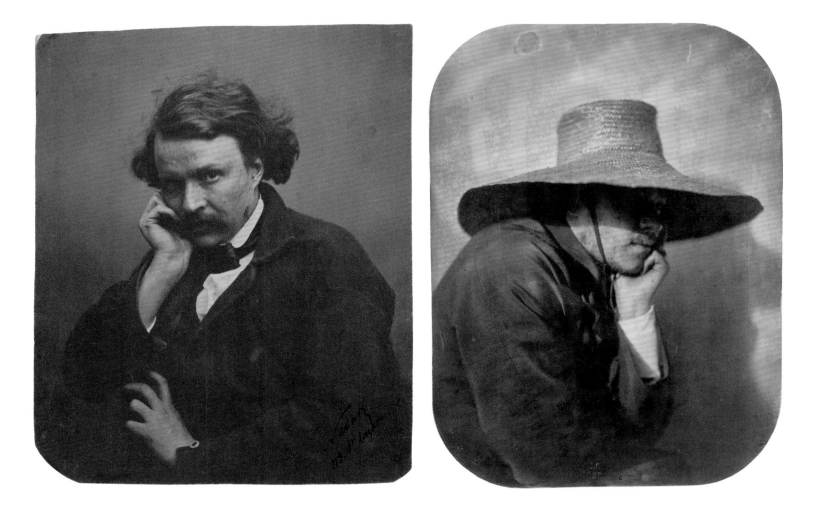

the older brother's own interest in photography, his curiosity about this medium that had found such popularity among French society's elite, and his requirement (similar to that of Hill and Adamson in an earlier generation) to quickly obtain numerous portraits for his *Panthéon Nadar* lithographs. The brothers were engaged in a partnership at the moment when commercial portrait studios began to proliferate in Paris. Adrien, the gifted and tormented artist, remained faithful to the artistic ideals he had absorbed from Le Gray's lessons—even when he was photographing prize livestock. Meanwhile, his brother—the caricaturist, journalist, and public relations genius—elaborately established himself on the rue Saint Lazare and made plans to use his wide circle of friends and acquaintances to produce salable photographic portraits (fig. 43).[28] Nadar began this enterprise at the same time that André Adolphe-Eugène Disdéri (1819–1889) and other producers of inexpensive portraits were establishing themselves. But Nadar was uniquely skillful in appropriating the aura associated with the elite circles described by Lacan, and for a number of years he succeeded in linking his photographic portraits with this artistic character. He maintained this balancing act into the 1860s, enjoying the patronage of figures from the world of art and literature; he made studio portraits of them with wet collodion plates and carefully printed them on salted

paper, considered to be a suitable artistic medium among those with refined tastes in such matters (plates 72, 73).[29] Le Gray had established a studio at 35, boulevard des Capucines in 1856 and he, too, sought to reconcile art and commerce, while all the time depending on substantial imperial commissions and on the unprecedented success of his marine views. But Le Gray's venture, like that of Bisson Frères, was destined to fail.

A signal of the radical change in the perception of photography that occurred in France after 1860 must certainly be the petition that circulated in 1862, titled "Objections by the Leading Artists to the Incorporation of Photography into Art"; the painter Jean-Auguste-Dominique Ingres was its most famous signatory.[30] This hostile reaction from the world of art was prompted not by photography itself so much as by the banal ways in which it was being used. After all the stimulating competition, the benevolent curiosity, and the fruitful exchange of the 1840s and 1850s, there emerged a steadfast refusal to broach incorporation of any kind of photography into what was considered to be art. The atmosphere that had characterized the preceding years—the brilliant explosion of works by gifted photographers, the profusion of novel images, the competition between great talents—was quickly forgotten. The extraordinary liberty in the choice of subjects, which went as far as to abandon the subject altogether in favor of a study of form[31]; the framing of the photographic image; the mastery of light and shadow; the exploration of the aesthetic possibilities of series of related images; the obsessive attention lavished on the control of print qualities: these were the foundational elements needed to solidly construct a new art form, and they began to slip away.

Not until the next golden age of French photography—in Paris between the twentieth century's two world wars—would photography be recognized once and for all as an art medium. It can be no coincidence that this was also the moment we began to rediscover these elements of the origins of photography.[32]

NOTES

1. See *Les multiples inventions de la photographie: Colloque de la Direction du patrimoine, Cerisy-la-Salle, 29 septembre–1er octobre 1988* (Paris: Mission de patrimoine photographique, 1989).

2. See Quentin Bajac and Dominique Planchon-de Font-Réaulx, eds., *Le daguerréotype français: Un objet photographique*, exh. cat. (Paris: Réunion des musées nationaux, 2003).

3. Françoise Heilbrun, "Les dessins photogéniques: Les inédits de William Henry Fox Talbot," *Lettre de l'Académie des beaux-arts, Institut de France* 28 (Winter 2002): 6–13; Nancy B. Keeler, "Souvenirs of the Invention of Photography on Paper: Bayard, Talbot, and the Triumph of Negative-Positive Photography," in *Photography: Discovery and Invention; Papers Delivered at a Symposium Celebrating the Invention of Photography* (Malibu: J. Paul Getty Museum, 1990), 47–62.

4. Paris, Collection of the Société française de photographie.

5. See Paul-Louis Roubert, "Le daguerréotype en procès: Le déclin de la pratique du daguerréotype," in Bajac and Planchon-de Font-Réaulx, *Le daguerréotype français*, 191–231.

6. See, for example, Bajac and Planchon-de Font-Réaulx, *Le daguerréotype français*.

7. See, among others, Nicolas le Guern, "Éloge de la simplicité: Adaptation et évolution du calotype en France de Fox Talbot à Le Gray," in *Primitifs de la photographie: Le calotype en France, 1843–1860*, ed. Sylvie Aubenas and Paul-Louis Roubert, exh. cat. (Paris: Gallimard, 2010), 20–33.

8. William Henry Fox Talbot, *The Pencil of Nature* (1844; Project Gutenberg, 2010), 11, http://www.gutenberg.org/files/33447/33447-pdf.pdf.

9. "Rapport sur les dessins produits par le procédé photogénique d'Hippolyte Bayard," *Procès-verbaux de l'Académie des beaux-arts: Tome sixième, 1835–1839* (Paris: École des Chartres, 2003), 521 (meeting of November 2, 1839).

10. Roger Taylor, *Impressed by Light: British Photographs from Paper Negatives, 1840–1860*, exh. cat. (New York: Metropolitan Museum of Art, 2007); *Éloge du négatif: Les débuts de la photographie sur papier en Italie, 1846–1862*, exh. cat. (Paris: Paris musées, 2010); Aubenas and Roubert, *Primitifs de la photographie*.

11. The only serious investigation of Blanquart-Evrard remains that of Isabelle Jammes, *Blanquart-Evrard et les origines de l'édition photographique française: Catalogue raisonné des albums photographiques édités, 1851–1855* (Geneva: Droz, 1981).

12. Talbot's calotype process was protected in France by a ten-year patent, filed August 20, 1841. The rivalry between Talbot and Blanquart-Evrard and the controversies that arose are fully described in the authoritative studies dedicated to these two inventors.

13. Louis Désiré Blanquart-Evrard, *Procédés employés pour obtenir les épreuves de photographie sur papier présentés à l'Académie des sciences* (Paris: Charles Chevalier, 1847).

14. Edmond de Valicourt, *Nouveaux renseignements pratiques sur le procédé de photographie sur papier, de M. Blanquart-Evrard* (Paris: Roret [et al.], 1847).

15. Valicourt, *Nouveaux renseignements pratiques*, 1–2.

16. The word *daguerreotype* should be understood in this context to mean *photograph*. Journal entry, Eugène Delacroix, May 21, 1853, cited in Sylvie Aubenas, "Les albums de nus d'Eugène Delacroix," in *Delacroix et la photographie*, ed. Christophe Leribault, exh. cat. (Paris: Musée du Louvre, 2008), 37.

17. See Elizabeth Anne McCauley, *Industrial Madness: Commercial Photography in Paris, 1848–1871* (New Haven: Yale University Press, 1994).

18. André Jammes and Eugenia Parry Janis, *The Art of French Calotype*, exh. cat. (Princeton: Princeton University Press, 1983).

19. On Le Gray's studio, see Sylvie Aubenas, "Barrière de Clichy: A 'University' of Photography," in *Gustave Le Gray, 1820–1884*, with contributions by Anne Cartier-Bresson et al., ed. Gordon Baldwin, exh. cat. (Los Angeles: J. Paul Getty Museum, 2002), 30–85; Vincent Rouby, "Répertoire biographique des élèves de Gustave Le Gray," in Anne de Mondenard and Marc Pagneux, *Modernisme ou modernité: Les photographes du cercle de Gustave Le Gray*, exh. cat. (Arles: Actes Sud, 2012), 379–91.

20. See Roubert, "Le daguerréotype en procès."

21. On paper photographers in Italy, see *Roma 1850: Il circolo dei pittori fotografi del Caffè Greco / Rome 1850: Le cercle des artistes photographes du Caffè Greco* (Milan: Electa, 2003); *Éloge du négatif* (see note 10 above).

22. Quentin Bajac, "La photographie à Sèvres sous le Second Empire: Du laboratoire au jardin," *48/14: La revue du Musée d'Orsay* 5 (Autumn 1997): 74–85.

23. Gustave Le Gray, "Note sur un nouveau mode de préparation du papier photographique négatif," *Comptes rendus hebdomadaires des séances de l'Académie des sciences* 33 (December 8, 1851): 643–44.

24. Gustave Le Gray, *Nouveau traité théorique et pratique de photographie sur papier et sur verre* (Paris: Lerebours et Secretan, 1851), 160.

25. Ernest Lacan, "IV. Du photographe amateur," *La lumière* 3, no. 9 (February 26, 1853): 6.

26. See the various monographs devoted to these photographers; and Sylvie Aubenas, ed., *Des photographes pour l'empereur: Les albums de Napoléon III*, exh. cat. (Paris: Bibliothèque nationale de France, 2004).

27. Marc Pagneux, "Adrien Tournachon, ou un Nadar peut en cacher un autre," in Mondenard and Pagneux, *Modernisme ou modernité*, 347–57.

28. McCauley, "Nadar and the Selling of Bohemia," in *Industrial Madness*, 105–48.

29. On Nadar, see Maria Morris Hambourg, Françoise Heilbrun, and Philippe Néagu, eds., *Nadar,* with contributions by Sylvie Aubenas et al., exh. cat. (New York: Metropolitan Museum of Art, 1995).

30. Cited in L. Sassère, "Code des photographes," *Le moniteur de la photographie* 19 (December 15, 1862): 149–51.

31. See Anne de Mondenard, "Le Gray et ses élèves: Une école de l'abandon du sujet," *48/14: La revue du Musée d'Orsay* 16 (Spring 2003): 64–73.

32. See Quentin Bajac, "Nouvelle vision, ancienne photographie," *48/14: La revue du Musée d'Orsay* 16 (Spring 2003): 74–83.

The Art and Science of the Paper Negative

Sarah Freeman

he paper negative (fig. 44) played a pivotal role, during its short history, in the establishment of the medium of photography as it became one of the most widely used technologies in the world. One of the earliest concerns that guided the development of photography on paper was the quest for image permanence. Among several factors that contributed to the continued use of paper negatives were the type of chemical formulation, the stabilization techniques, the quality of the paper, and the hand of the photographer. This essay will highlight the work of three innovators of the negative-positive technique, William Henry Fox Talbot (1800–1877), Louis Désiré Blanquart-Evrard (1802–1872), and Gustave Le Gray (1820–1884), whose contributions to darkroom processing and materials solidified the commercialization and widespread use of photography.

The history of the French paper negative is an important component of *Real/Ideal: Photography in Mid-Nineteenth-Century France*. To complement the exhibition and to increase our knowledge of the material nature of paper negatives, close examination of these objects using high-resolution digital imaging, microscopy, and noninvasive scientific analysis was conducted. Sixteen negatives created by comte Jean-François-Charles-André Flachéron (1813–1883), Baron Louis-Adolphe Humbert de Molard (1800–1874), Henri Le Secq (1818–1882), Charles Nègre (1820–1880), Henri-Victor Regnault (1810–1878), and Louis-Rémy Robert (1811–1882) in the J. Paul Getty Museum's collection were examined in collaboration with the Getty Conservation Institute. The findings are described below, including a summary of the materials and associated condition issues of negatives, as well as examples of early preservation measures and current conservation practice.

Three Major Innovations in Photography Using Paper Negatives

The first negative-positive practice in photography, on which all darkroom photographic processes are based, was invented by the English scientist William Henry Fox Talbot. Announced in 1841, his calotype-negative process (fig. 45),[1] from which multiple positive prints could be made, impressed those of his colleagues interested in realism and reproducibility. Talbot's process can be described in the following simplified set of actions: preparing the paper for the negative with silver halide chemistry; exposing the sensitized paper negative in the camera and processing it chemically; and using the calotype negative to make a positive image on paper by exposing another sheet of sensitized paper in sunlight and stabilizing the image in a salt solution. See table 1 for more details of Talbot's process.

Because Talbot had experienced difficulties with competitors over his prior discovery of the photogenic drawing, he felt protective of his new calotype invention. He quickly followed its announcement with a restrictive patent.[2] Despite these limitations, some members of scientific and artistic circles in France learned the calotype process. The technique slowly gained prominence as an art form in the 1850s, and practitioners added their own personal adaptations; this was particularly true of Talbot's contemporaries Louis Désiré Blanquart-Evrard and Gustave Le Gray. Each was very influential in the advancement of photography in France, having experimented with silver halide chemistry, papers, and finishing techniques in order to develop his own aesthetic.

Blanquart-Evrard is believed to have learned Talbot's technique from one of his followers soon after Talbot made demonstrations in Paris.[3] His preliminary modifications of Talbot's calotype process led to significant improvements in the technique, which Blanquart-Evrard

Table 1. Talbot's three-step calotype process

Step One	Step Two	Step Three
Prepare the calotype paper	Make the calotype negative	Make salt prints
1 Select good-quality writing paper and coat by brush with silver nitrate solution on one side; allow to dry by candlelight or in the dark.	**1** Place the sensitized paper into the camera obscura facing the lens, and expose to light for approximately one minute. (This is one hundred times faster than the photogenic drawing technique.)	**1** Place the sensitized paper in direct contact with the negative and expose it to intense sunlight.
2 Dip the paper in a solution of potassium iodide, rinse with water, and then dry by firelight or air-dry; keep in a drawer until ready to use.	**2** Take the paper from the camera, dip the sheet in a solution of gallo-nitrate of silver, and watch the latent image develop to desired darkness.	**2** Process the exposed paper by immersing it in a salt solution such as sodium chloride, then rinse in water.
3 Take the previously iodized paper and apply a solution of gallo-nitrate of silver (a mixture of concentrated silver nitrate, acetic acid, and gallic acid) to the previously coated side of the paper by candlelight.	**3** Fix the negative image by dipping the paper in a solution of potassium bromide, and rinse in water.	
4 Rinse the sensitized paper (light-sensitive photographic paper) in water and dry by candlelight or in the dark.	**4** Dry completely and then use the calotype negative to create multiples.	
5 Use the calotype paper immediately, while still moist, or when completely dry, but very soon after it's made.		

Source: William Henry Fox Talbot, "An Account of Some Recent Improvements in Photography," *Proceedings of the Royal Society* 4, no. 48 (1841): 312–16.

first presented in 1847.[4] Blanquart-Evrard reduced the exposure time for both the negative and the positive prints from several hours or minutes to just a few minutes or even seconds. He achieved this by keeping the sensitized negative paper moist during both exposure in the camera and the printing process. The paper was initially floated in an iodide salt solution, then laid on a glass plate that was already coated with a silver nitrate solution. The newly sensitized wet paper was backed with a second sheet of damp paper and a second sheet of glass to preserve wetness during exposure. This glass sandwich was inserted directly into the camera for exposure. Blanquart-Evrard's "wet" process also allowed for improved working conditions for photographers in the field. If the paper was kept moist, it could remain sensitive for a full day, which permitted traveling photographers to expose the papers on-site and develop prints later in the studio.

In addition to reducing the exposure time, Blanquart-Evrard created faster processing times for positive prints by altering the darkroom chemistry. He developed the exposed positive papers in a solution of concentrated gallic acid (in place of gallo-nitrate of silver, which was introduced by Talbot to the calotype process). This cut the development time of the latent image to just seconds, allowing for greater numbers of reproductions to be made from each negative. He also gave recommendations about varying the strength of the sensitizer to create a pictorial effect (a concept well understood by formally educated artists at that time) in which the subject is depicted with the same soft lines and opposing shadows, and the same broad tonal variations, that were achieved in painting.[5] Blanquart-Evrard's new variations of the salted paper print were different in tonality from Talbot's calotypes, and

they were not as vulnerable to fading. This greater image stability, which was recognized at the time, is still evident in examples today; a salted paper print in the *Real/Ideal* exhibition that was made at Blanquart-Evrard's studio in 1853, from a negative created by Le Secq in 1851, shows minimal fading (plate 58).

In 1850, a year before Blanquart-Evrard opened his printing company, the Imprimerie photographique studio, Gustave Le Gray presented his treatise on the "dry waxed-paper negative process."[6] Le Gray's modification of Talbot's calotype process (Le Gray appears to have learned the calotype technique independently of Blanquart-Evrard) included preparing the paper negative by coating the sheet entirely with wax before sensitizing it with salt and silver nitrate solutions. The wax-impregnated paper could be prepared in advance and stored dry until sensitization. Although wax added a smooth, transparent quality to the paper, its impermeable nature prevented the sensitizer solution from evenly coating the paper surface. Le Gray added an organic binder such as egg albumen or isinglass (fish glue) to the sensitizer solution to aid in the adhesion of the silver halide layer to the waxed surface. Le Gray's method was considered a major improvement to the paper-negative process because it further increased the fine detail and tonal range captured in the negative and reproduced in the final print.

The innovations of Talbot, Blanquart-Evrard, and Le Gray described here, and subsequent discoveries by them, changed the direction and meaning of photography at that moment. The ability of the photographer to create multiple images quickly, with greater detail and in varied compositions, fueled the desire for even more improved photographic technologies, which quickly surpassed the paper negative. Blanquart-Evrard and Le Gray remained influential in French photography, motivated to further develop and master the use of albumen silver papers and glass-plate negatives in their work. Paper negatives remained a preferred choice over glass plates for some photographers, but by 1860 paper negatives fell into obscurity as reliance on glass-plate negatives grew with the rise of commercial photography.

The Materials of Paper Negatives

PAPER

The papers used in early photography were primarily writing papers made from vegetable fibers (fig. 46). They were typically thin, small, semitransparent, and slightly textured. In the early 1850s, paper manufacturers responded to the new medium of photography by making

Fig. 46.
Detail of figure 44. Micrograph. A closer look at 50× magnification reveals a one-layer structure of silver particles embedded in the top layer of the paper fibers of the primary paper support.

Figs. 47a, 47b.
Henri Le Secq, *South Porch, Central Portal, Left Jamb with Saints Matthew, Thomas, Philip, Andrew, and Peter, Chartres Cathedral*, 1852 (details, plate 14). Detail in transmitted illumination illustrating high contrast in the negative (a) and digitally created positive of the negative image (b)

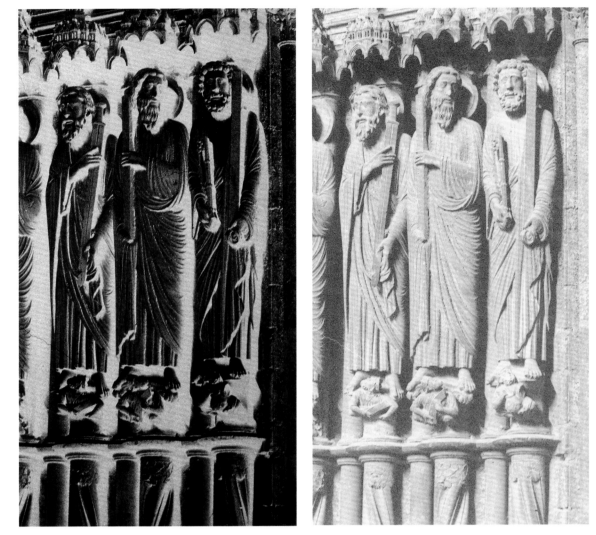

commercial papers specifically formulated for paper negatives, with variations in color, texture, additives, and thickness. The papers and the effects each could bring to the final image are described in, among other sources, Thomas Sutton's handbook *The Calotype Process* (1855), which summarizes the effect thickness and sizing of the papers had on the grain and density of the image.[7] Henri Le Secq, an expert in the representation of architectural subjects, specifically chose papers that would provide greater density and allow for higher contrast. He often used long exposures to capture his sculptural forms accentuated with dark shadows (figs. 47a, 47b).

Making manufacturing distinctions among nineteenth-century papers today is difficult. In order to distinguish papers, manufacturers often used proprietary watermarks. Watermarks were usually trimmed in preparation for making photographs since they could interfere with the final image, but some examples survive. A watermark from the J. Whatman Turkey Mill, a British paper manufacturer, is found in a negative by Henri-Victor Regnault (fig. 48). This object also contains an additive called smalt (figs. 49a, 49b). Smalt (blue glass) was historically used as a "bluing agent" to brighten paper. The chemical elements arsenic and cobalt, indicators for smalt, were found with a noninvasive analytical technique called X-ray fluorescence spectroscopy (XRF)[8] and microscopy in four of the Getty collection negatives. The differences between English and French papers in the context of photography

Fig. 48.
Henri-Victor Regnault, *Sèvres and Environs: River Landscape with Boat*, 1852 (detail, plate 3). Detail in transmitted illumination showing J. Whatman Turkey Mill watermark

were well known to photographers.[9] For instance, French papers were sized with starch and did not yield the red-toned images created from gelatin-sized English papers.[10]

COATINGS

Equal in importance to the paper were the coatings added to the negative during preparation or after processing. Wax alone was the most common choice for coating negatives, but admixtures with resins and varnishes were also used.[11] The purpose of wax coatings was twofold: to impart transparency, allowing for more detail and clarity in the final positive image, and to protect the paper during repeated use in a wet environment. Beeswax, which typically appears pale yellow to amber in color, and paraffin wax, which is white when fresh, were two common coating choices.[12] Wax-application techniques were widely published in a variety of sources. There were several methods used to apply wax to negative paper, either before or after processing: wax was heated with lamps or metal plates; papers could be immersed in a bath of molten wax; wax layers could be spread with an iron and blotter paper or with a variety of stacking techniques that allowed the wax to penetrate the paper. Wax coatings used in the Le Gray wax process (prior to processing) were prepared with additional coatings of binders such as albumen to encourage even coating of the sensitizer solutions. Wax applied after processing included admixtures of resins and varnishes in solvent solutions that were brush-applied to protect the negative.[13]

Attenuated total reflectance Fourier transform infrared spectroscopy (ATR-FTIR)[14] is a noninvasive technique that is often useful in detecting coatings. However, the thinness

Figs. 51, 51a.
Henri-Victor Regnault, *Sèvres and Environs: River Landscape with Boat,* 1852 (plate 3). Overall and micrograph at 20x magnification in reflected illumination showing pencil marks to correct the negative

Figs. 52, 52a, 52b.
Charles Nègre, *Tarascon,* 1852 (details, plate 15). Details in raking illumination showing selectively applied pigment to enhance the skyline (a) and digitally created positive of the negative image (b)

of coatings on paper negatives can be a limitation with this form of analysis. Of the Getty Museum's negatives analyzed, only two contain beeswax[15] detectable with ATR-FTIR, despite the visual certainty that the other negatives, too, are coated (fig. 50). Other techniques are available for identification of coatings, but they require taking a sample.[16] Because wax can so effectively saturate the paper, it is difficult to assess whether wax has been applied before or after exposure.

FINISHING TECHNIQUES

Besides making deliberate choices of paper and coatings for negatives, photographers employed several finishing techniques to enhance the final image. Fine pencil lines were often used to fill in irregularities or to highlight details of the composition. For example, pencil lines were applied to correct areas of uneven density in the negative of Henri-Victor Regnault's *Sèvres and Environs: River Landscape with Boat* (figs. 51, 51a). Capturing the landscape without overexposing in daylight sun was challenging. Often, brush-applied washes of graphite, gouache, or pigment were added to increase depth and form, to create clouds and increase the midtone density in an otherwise overexposed skyline.[17] Charles Nègre used two colors, combined with deliberate brushstrokes, to create cloud forms, adding depth and dimension to the composition of *Tarascon* (figs. 52, 52a, 52b). Other finishing techniques such as masking tissues of different colors were utilized to create skylines or backgrounds.

AGING IN PAPER NEGATIVES

Issues of image fading in paper negatives and salted paper prints were of concern from the start. The focus in the historical literature is primarily on the final positive prints made from paper negatives, but Talbot acknowledged as early as 1841 in his notebook *Q*, which details his experiments with calotypes, that negatives stabilized with potassium iodide or bromide were prone to fading with repeated exposure to sunlight.[18] Differences in the physical chemistry of the negative and the positive salted paper print suggest that negatives were less vulnerable to fading from light exposure and to deterioration from air pollution and humidity. Larger silver particles are more stable chemically and therefore expected to be more resistant to deterioration such as fading. The silver particles that were created by "printing out"

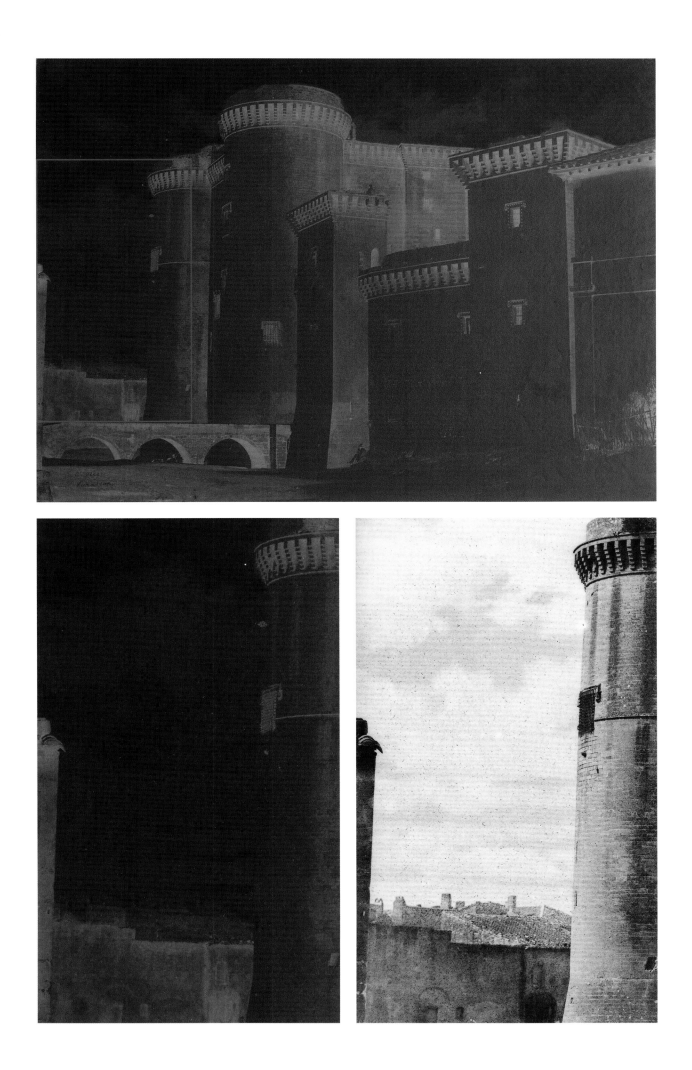

Figs. 53a, 53b.
Henri-Victor Regnault, *Sèvres and Environs: River Landscape*, 1852 (plate 3). In transmitted and reflected illumination. Darkening, staining, and tears that are nearly invisible in transmitted illumination (a) are visible in reflected illumination (b).

(developing in sunlight) were much smaller than the silver particles that were chemically reduced (developed out in the darkroom).[19]

To combat fading, some photographers began using a more permanent fixer in the 1840s called hyposulfite of soda (or sodium thiosulphate, commonly called hypo), which Talbot included in his revised patent in 1843.[20] The use of hypo[21] was somewhat controversial at first, because it could cause rapid fading if the print was not rinsed properly.[22] This added stage of fixing with hypo altered the tone of the image from red-brown to yellow-brown, which may have deterred some photographers from using it. Hypo eventually became the standard fixer used to ensure the stability and permanence of photographs, and it remains an essential component of silver halide processing today.

A second preservation technique was suggested in 1847 by P.-F. Mathieu, who described the use of gold toning, a step borrowed from daguerreotypists.[23] Gold was employed to replace some silver in the image-forming layer, to modify the tonality and to stabilize the image. Toning was slow to be accepted but became popular after 1850, when it was encouraged as a preservation measure by Le Gray. The use of gold toning was further accepted following reports by the Fading Committee in England and by Louis-Alphonse Davanne (1824–1912) and Jules Girard in Paris, both published in 1855.[24]

Even if paper negatives were less vulnerable than early prints, the fading of negatives has been a cause for concern. Coated negatives typically darkened and became embrittled over time, from cumulative exposure to air pollutants, humidity, and light, and they were vulnerable to physical damage, such as creases and tears from handling. Darkening is well documented as the result of the aging of the organic compounds in the coatings. In addition, some papers, which are composed primarily of cellulose, become more acidic, causing them to become embrittled and to break. Physical damages can be highly visible in reflected illumination, but may be nearly undetectable when illuminated with transmitted light (figs. 53a, 53b). Physical damage that resulted from handling is likely the main reason so few examples have survived.[25]

CONSERVATION OF PAPER NEGATIVES

Our understanding of the fragility of paper negatives and their inherent vulnerability to light damage mandates careful consideration of display and accessibility to the public. Until recently, the display of paper negatives has occurred infrequently, in large part owing to a lack of scientific research on light damage and deterioration of paper artifacts. Negatives should not be displayed without a careful choice of the illumination source (either transmitted or reflected). Case design should provide minimal light exposure yet allow for an optimal view.[26] Control of the specific light-color temperature, with filtration of ultraviolet radiation, reduction of light intensity, and avoidance of excessive heat, is critical in the safe display of waxed materials. Ideally, environmental monitors should be in place for each object to ensure that consistency and appropriate temperature and humidity levels are maintained during display.

One technique that can aid in the decision whether to display photographic materials is microfade testing,[27] a noninvasive form of analysis that can show differences in the light stability of many photographic materials and can be used to predictively measure change before display begins. The sixteen negatives from the Getty Museum's collection were analyzed for light stability with the technique. Three of the negatives tested within the highest sensitivity rating, making them ineligible for display in the *Real/Ideal* exhibition. These objects were also analyzed with XRF, and iodine and bromine were detected in all three, though not found in the negatives with good stability ratings. Iodine and bromine are used during the creation of the image, but should no longer be present after proper processing. Silver iodide is very light sensitive and will darken upon exposure to light, if not properly stabilized. The combined results of microfade testing and XRF analysis suggest that three unstable Getty negatives will darken with light exposure, owing to incomplete processing.

The conservator's role in safeguarding these fragile and unique objects is not only to monitor display and storage environments but also to work closely with art historians, imaging technicians, and scientists to better characterize these objects so that they can be accessible to broader audiences. Museums working with new digital formats can provide access to researchers and the public online and with interactive programs in the galleries. Through careful and measured preservation practices, paper negatives can be conserved for future generations.

NOTES

1. William Henry Fox Talbot, "An Account of Some Recent Improvements in Photography," *Proceedings of the Royal Society* 4, no. 48 (1841): 312–16.

2. William Henry Fox Talbot, Photographic pictures, British Patent 8442, filed February 8, 1841, and issued September 29, 1841. Talbot filed another patent in 1843 (see note 20 below).

3. Isabelle Jammes, "Louis-Désiré Blanquart-Evrard, 1802–1872," *Camera* 57, no. 12 (1978): 4–42.

4. Louis Désiré Blanquart-Évrard, *Procédés employés pour obtenir les épreuves de photographie sur papier* (Paris: C. Chevalier, 1847).

5. James Borcoman, *19th-Century French Photographs from the National Gallery of Canada*, exh. cat. (Ottawa: National Gallery of Canada, 2010), 20.

6. Gustave Le Gray, *Nouveau traité théorique et pratique de photographie sur papier et sur verre* (Paris: Lerebours et Secretan, 1851), translated as *Dry Waxed Paper Negative Process of Le Gray*, in André Jammes and Eugenia Parry Janis, *The Art of French Calotype*, exh. cat. (Princeton: Princeton University Press, 1983), 259–62. This is the second edition of Le Gray's 1850 treatise.

7. Thomas Sutton, *The Calotype Process: A Hand Book to Photography on Paper* (New York: H. H. Snelling, 1856), 44–45. The book was first published in London in 1855.

8. X-ray fluorescence spectroscopy (XRF) is a form of elemental analysis. X-rays cause the ejection of inner shell electrons from an atom; when other electrons drop down to fill this vacancy they emit a secondary (fluorescence) X-ray with an energy equal to this transition and unique to a particular element; the secondary (fluorescence) energy can be measured; elements can be identified based on the secondary energy level. This helps identify the photographic medium and components such as additives in the paper.

9. Robert Hunt, *A Popular Treatise on the Art of Photography, Including Daguerréotype, and All the New Methods of Producing Pictures by the Chemical Agency of Light. . . .* (Glasgow: Griffin, 1841), 7–9.

10. James M. Reilly, *The Albumen & Salted Paper Book: The History and Practice of Photographic Printing, 1840–1895*, 2nd ed. (Rochester, NY: Cary Graphics Arts Press, 2012), 21.

11. Lee Ann Daffner, "Coatings on Paper Negatives," in *Coatings on Photographs: Materials, Techniques, and Conservation*, ed. Constance McCabe (Washington, DC: American Institute for Conservation, 2005), 66–77.

12. Katherine Jennings, Jiuan-jiuan Chen, and Gary E. Albright, "The Treatment of Wax-Impregnated Paper Negatives," in McCabe, *Coatings on Photographs*, 255–57.

13. Daffner, "Coatings on Paper Negatives," 70.

14. Attenuated total reflectance is a sampling technique used in combination with Fourier transform infrared spectroscopy whereby a beam of infrared radiation is focused onto the surface of a material, some of which is absorbed by the sample and some of which is reflected. The reflected radiation can be measured and illustrated graphically. The absorption at a particular wavelength can correspond to particular functional groups in organic molecules. This technique can be useful in identifying compounds such as waxes.

15. Jennings, Chen, and Albright, "The Treatment of Wax-Impregnated Paper Negatives," 255–57.

16. Lee Ann Daffner, "'A 'Transparent Atmosphere': The Paper Negatives of Frédéric Flachéron in the Harrison D. Horblit Collection," *Journal of the American Institute for Conservation* 42, no. 3 (Autumn–Winter 2003): 425–39.

17. James Borcoman, *Charles Nègre, 1820–1880*, exh. cat. (Ottawa: National Gallery of Canada, 1976), 22.

18. Mike Ware, *Mechanisms of Image Deterioration in Early Photographs: The Sensitivity to Light of W.H.F. Talbot's Halide-fixed Images, 1834–1844* (London: Science Museum and National Museum of Photography, Film & Television, 1994), 33.

19. Ibid., 19–20.

20. William Henry Fox Talbot, Modifications to the calotype process, British Patent 9573, filed June 1, 1843, and issued December 1, 1843.

21. In 1839, Sir John Herschel (1792–1871) presented to the Royal Society the use of hyposulfite of soda to fix images, in a paper entitled "Note on the Art of Photography, or The Application of the Chemical Rays of Light to the Purpose of Pictorial Representation," but hypo was initially ignored by most practitioners.

22. Helmut Gernsheim, *The Origins of Photography*, rev. 3rd ed. (New York: Thames and Hudson, 1982), 207.

23. P.-F. Mathieu, *Auto-Photographie, ou Méthode de reproduction par la lumière des dessins, lithographies, gravures, etc., sans l'emploi du daguerréotype* (Paris: Imprimerie de bureau, 1847), 14.

24. Philip H. Delamotte et al., "First Report of the Committee Appointed to Take into Consideration the Question of Fading of Positive Photographic Pictures upon Paper (1855)," in *Issues in the Conservation of Photographs*, eds. Debra Hess Norris and Jennifer Jae Gutierrez (Los Angeles: Getty Conservation Institute, 2010), 112–15; Louis-Alphonse Davanne and Jules Girard, "Photographic Journal, 2, 202," *Journal of the Photographic Society* 36 (November 1855): 251–52.

25. Daffner, "A Transparent Atmosphere."

26. Marsha Sirven, "L'intégration de la conservation préventive dans l'exposition 'Rome 1850, le cercle des artistes photographes du Caffè Greco,'" *Support/Tracé* 7 (2007): 37–43.

27. Microfade testing is an accelerated light fading test. A small area of the image is exposed to intense light; the rate of change (fading and color shift) is measured over time. Computer software predicts the rate of sensitivity mathematically. See S. Freeman et al., "Monitoring Photographic Materials with a Microfade Tester," in *ICOM-CC: 17th Triennial Conference Preprints, Melbourne, 15–19 September 2014*, ed. Janet Bridgland, paper 1402.

NEGATIVES

The human soul . . . has still greater need of the ideal
than of the real. It is by the real that we exist; it is by the
ideal that we live.

VICTOR HUGO
William Shakespeare (1864)

1

Reverend Calvert Jones
Combe Martin Bay, Devonshire, 1846
Paper negative with applied ink

2

Attributed to Henri-Victor Regnault
Rooftops at Sèvres, early 1850s
Waxed-paper negative

3

Henri-Victor Regnault
Sèvres and Environs: River Landscape with Boat, 1853
Waxed-paper negative

4

Henri-Victor Regnault
River Landscape, ca. 1853
Waxed-paper negative

5

Baron Louis-Adolphe Humbert de Molard
Two Men and a Girl Seated under a Trellis, ca. 1848
Calotype negative

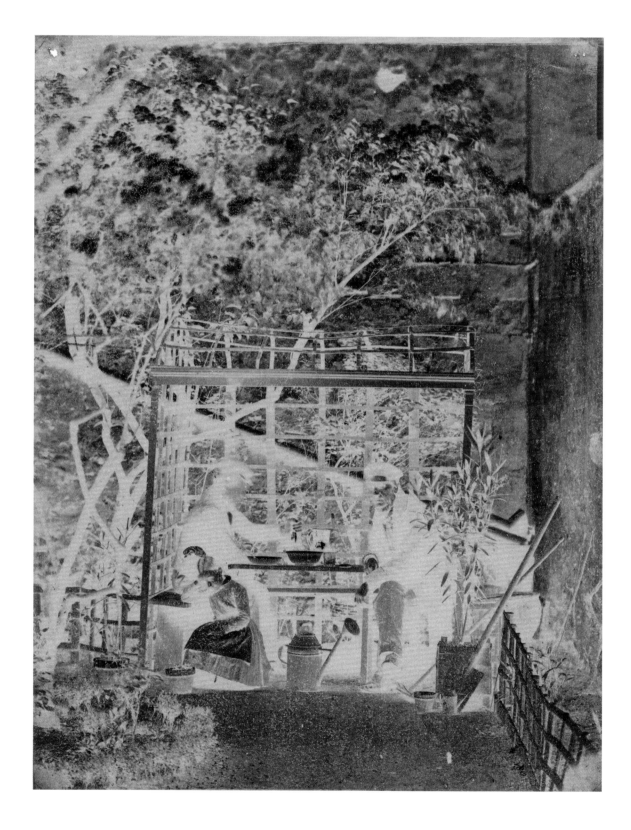

6

Louis-Rémy Robert
Plow, ca. 1852
Waxed-paper negative

7

Louis-Rémy Robert
Four Statues at Versailles, early 1850s
Waxed-paper negative

8

Comte Jean-François-Charles-André Flachéron
Colosseum, 1850
Salted paper print

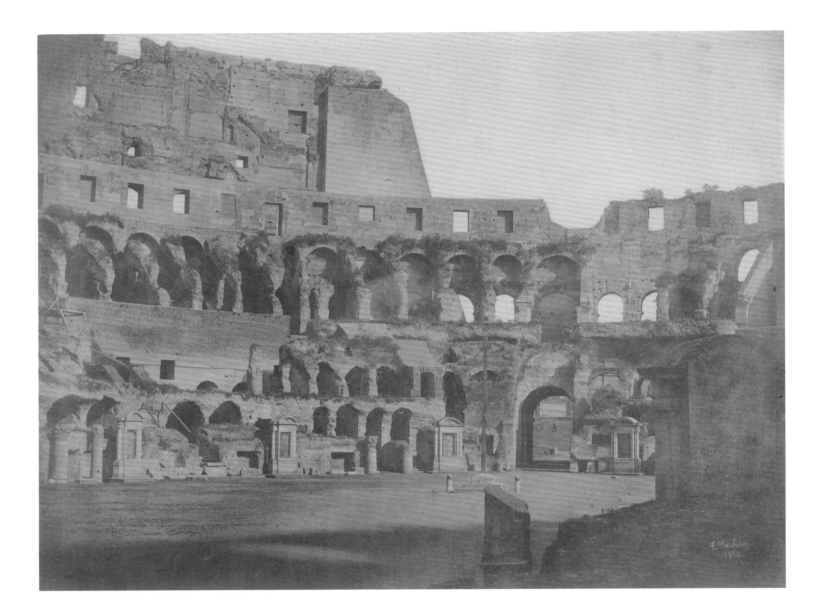

9

Comte Jean-François-Charles-André Flachéron
Colosseum, 1850
Waxed-paper negative

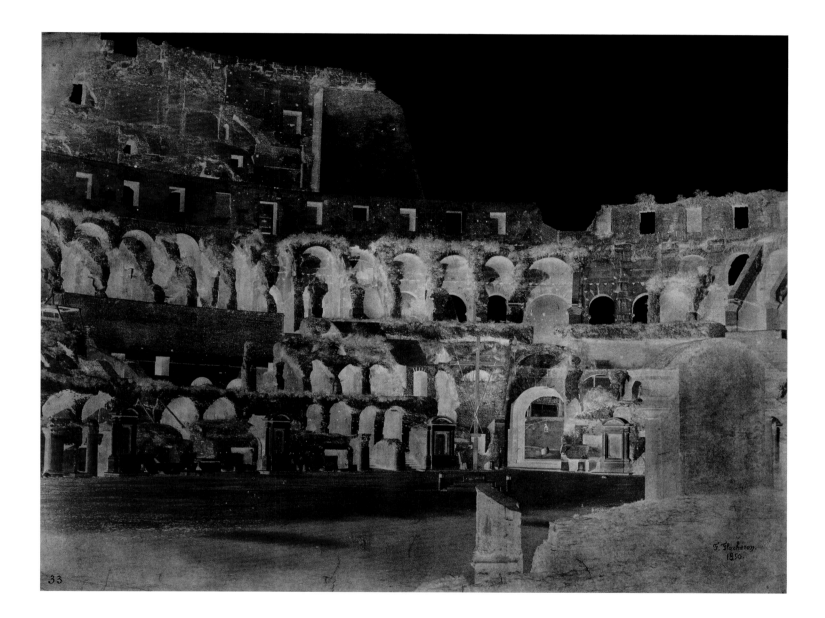

10

Charles Nègre
Plaster Cast of Venus de Milo, ca. 1849
Salted paper print

11

Charles Nègre
Plaster Cast of Venus de Milo, ca. 1849
Waxed-paper negative

12

Édouard Baldus
Arles (Bouches-du-Rhône)—Amphitheater, Interior View, 1851
Paper negatives

13

Gustave Le Gray and Auguste Mestral
Tours (Indre-et-Loire)—West Facade, Cathedral of Saint-Gatien, 1851
Negative on dry waxed paper

7487 TOURS (Indre-et-Loire). — Cathédrale, ensemble ouest

14

Henri Le Secq
South Porch, Central Portal, Left Jamb with Saints Matthew, Thomas,
Philip, Andrew, and Peter, Chartres Cathedral, 1852
Waxed-paper negative

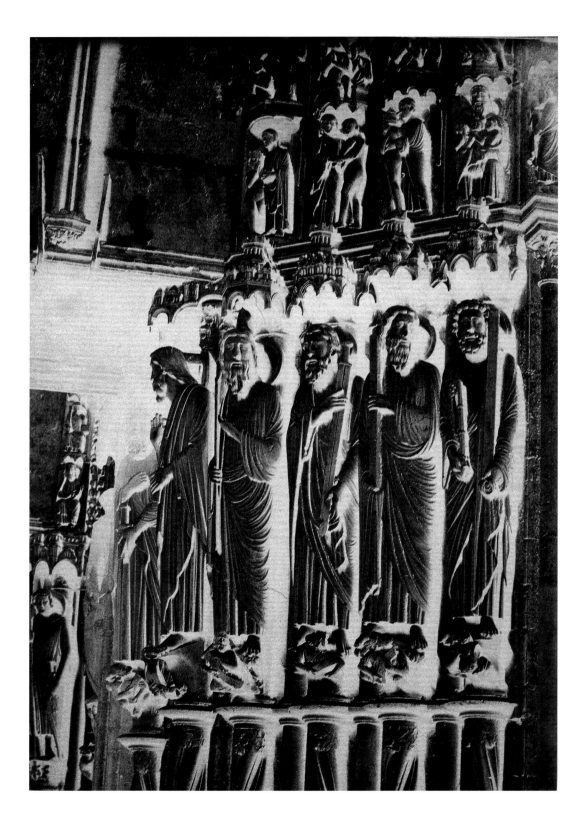

15

Charles Nègre
Tarascon, 1852
Waxed-paper negative with selectively applied pigment

Henri Le Secq
Jug, Pipe, and Mugs, ca. 1855
Waxed-paper negative

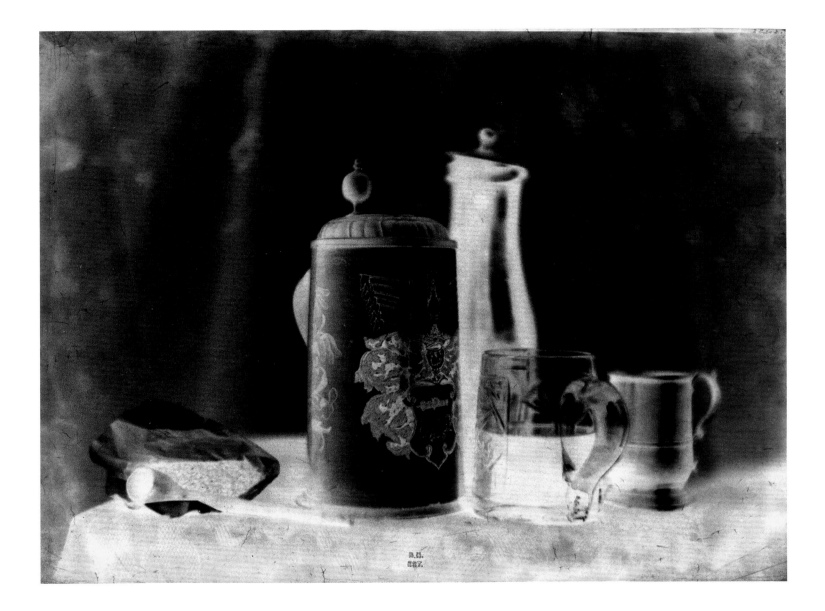

17

Henri Le Secq
Smoked Herring, ca. 1855
Waxed-paper negative

18

Attributed to Henri Le Secq
Sailboats Docked at the Port of Dieppe, France, ca. 1852–55
Waxed-paper negative

Charles Nègre
Saint-Honorat des Alyscamps, Arles, 1852
Waxed-paper negative

Charles Nègre
Saint-Gilles, 1852
Salted paper print

Charles Nègre
Saint-Gilles, 1852
Waxed-paper negative with selectively applied pigment

Gustave Le Gray
Pavillon Rohan, the Louvre, Paris, ca. 1857–59
Albumen silver print

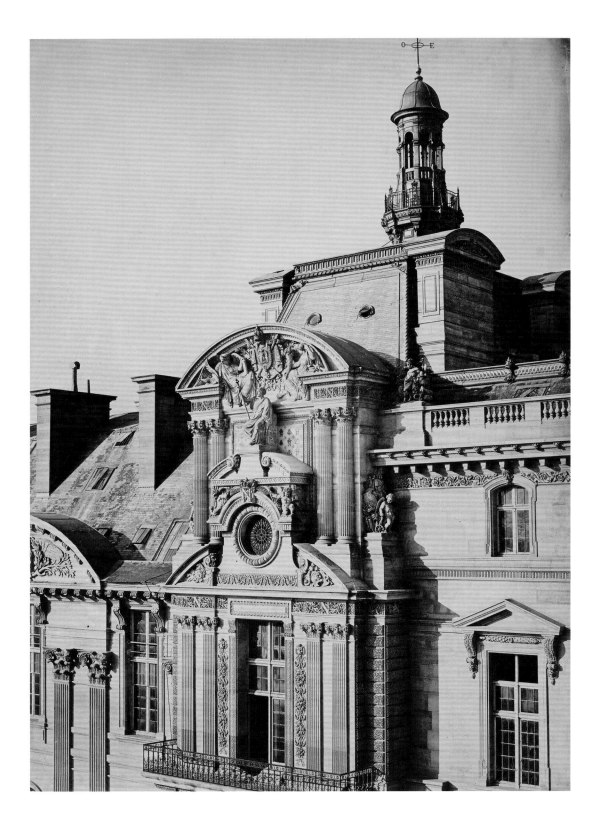

23

Gustave Le Gray
Pavillon Rohan, the Louvre, Paris, ca. 1859
Collodion-on-glass negative

24

Charles Nègre
Notre-Dame, Paris, ca. 1853
Salted paper print

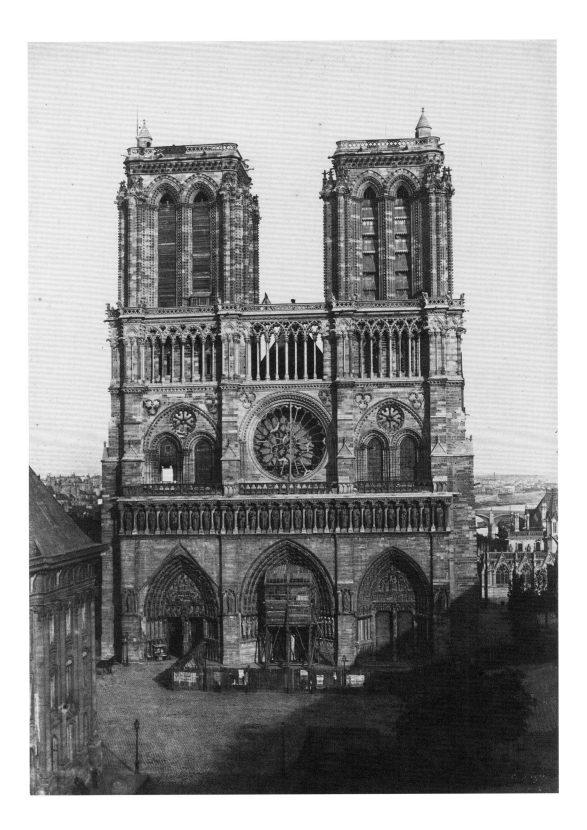

Charles Nègre
Notre-Dame, Paris, ca. 1853
Waxed-paper negative

John Beasly Greene
Tree at the Side of a Road, 1850s
Waxed-paper negative

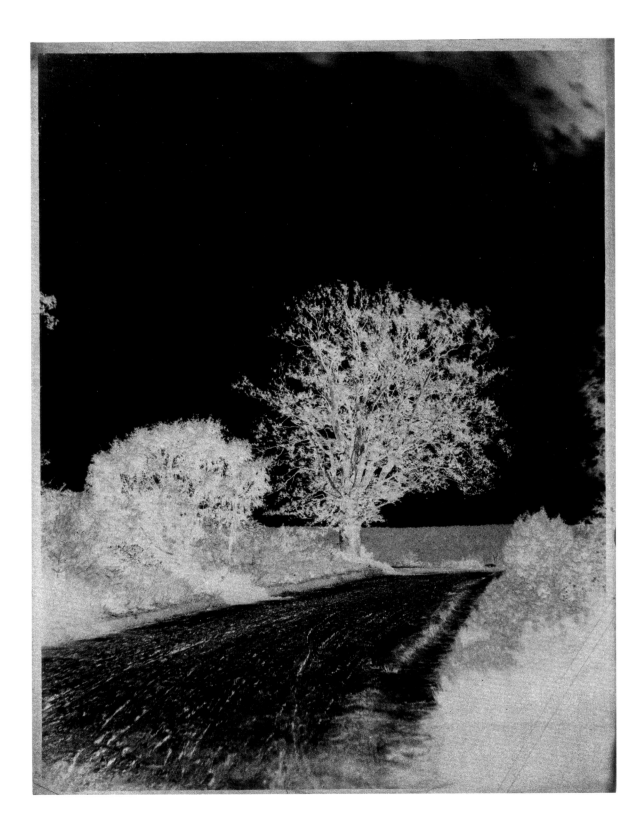

PRINTS

The entire future of photography is on paper.

GUSTAVE LE GRAY
Traité pratique de photographie sur papier et sur verre (1850)

27

Hippolyte Bayard
Chair and Watering Can in a Garden, ca. 1843–47
Salted paper print

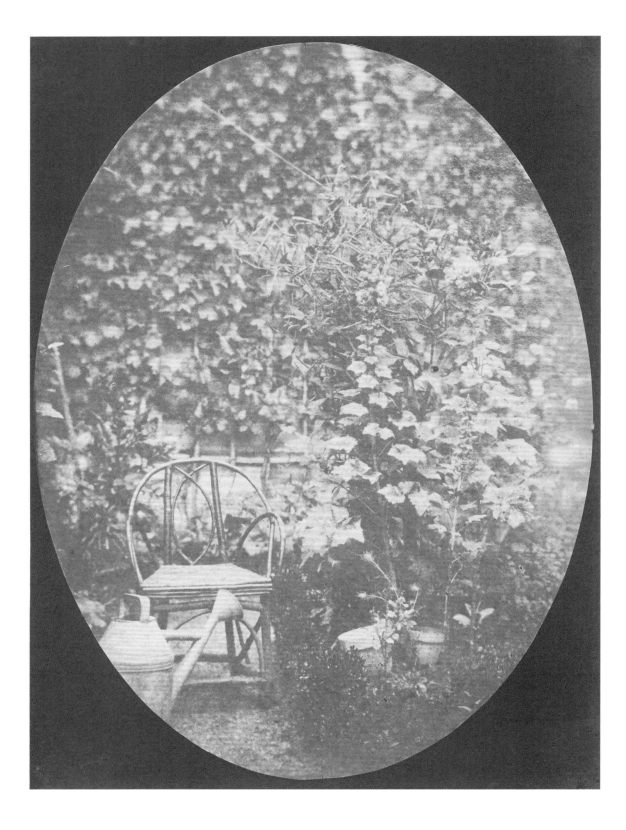

28

Hippolyte Bayard
Self-Portrait Seated in a Garden, ca. 1843–47
Salted paper print

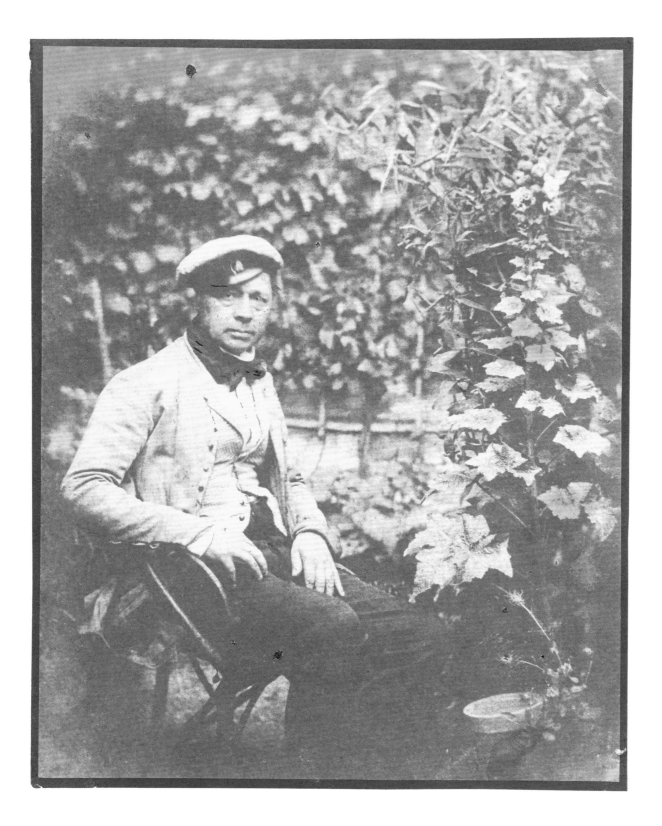

29

Unknown French photographer
The Barrière de Clichy
from in Front of Le Gray's Studio, 1852–55
Salted paper print

Unknown French photographer
Vicomte Odet de Montault, 1852–55
Salted paper print

30

Unknown French photographer
Madame the Vicomtesse de Montbreton, 1852–55
Salted paper print

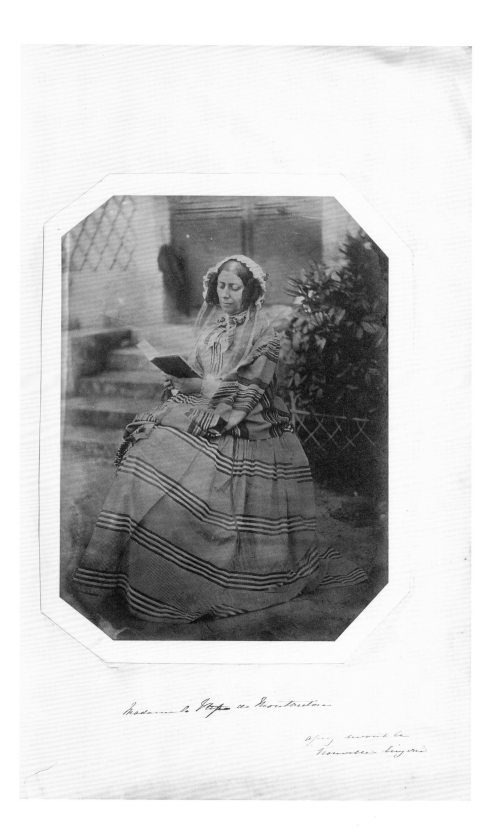

If you are a poet, if you love the grand aspects of nature . . .
follow Monsieur Baldus through the grandiose sites of the Auvergne.

ERNEST LACAN
"De la photographie et ses diverses applications aux beaux-arts et aux sciences," *La lumière* (1855)

Gustave Le Gray and Auguste Mestral
West Facade, Church of Saint-Jacques, Aubeterre, 1851
Salted paper print

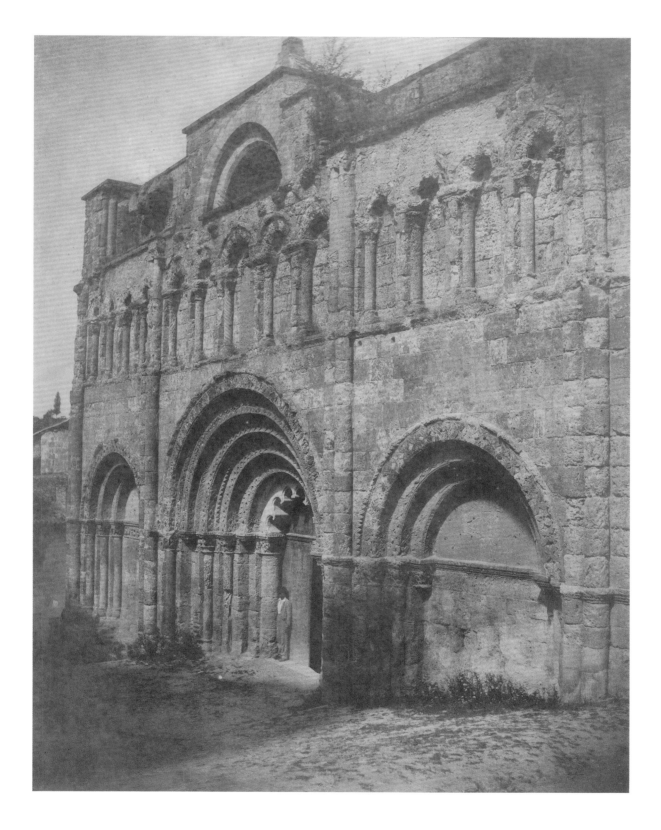

32

Gustave Le Gray and Auguste Mestral
End Pavilion of the Château de Chenonceaux, 1851
Salted paper print

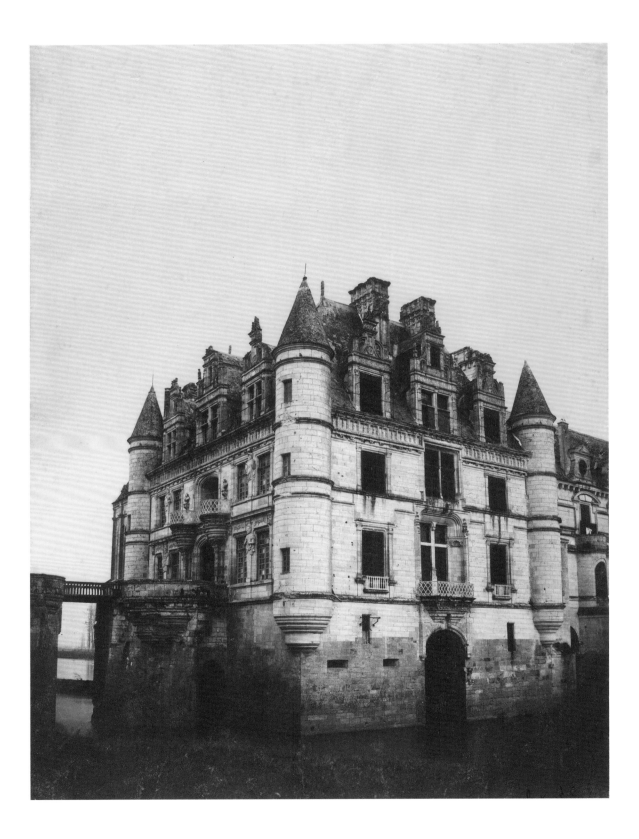

33

Henri Le Secq
Tower of the Kings at Reims Cathedral, ca. 1853
Salted paper print

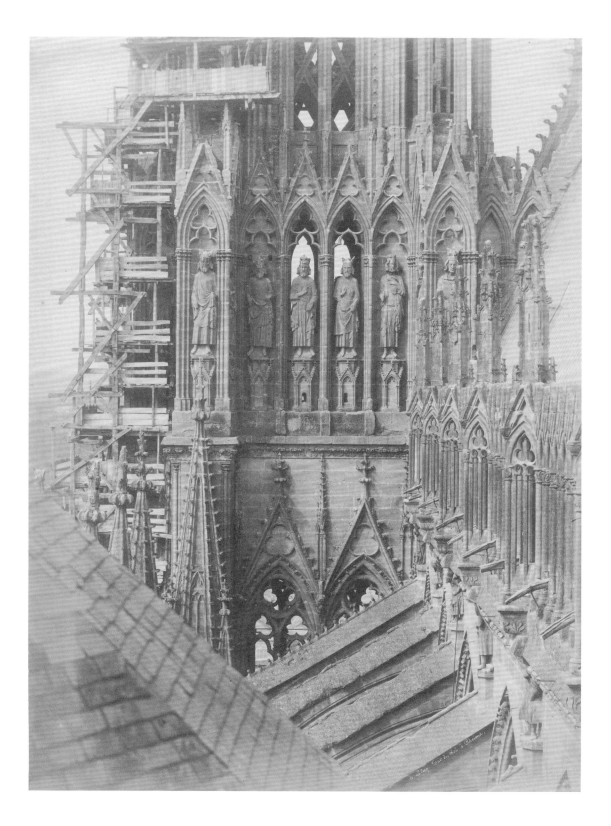

34

Henri Le Secq
Strasbourg (Bas-Rhin), Cathedral of Notre-Dame, 1851
Waxed salted paper print

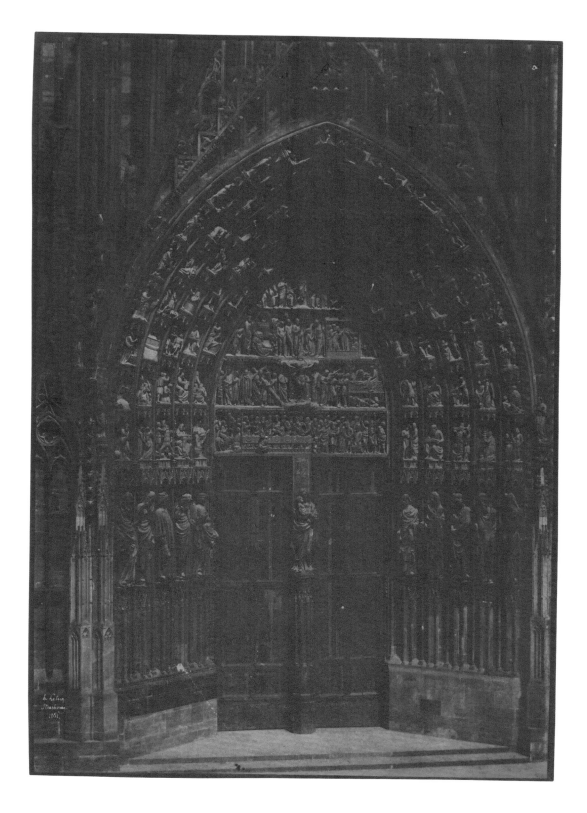

35

Bisson Frères
Amiens Cathedral, Main Facade, Portal of the Virgin Mary, 1850s
Albumen silver print

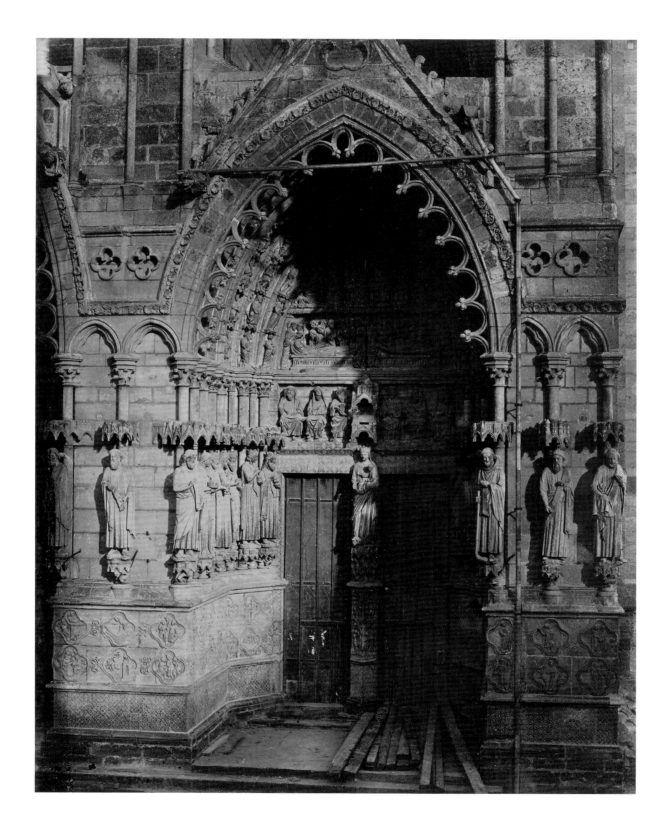

36

Édouard Baldus
Cloister of Saint-Trophime, Arles, ca. 1851
Salted paper print

37

Édouard Baldus
Cloister of Saint-Trophime, Arles, ca. 1851
Salted paper print

38

Édouard Baldus
Cloister of Saint-Trophime, Arles, ca. 1851
Salted paper print

39

Édouard Baldus
Cloister of Saint-Trophime, Arles, ca. 1861
Albumen silver print

40

Édouard Baldus
Cloister of Saint-Trophime, Arles, ca. 1861
Albumen silver print

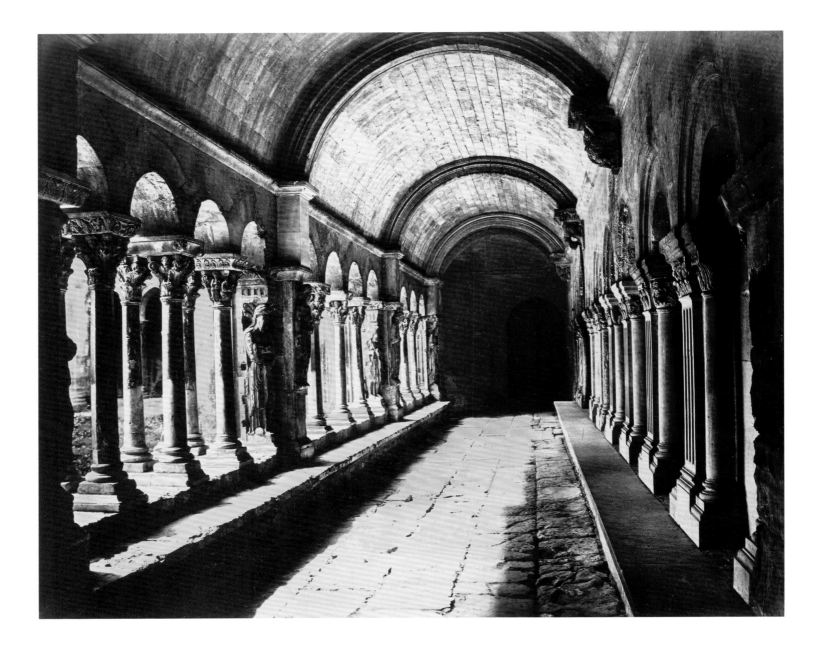

41

Charles Nègre
An Aisle of the Cloister of Saint-Trophime, Arles, ca. 1852
Salted paper print

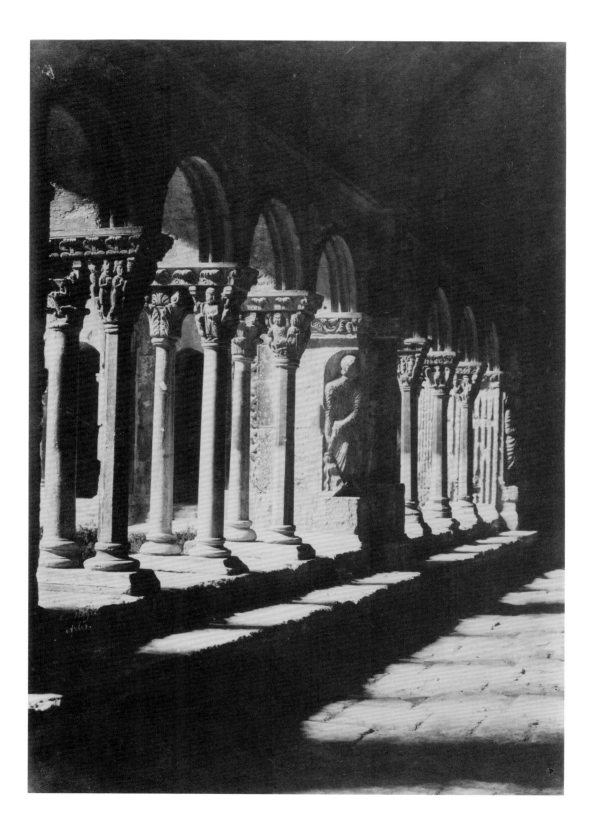

Charles Nègre
Right Side of the Main Portal of Saint-Trophime, Arles,
with Two Evangelists and the Damned, 1852–53
Salted paper print

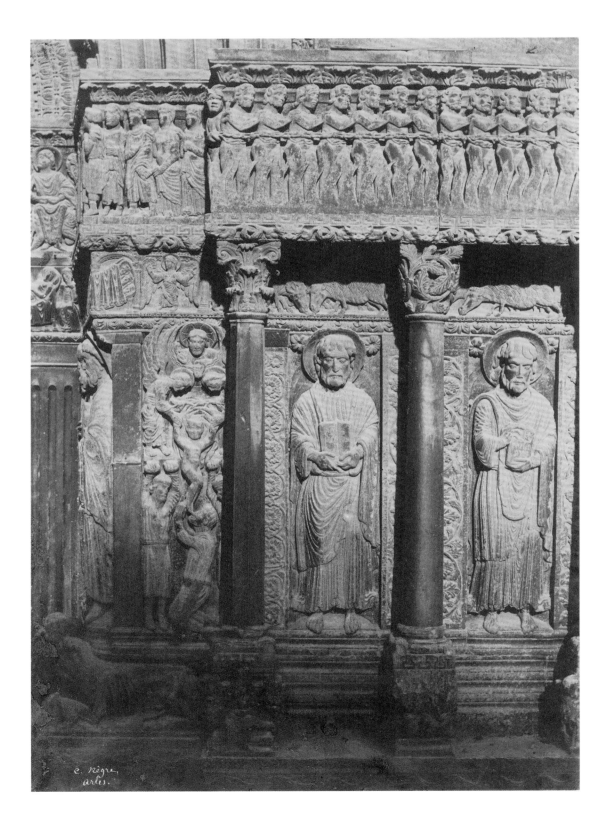

43
Édouard Baldus
Church of Saint-Trophime, Arles, 1850s
Albumen silver print

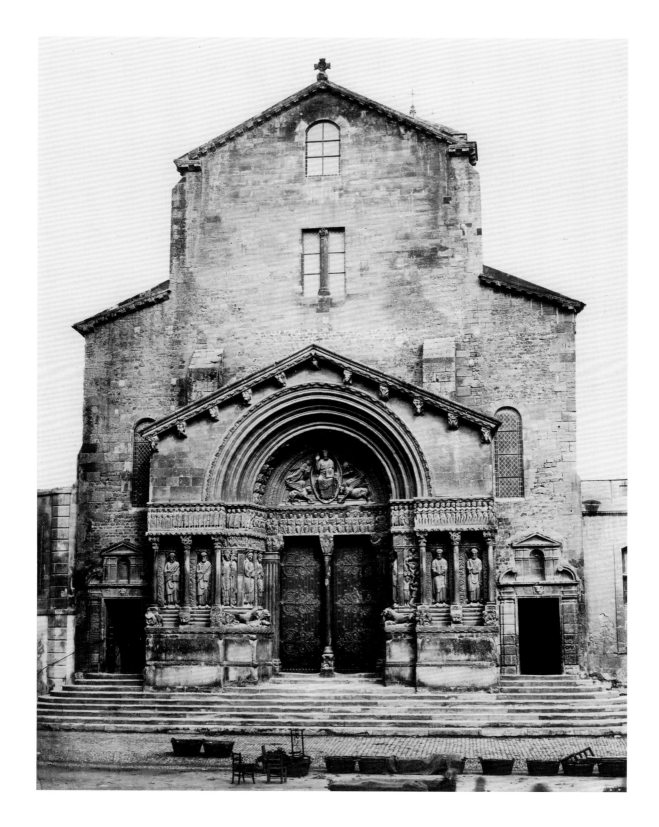

Charles Nègre
Church of Saint-Gabriel, near Arles, 1852
Salted paper print

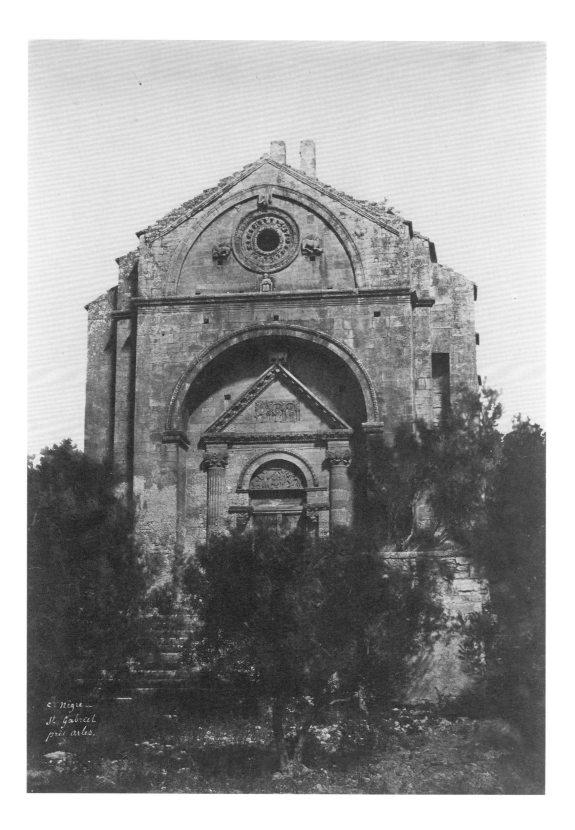

45

Charles Nègre
Roman Ramparts, Arles, 1852
Salted paper print

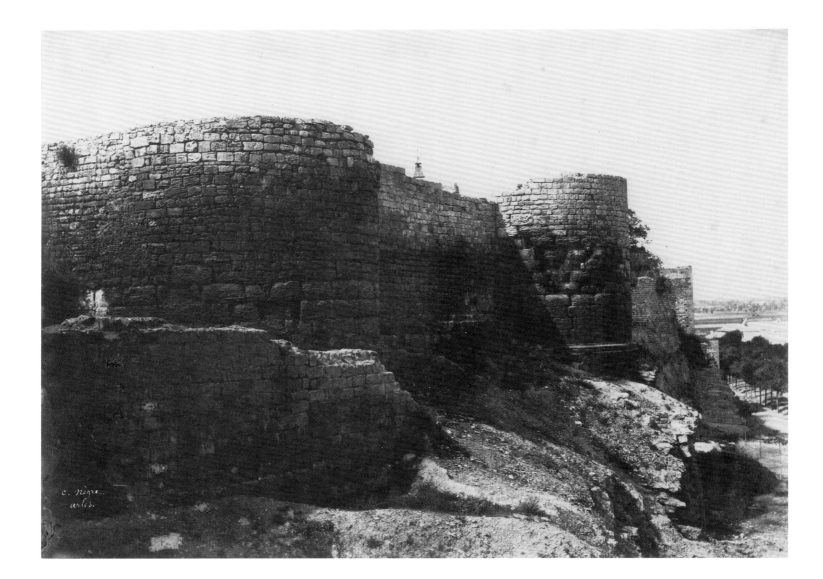

46

André Giroux
Square Courtyard of the Arles Amphitheater, 1850s
Salted paper print

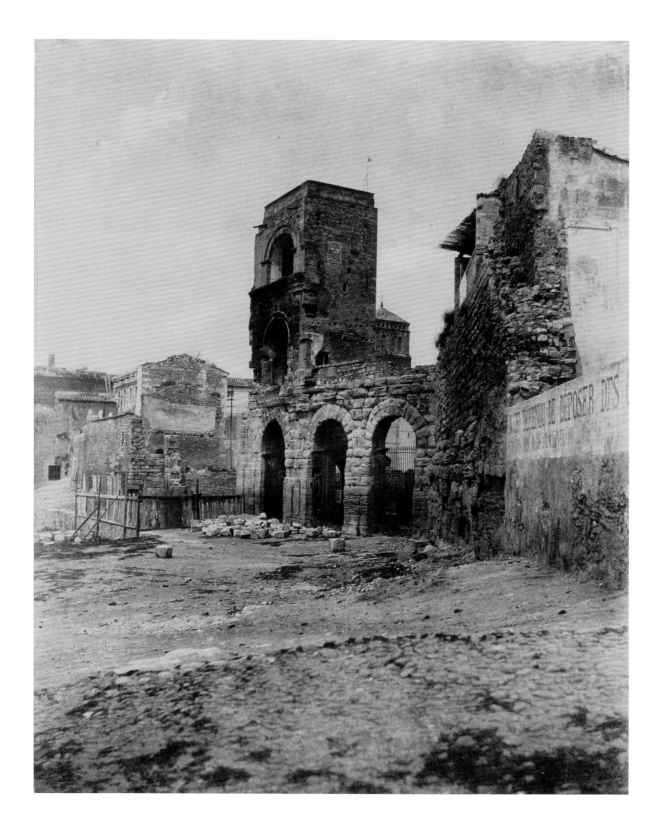

47

Charles Nègre
Roman Tower Restored under Francis I, Arles, 1852
Waxed-paper negative

48

Charles Nègre
Roman Tower Restored under Francis I, Arles, 1852
Salted paper print

49

Charles Nègre
Roman Tower Restored under Francis I, Arles, 1852
Salted paper print

50

Charles Nègre
Papal Palace, Avignon, 1852
Salted paper print

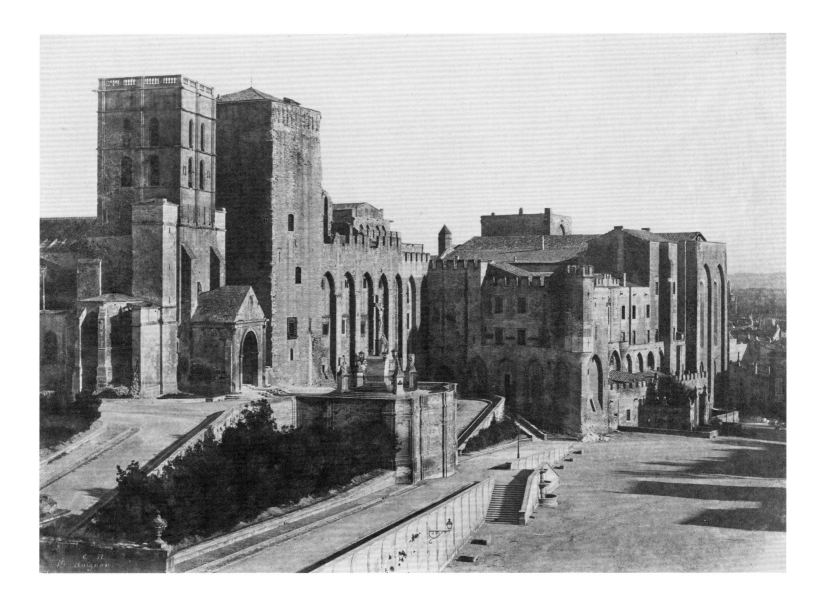

51

Édouard Baldus
Papal Palace, Avignon, ca. 1861
Albumen silver print

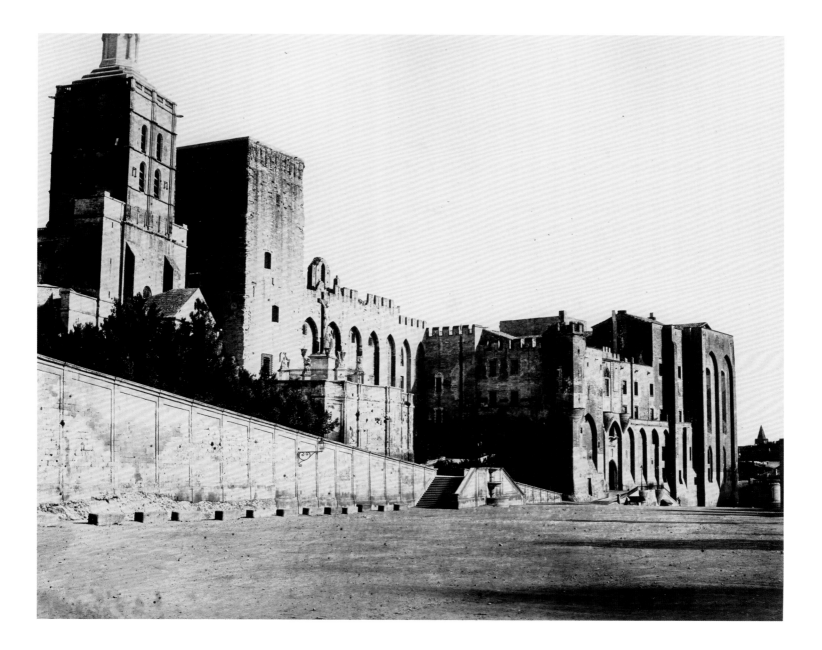

Our albums are our exhibitions; they furnish theory with novel
points of view concerning art and provide valuable insights
with regard to science; they offer to the descriptive imagination
scenes that are stimulating and satisfying, all the more so since
they border so closely on the true appearance of things;
they are, in fact, the most immediate translation of nature possible.

FRANCIS WEY
"Album de la Société héliographique," *La lumière* (1851)

52

Henri Le Secq
South Arm of the Transept of Notre-Dame, Paris, 1851
Salted paper print

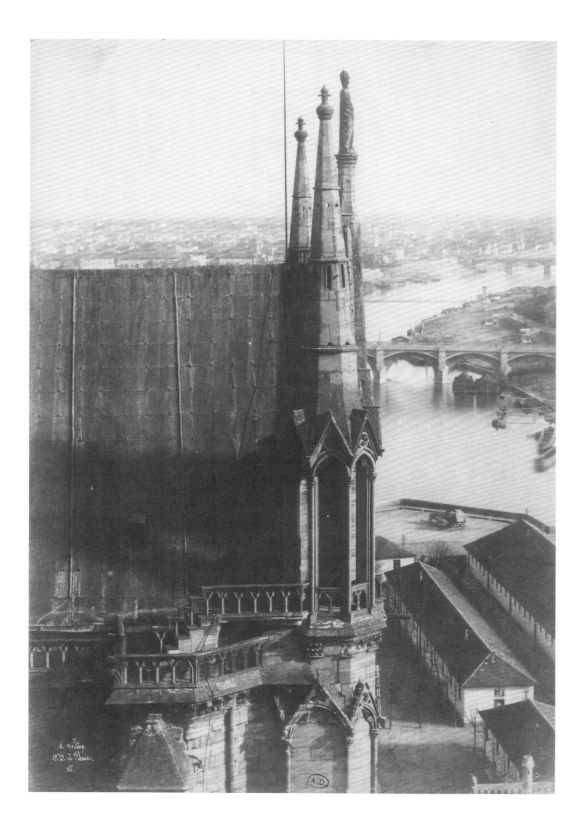

53

Charles Nègre
The Angel of the Resurrection on the Roof of Notre-Dame, Paris, 1853
Salted paper print

54

Charles Nègre
Entrance to the Sacristy, Notre-Dame, Paris, ca. 1853
Salted paper print

55

Henri Le Secq
Demolitions in the Place de l'Hôtel de Ville, Paris, 1852
Salted paper print

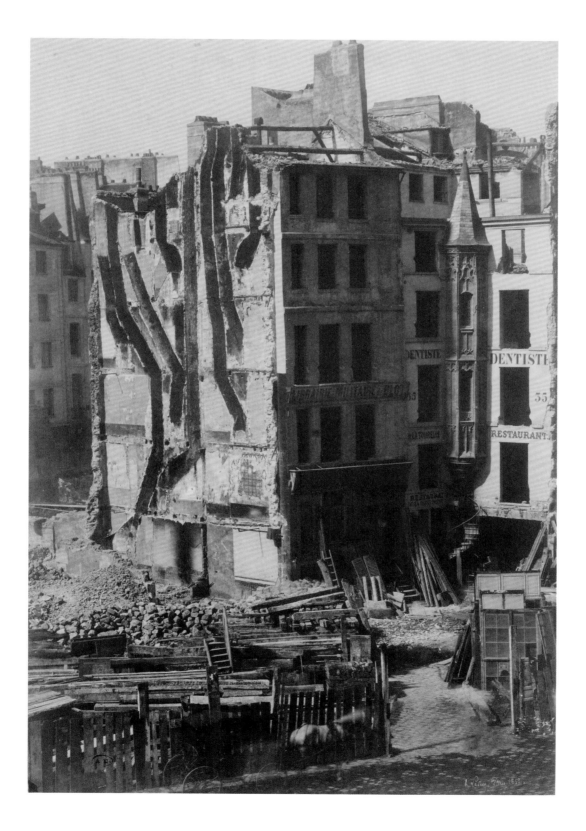

Édouard Baldus
The Tour Saint-Jacques, 1852–53
Salted paper print

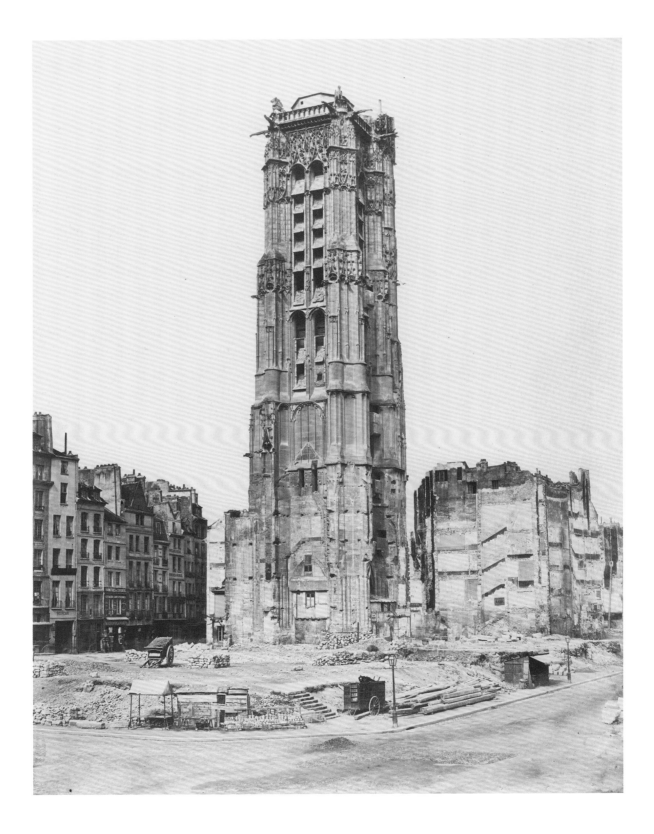

57

Gustave Le Gray
The Tour Saint-Jacques, ca. 1857–59
Albumen silver print

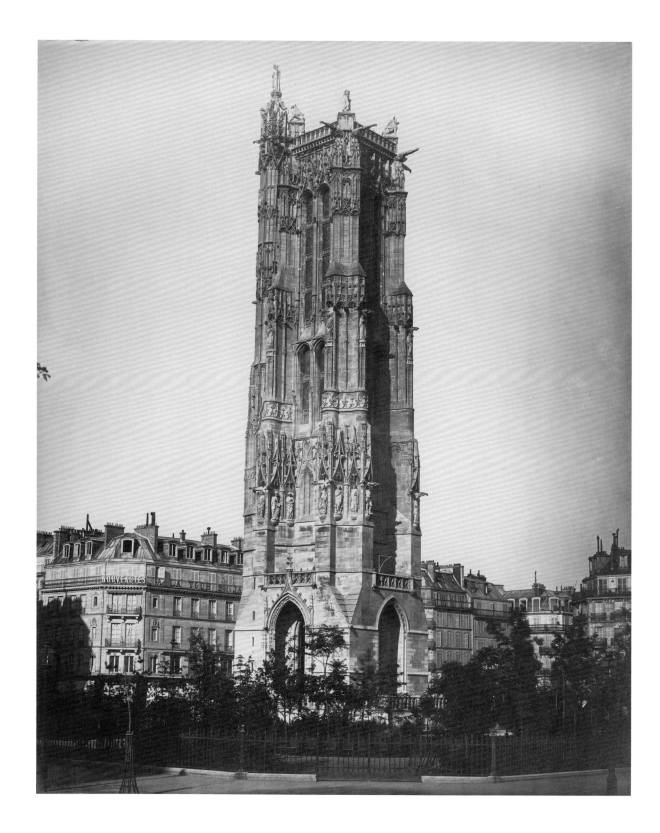

58

Henri Le Secq (print by Louis Désiré Blanquart-Evrard)
Church of the Madeleine, 1851–53
Salted paper print

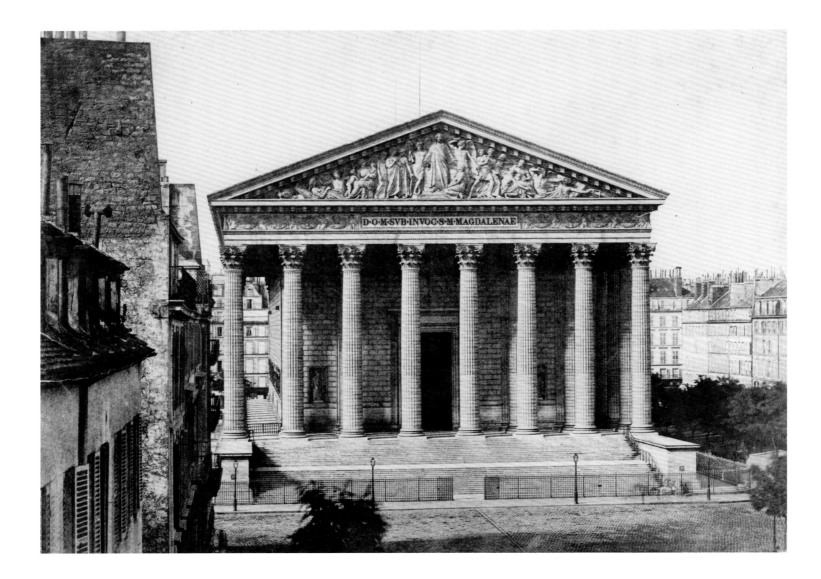

59

Bisson Frères
Entrance to the Imperial Library, the Louvre Palace, Paris, ca. 1858
Albumen silver print

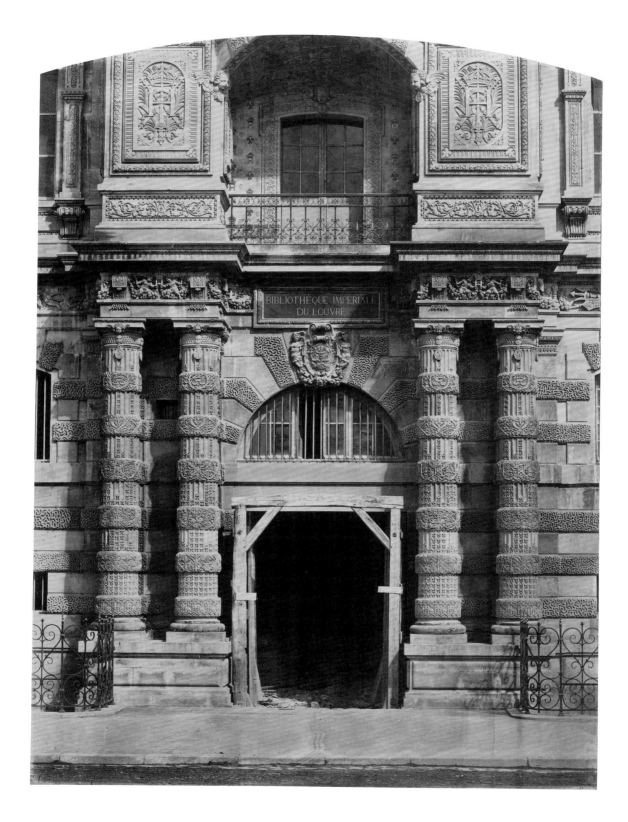

60

Charles Nègre
Pavillon de l'Horloge, the Louvre, Paris, 1855
Salted paper print

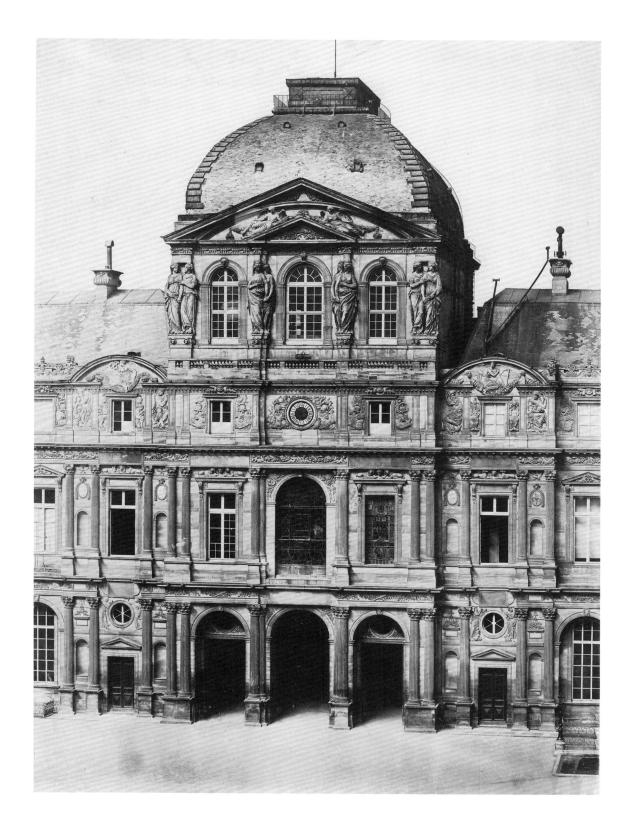

61

Gustave Le Gray
Pavillon Mollien, the Louvre, Paris, 1859
Albumen silver print

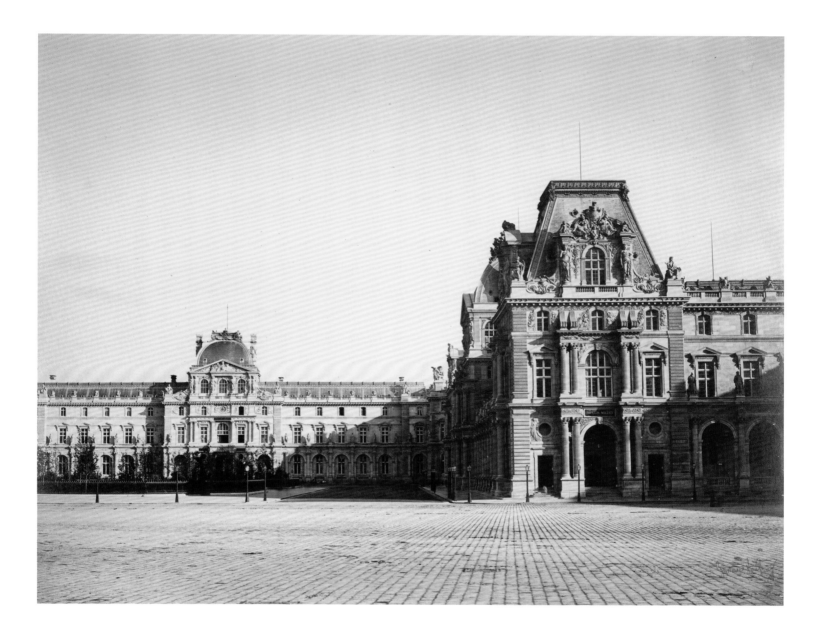

Édouard Baldus
Pont de la Mulatière, ca. 1861
Albumen silver print

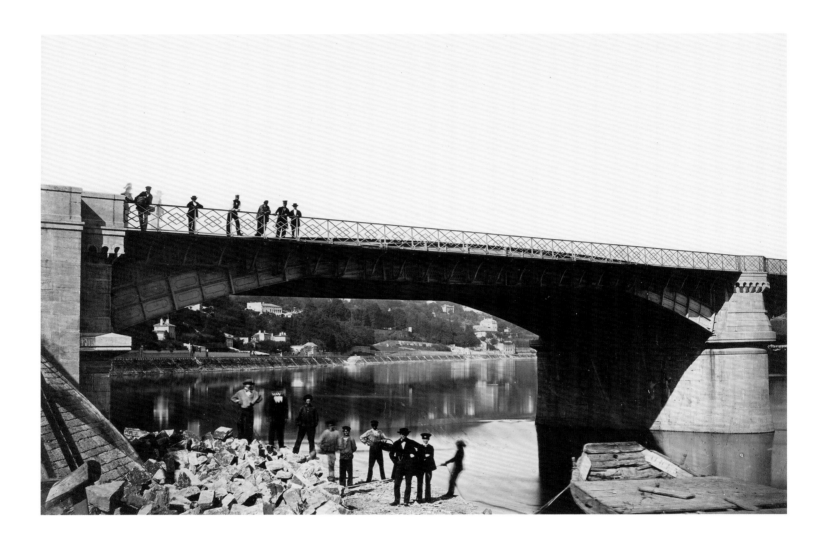

63

Gustave Le Gray
The Pont du Carrousel Seen from the Pont Royal, 1857
Albumen silver print

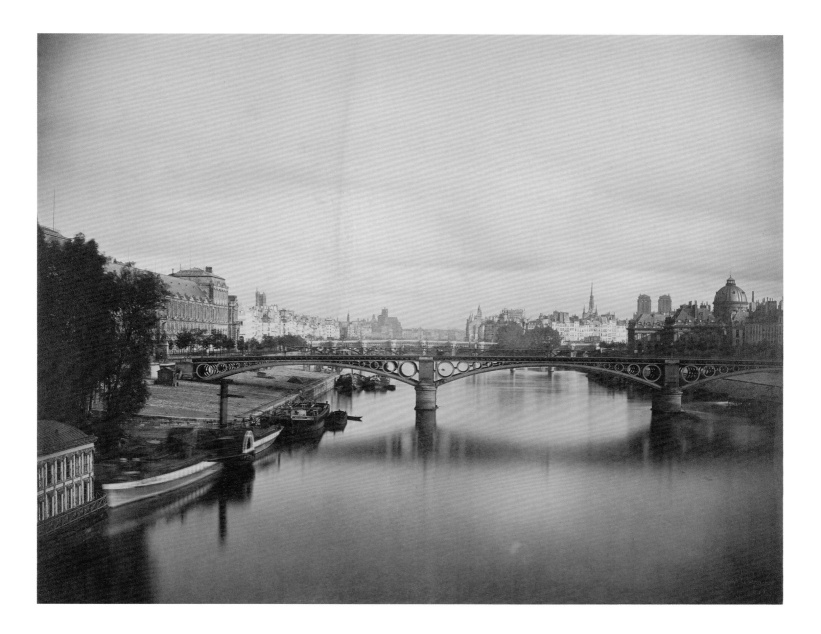

Where science ends, art begins. . . . When the chemist prepares the paper, the artist directs the lens, and by means of the three beacons that guide him ceaselessly in the study of nature—observation, feeling, and reasoning—he reproduces the effects that make us dream, the simple patterns that move us, and the sites with powerful and bold silhouettes that surprise us and frighten us.

CHARLES NÈGRE
"Héliographie sur papier ciré et à sec," *La lumière* (1851)

64

Charles Nègre
Resting Chimney Sweeps, 1851
Salted paper print

65

Charles Nègre
Italian Street Musicians at Entrance to 21, Quai de Bourbon, Paris, 1851
Salted paper print

66

Charles Nègre
Organ-Grinder at 21, Quai de Bourbon, Paris,
before March or May 1853
Salted paper print

———————

67

Charles Nègre
Licorice-Water Vendor at 21, Quai de Bourbon, Paris, ca. 1852
Waxed-paper negative

68

Charles Nègre
Licorice-Water Vendor at 21, Quai de Bourbon, Paris, ca. 1852
Salted paper print

69

Charles Nègre
Licorice-Water Vendor at 21, Quai de Bourbon, Paris, ca. 1852
Oil on panel

70

Charles Nègre
Rachel Félix and Two Unidentified Men on a Balcony, 1853
Salted paper print

71

Gustave Le Gray
Victor Cousin, ca. 1856
Albumen silver print

72

Nadar (Gaspard-Félix Tournachon)
Henri Murger, ca. 1855
Salted paper print

73

Nadar (Gaspard-Félix Tournachon)
Henri Murger, ca. 1855
Hand-painted salted paper print

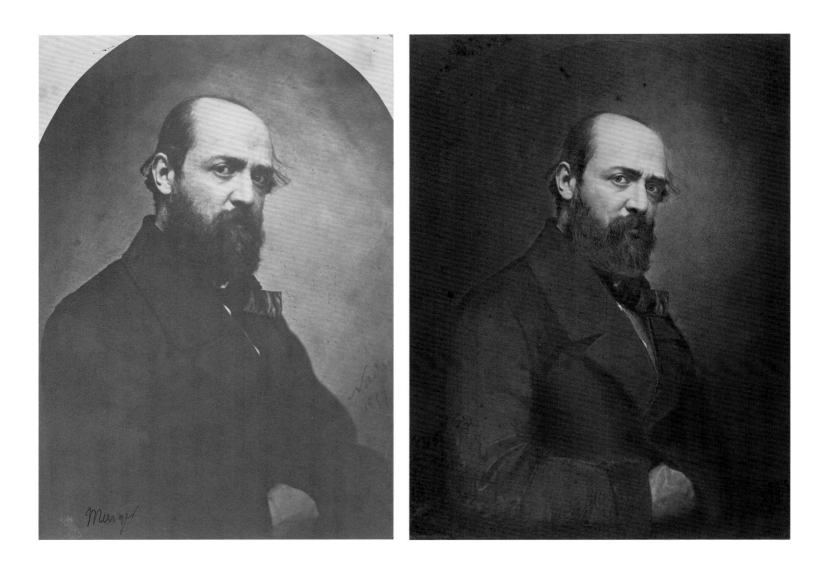

74

Nadar (Gaspard-Félix Tournachon)
Alexandre Dumas, 1855
Salted paper print

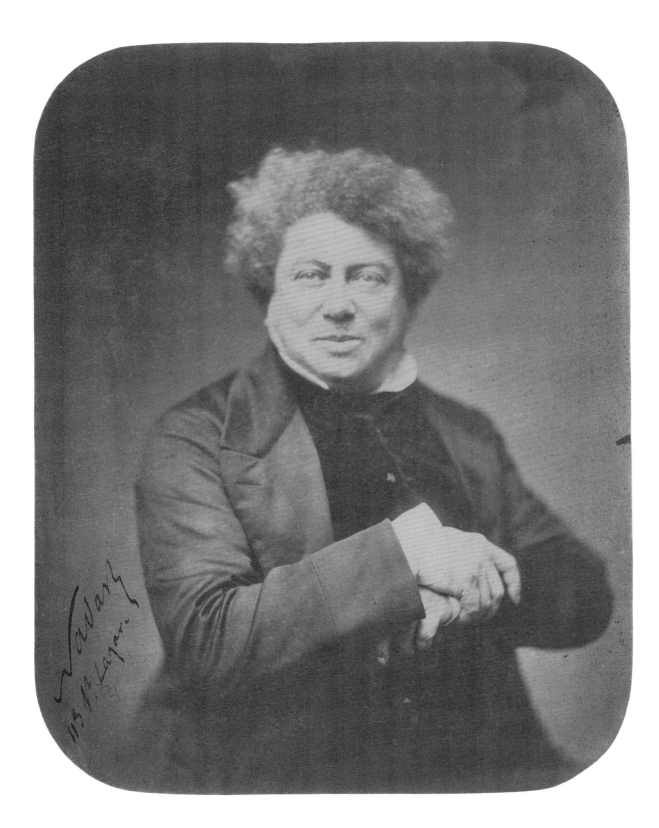

75

Nadar (Gaspard-Félix Tournachon)
Théophile Gautier, ca. 1856
Salted paper print

76

Nadar (Gaspard-Félix Tournachon)
George Sand (Amandine-Aurore-Lucile Dupin), ca. 1865
Albumen silver print

77

Nadar (Gaspard-Félix Tournachon)
Émile Augier, ca. 1852
Graphite on paper

78

Nadar (Gaspard-Félix Tournachon)
Émile Augier, ca. August 1857
Salted paper print

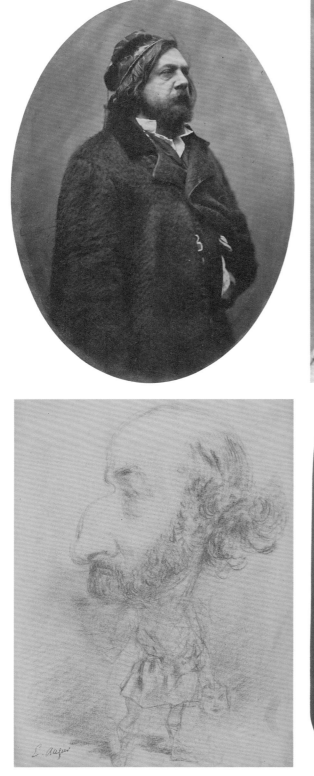

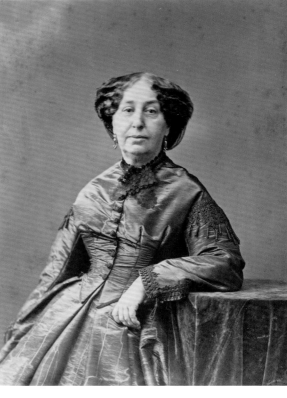

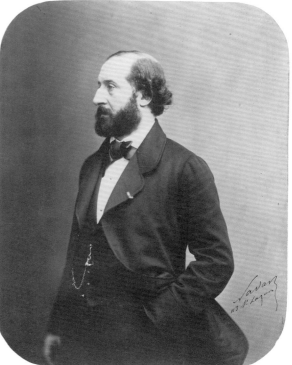

Nadar (Gaspard-Félix Tournachon)
Charles Philipon, 1856–58
Salted paper print

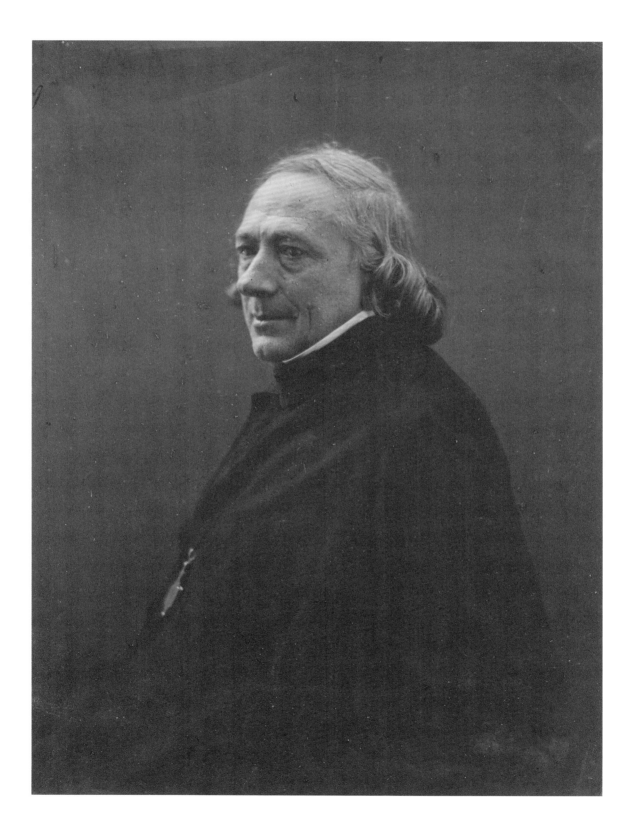

80

Nadar (Gaspard-Félix Tournachon)
Auguste Vacquerie, ca. 1865
Albumen silver print

81

Nadar (Gaspard-Félix Tournachon)
Auguste Vacquerie, ca. 1865
Hand-painted salted paper print

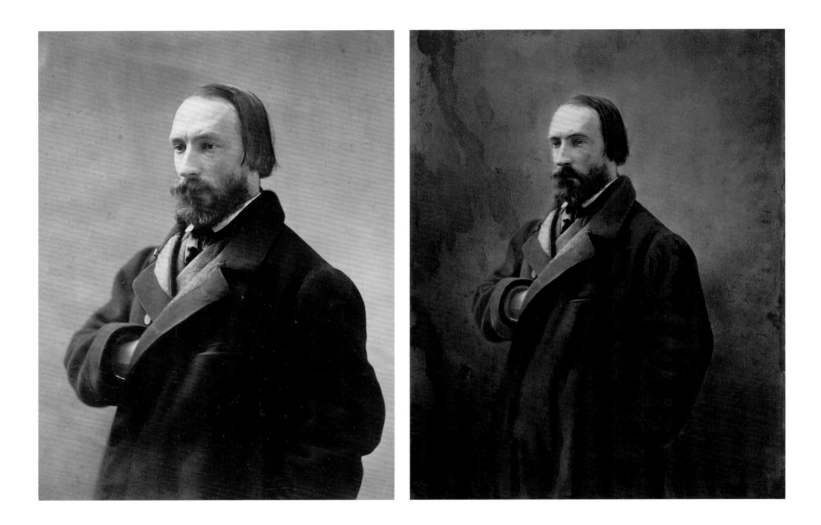

82

Nadar (Gaspard-Félix Tournachon)
Jean-François Millet, 1856–58
Salted paper print

83

Nadar (Gaspard-Félix Tournachon)
Théodore Rousseau, 1857
Salted paper print

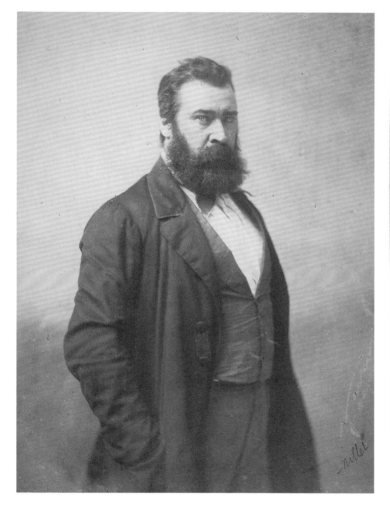

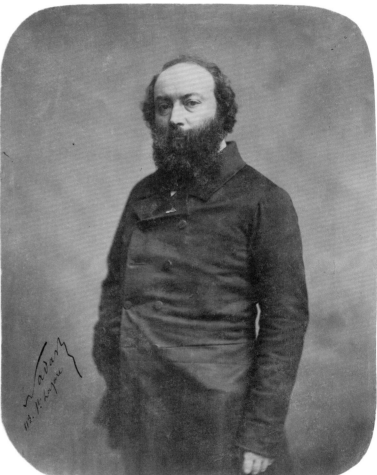

At all times there have existed in painting two schools: that of the idealists and that of the realists.

THÈOPHILE GAUTIER
"Salon de 1850–51," *La presse* (1851)

84

Charles Nègre
A Street in Grasse, 1852
Waxed salted paper print

Charles Nègre
Mill, Grasse, 1852
Albumen silver print

86

Charles Nègre
The Gate of the Chestnuts, Arles, 1852
Salted paper print

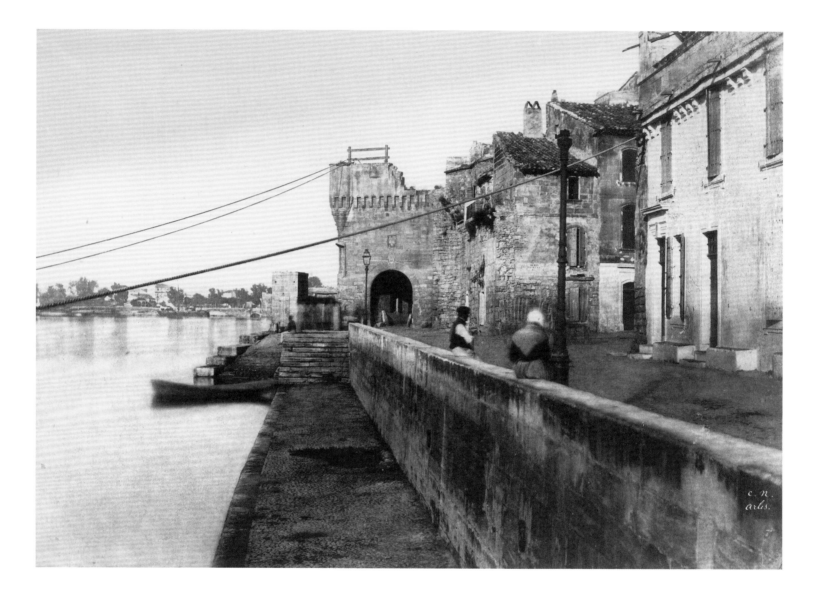

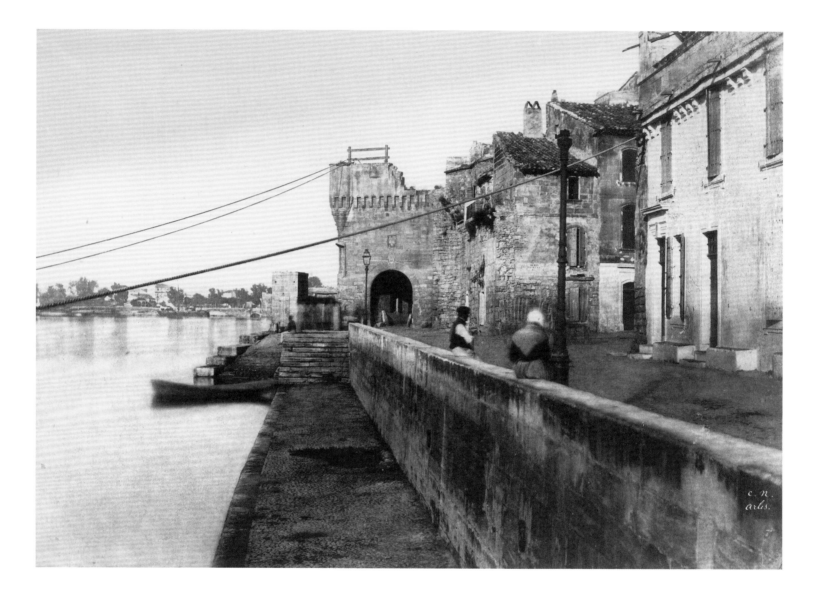

87

Henri Le Secq
Small Dwelling in Mushroom Cave, 1851
Salted paper print

88

Henri Le Secq
Three Peasants, 1853
Salted paper print

89

Henri Le Secq
Stairs of the Reine Berthe, Chartres, 1852
Salted paper print

90

André Giroux
Village Scene with Geese, ca. 1855
Salted paper print

91

André Giroux
Thatched Cottage with Geese in Boursadière, Allier, ca. 1855
Salted paper print

92

Édouard Baldus
Landscape with Stream and Stone and Wooden Bridge, 1854–55
Salted paper print

93

Henri-Victor Regnault (print by Alphonse-Louis Poitevin)
The Seine at Meudon, Sèvres, negative, ca. 1853; print, 1855–60
Carbon print

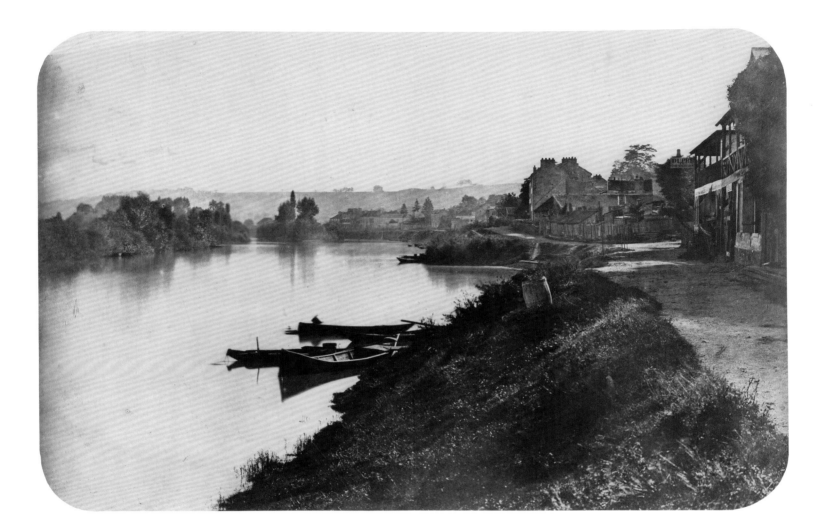

Yesterday, steam, that eloquent expression of modern society, was giving a powerful helping hand to all industrial products imbued with the influence of the arts; today photography, the perfect ideal of mechanical art, is initiating the world to the beauties of divine and human creations.

LÉON DE LABORDE
Exposition universelle de Londres: Travaux de la Commission française sur l'industrie des nations; Vie groupe. 30e jury. Beaux-arts (1856)

94

Édouard Baldus
Millstream in the Auvergne, with Camera, 1854
Albumenized salted paper print

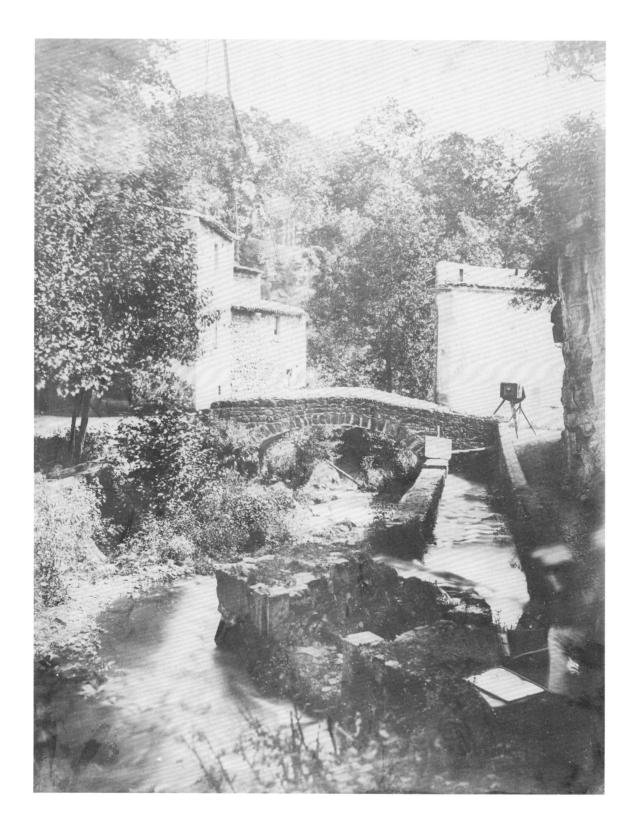

95

Henri Le Secq
Study of the Head of a Woman with Closed Eyes, 1850s
Oil on canvas

96

Charles Nègre
Universal Suffrage: A Study, 1850s
Oil on canvas

97

Charles Nègre
Nègre's Painting "The Strength of Man," after 1859
Albumen silver print

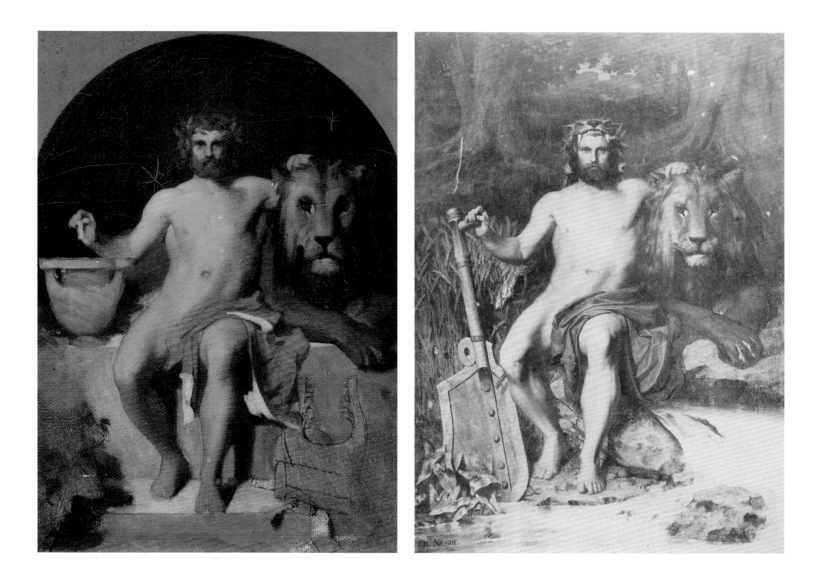

98

Gustave Le Gray
Millet's Drawing of the "Mona Lisa," 1854–55
Albumen silver print

99

Gustave Le Gray
Salon of 1852, Palais-Royal, 1852
Salted paper print

100

Gustave Le Gray
The Salon of 1850, 1850
Salted paper print

Gustave Le Gray
Salon of 1852, 1852
Salted paper print

102

Jean-Louis-Marie-Eugène Durieu, possibly with Eugène Delacroix
Draped Model, ca. 1854
Albumen silver print

103

Attributed to Félix-Jacques Moulin
Female Nude, 1856
Albumen silver print

104

Gustave Le Gray
Reclining Female Nude, ca. 1856
Albumen silver print

105

Achille Devéria
Outdoor Portrait of a Young Lady, probably Cécile Devéria, 1854
Salted paper print with ink

From my point of view, the artistic beauty of a photographic print nearly always lies . . . in sacrificing certain details so as to produce an effect that sometimes achieves the most sublime of art.

GUSTAVE LE GRAY
Photographie: Traité nouveau théorique et pratique des procédés et manipulations sur papier et sur verre (1852)

106

Gustave Le Gray
Route de Chailly, Fontainebleau, paper negative, ca. 1852;
glass negative for sky, ca. 1856; print, ca. 1856
Albumen silver print

107

Gustave Le Gray
Curtain of Trees, Fontainebleau, 1849–50
Salted paper print

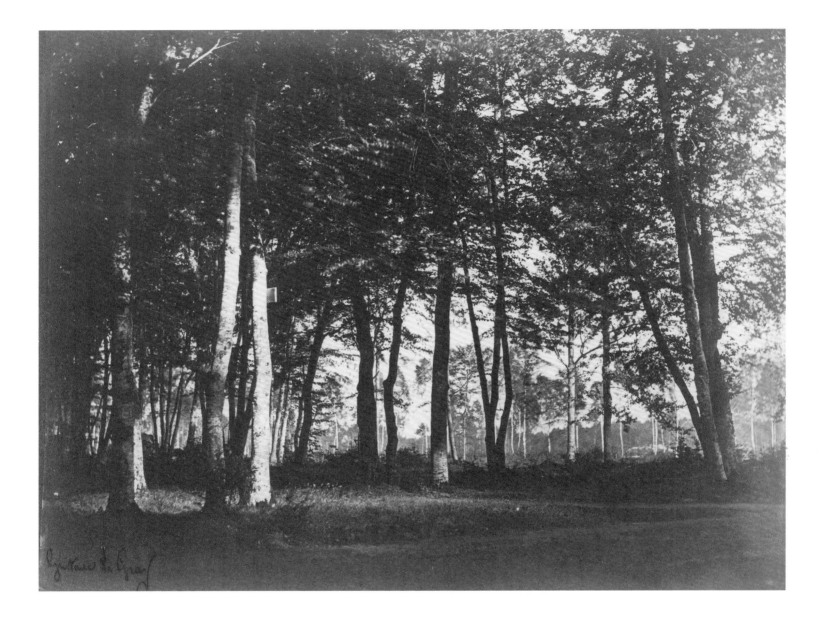

108

Gustave Le Gray
Forest Scene, Fontainebleau, 1852
Albumen silver print

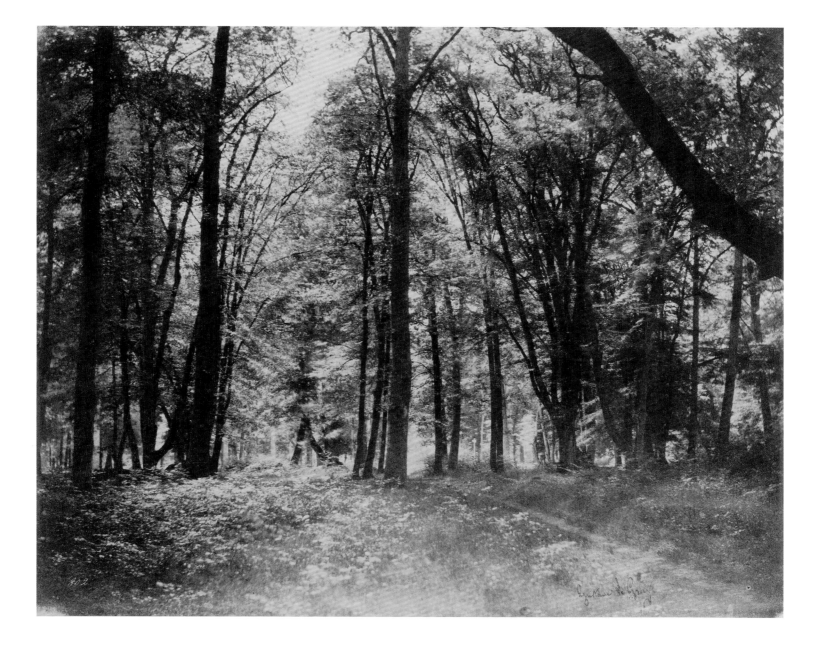

109

Eugène Cuvelier
Forest Scene, Fontainebleau, 1863
Albumen silver print

———————

Eugène Cuvelier
Landscape Study, ca. 1862
Albumen silver print

111

Eugène Cuvelier
Achicourt, near Arras, ca. 1860
Salted paper print

112

Comte Olympe Aguado
Large Oak in the Bois de Boulogne, ca. 1855
Albumen silver print

113

André Giroux
The Ponds at Optevoz, Rhône, ca. 1855
Salted paper print

114

Gustave Le Gray
The Beach at Sainte-Adresse, 1856
Albumen silver print

115

Gustave Le Gray
Lighthouse and Jetty, Le Havre, 1856–58
Albumen silver print

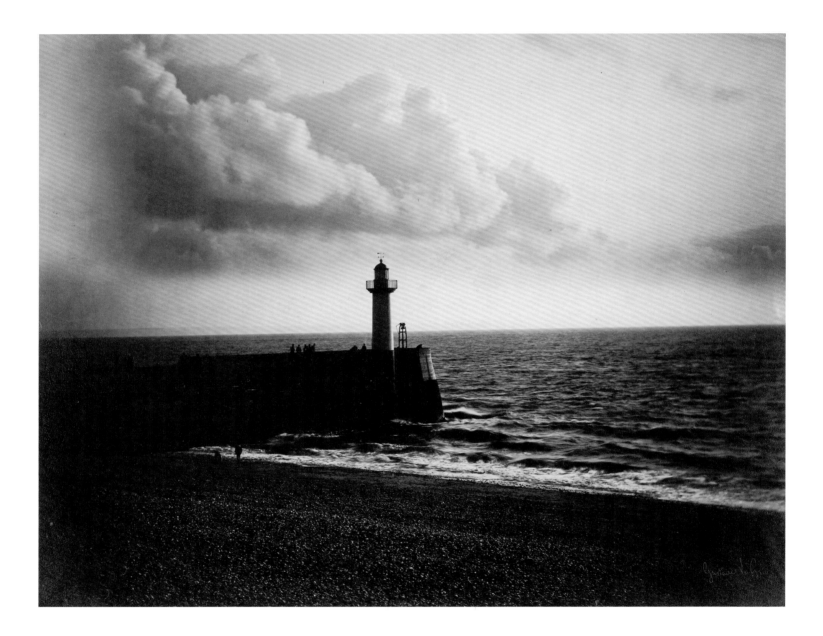

Gustave Le Gray
An Effect of Sunlight—Ocean No. 23, ca. 1858
Albumen silver print

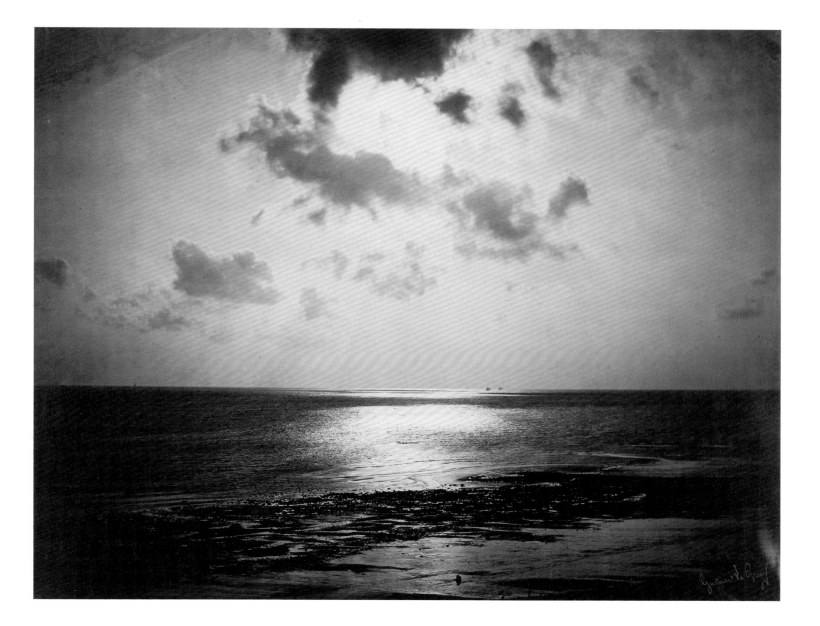

117

Gustave Le Gray
The Sun at Its Zenith, Normandy, ca. 1858
Albumen silver print

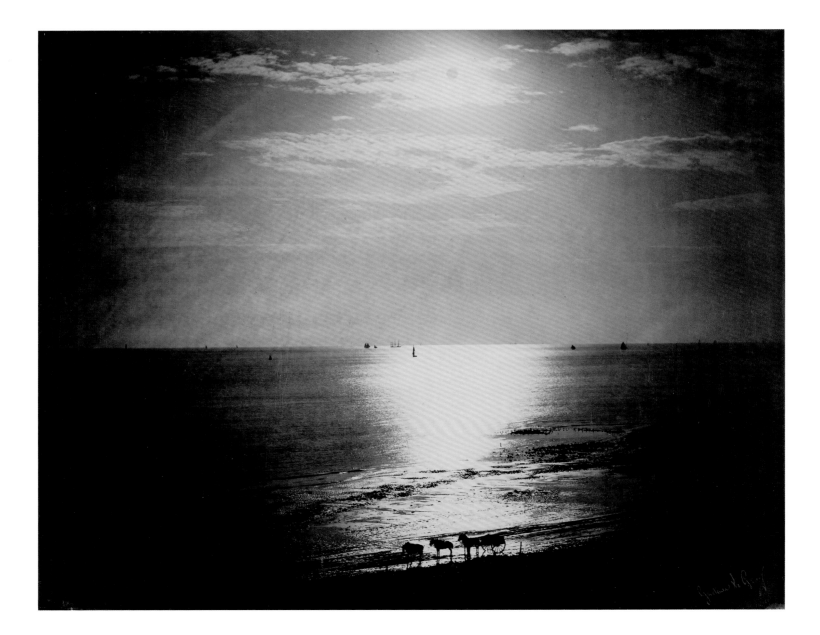

118

Gustave Le Gray
The Brig, 1856
Albumen silver print

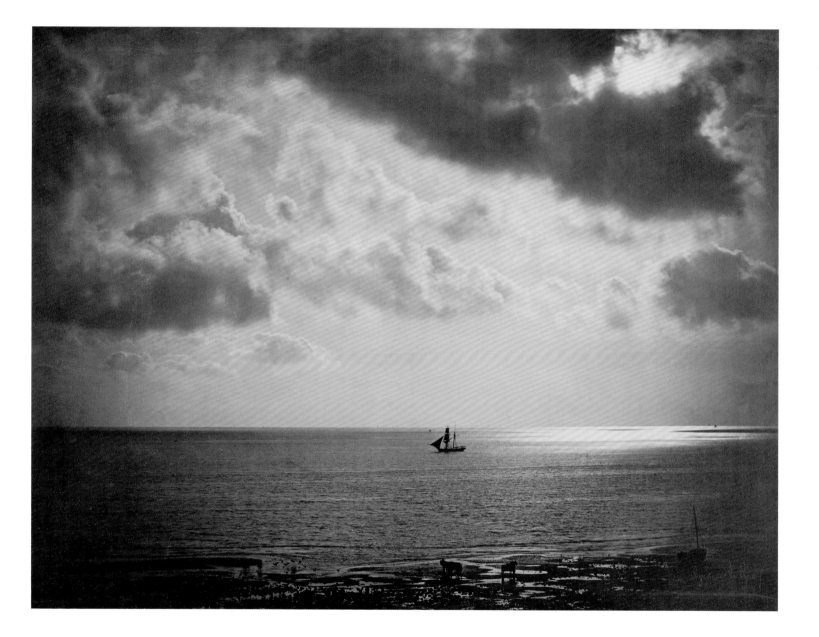

119

Gustave Le Gray
Seascape with a Ship Leaving Port, 1856–58
Albumen silver print

120

Gustave Le Gray
The Breaking Wave, 1857
Albumen silver print

What is art, monsieur, but nature concentrated?

HONORÉ DE BALZAC
Lost Illusions, part 1 (1837)

121

Henri Le Secq
Fantasies, ca. 1855
Cyanotype

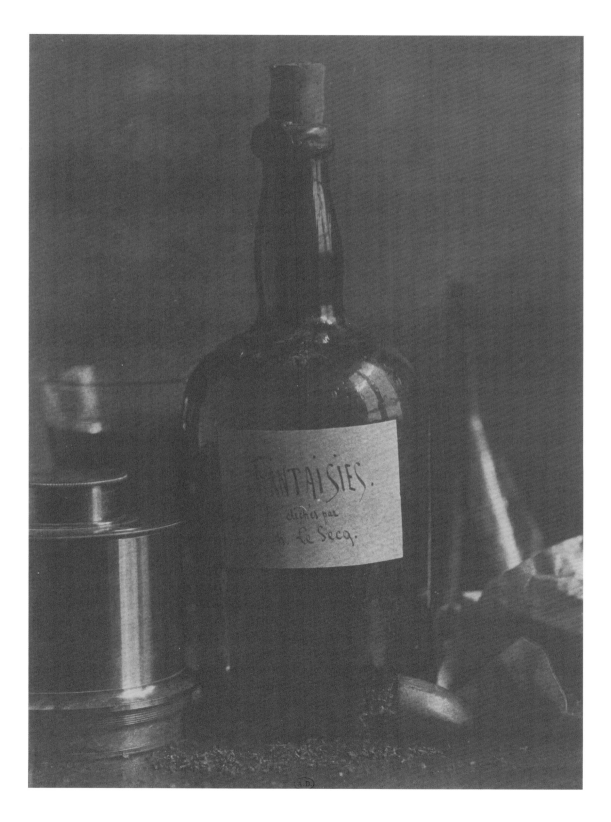

122

Henri Le Secq
Romanesque Ornaments, ca. 1853–55
Salted paper print

123

Louis-Rémy Robert
Still Life with Statuette and Vases, negative, 1855; print, 1870s
Carbon print

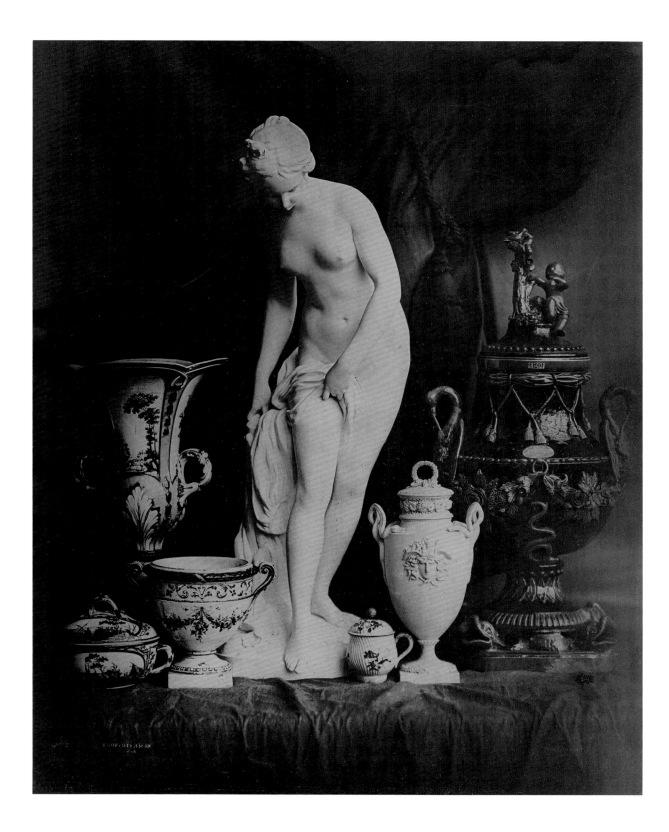

124

**Attributed to Henri-Victor Regnault
and Louis Désiré Blanquart-Evrard**

Still Life with Straw Basket, Rug, and Potted Plant on Ladder, ca. 1853
Albumen silver print

125

Henri-Victor Regnault and Louis Désiré Blanquart-Evrard
Still Life with Straw Baskets, Broom, Opened Sack of Potatoes,
and Potted Plants, ca. 1853
Albumen silver print

126

Charles Marville
Rue au Lard, Paris, 1865–69
Albumen silver print

127

Henri Le Secq
In the Field of the Cossacks, Montmirail, 1852–53
Salted paper print

128

Gustave Le Gray
Factory, Terre-Noire, 1851–55
Salted paper print

129

Bisson Frères
After an Earthquake near Viège, Valais, Switzerland, July 25–26, 1855
Albumen print

130

Bisson Frères
Destroyed House, after an Earthquake near Viège, Valais, Switzerland,
July 25–26, 1855
Albumen silver print

131

Édouard Baldus
Lyon (Floods), 1856
Salted paper print

132

Édouard Baldus
Avignon (Flood of 1856), 1856
Salted paper print

133

Gustave Le Gray
Panorama of the Camp at Châlons, 1857
Albumen silver prints (six photographs in three frames)

134

Gustave Le Gray
The French Fleet, Cherbourg, August 4–6, 1858
Albumen silver print

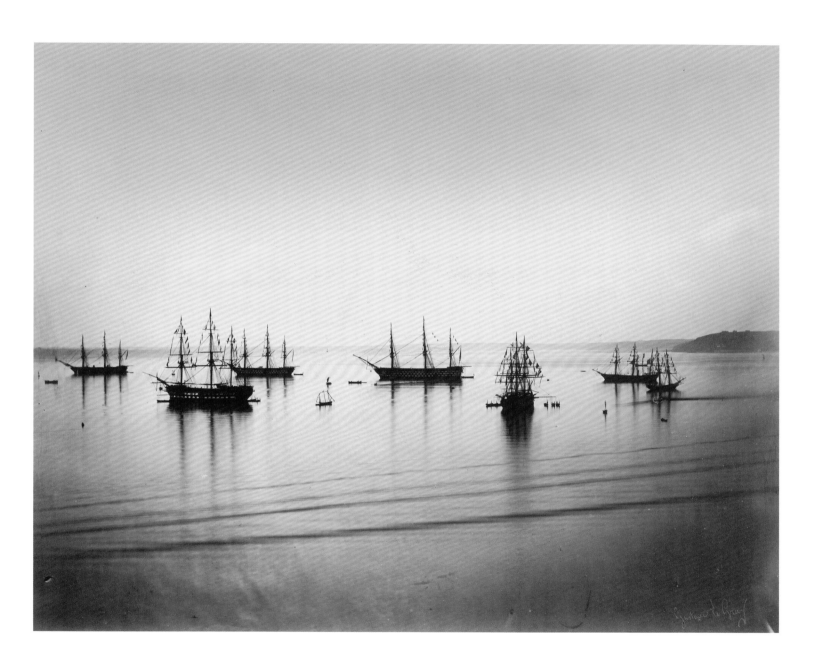

135

Édouard Baldus
Bandol, ca. 1860
Albumen silver print

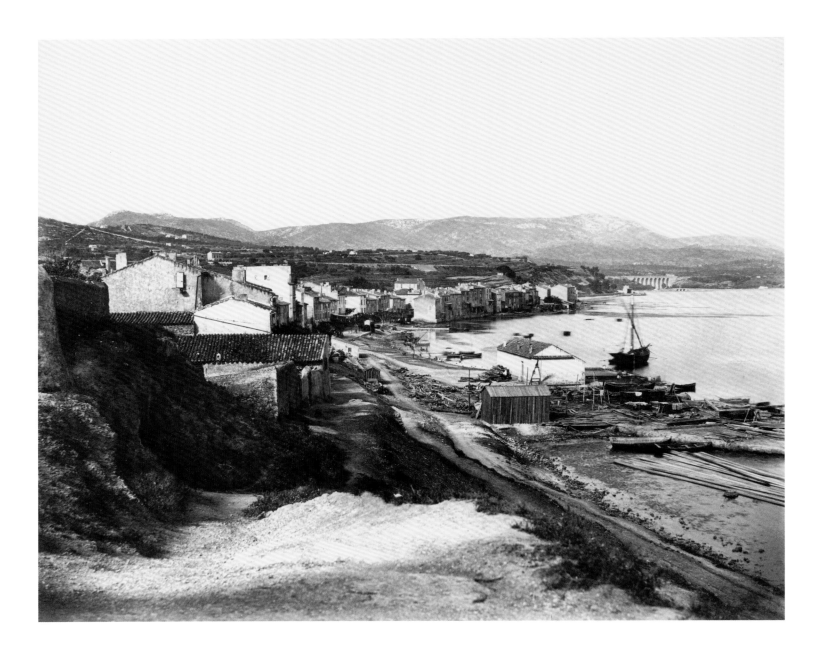

Édouard Baldus
Entrance to the Donzère Pass, ca. 1861
Albumen silver print

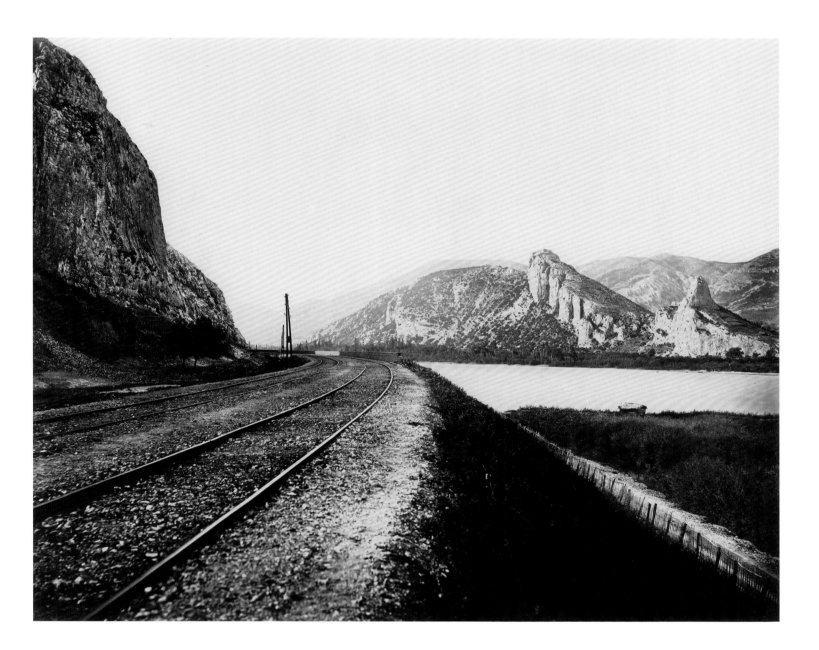

137

Henri Le Secq
Statue of Christ, Reims Cathedral, ca. 1853
Salted paper print

138

Henri Le Secq
Statue of Christ, Reims Cathedral, negative, ca. 1853; print, 1870s
Photolithograph

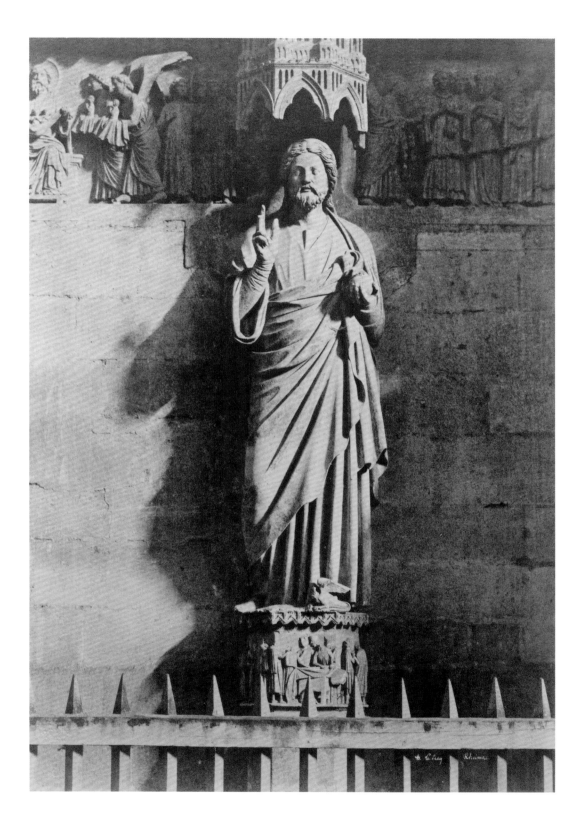

139

Henri Le Secq
Chartres Cathedral, negative, 1852; print, 1870s
Photolithograph

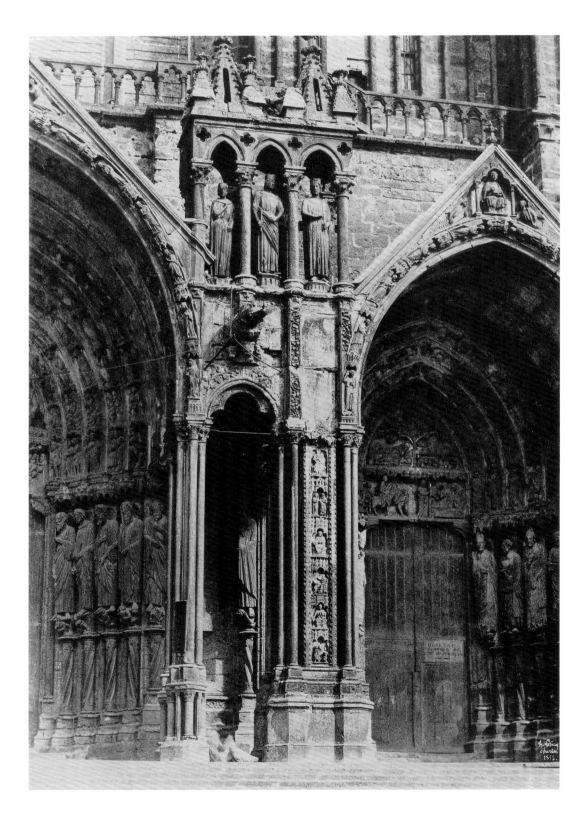

140

Henri Le Secq
North Transept, Chartres Cathedral, negative, 1852; print, 1870
Photolithograph

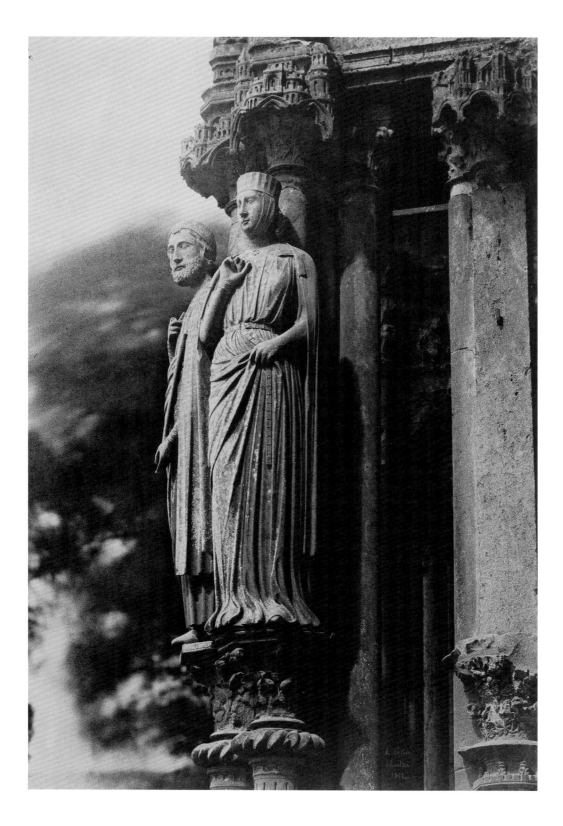

141

Charles Nègre
Italian Musicians (Pifferari) *at 21, Quai de Bourbon, Paris,*
negative, summer 1853; print, 1854
Photogravure

Charles Nègre
Italian Musicians (Pifferari) *at 21, Quai de Bourbon, Paris,*

142

Charles Nègre
Mason Kneeling, negative, before September 1853;
print, February–March 1854
Photogravure

143

Charles Nègre
Royal Portal (The Incarnation Portal), South Lateral Doorway,
Chartres Cathedral, 1857
Heliogravure

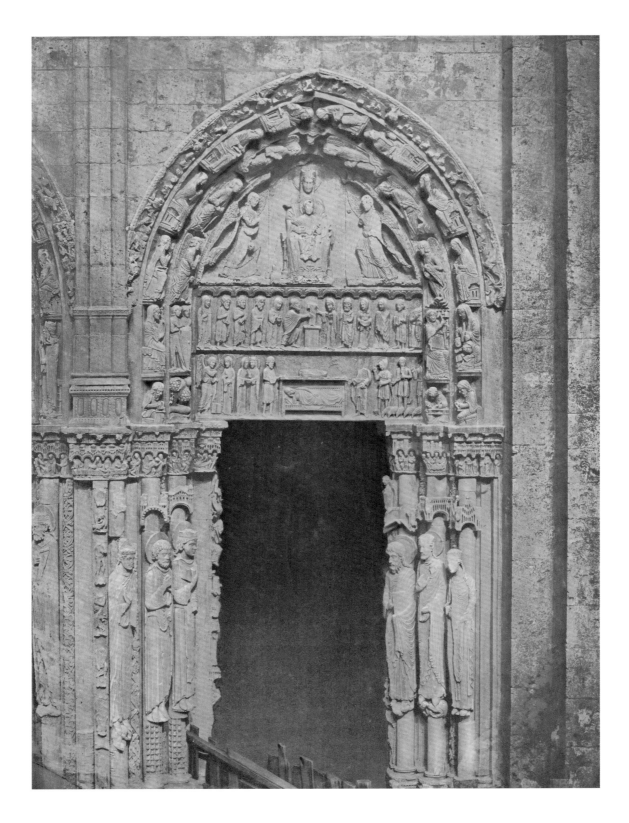

144

Lieutenant Louis Vignes and Charles Nègre
View of Sidon, negative, 1864; print, 1875
Heliogravure

Plate List

The negatives in this volume are reproduced to match the orientation of their positive counterparts, if known.

Negatives

1 **Reverend Calvert Jones**
English, 1804–1877
Combe Martin Bay, Devonshire, 1846
Paper negative with applied ink
22.7 × 18.6 cm (8¹⁵⁄₁₆ × 7⁵⁄₁₆ in.)
Los Angeles, J. Paul Getty Museum
85.XM.150.61

2 **Attributed to Henri-Victor Regnault**
French, 1810–1878
Rooftops at Sèvres, early 1850s
Waxed-paper negative
24.5 × 18.1 cm (9⅝ × 7⅛ in.)
Los Angeles, J. Paul Getty Museum
2015.44

3 **Henri-Victor Regnault**
French, 1810–1878
Sèvres and Environs: River Landscape with Boat, 1853
Waxed-paper negative
23.7 × 26.5 cm (9⁵⁄₁₆ × 10⁷⁄₁₆ in.)
Los Angeles, J. Paul Getty Museum
84.XP.259.10

4 **Henri-Victor Regnault**
French, 1810–1878
River Landscape, ca. 1853
Waxed-paper negative
32.9 × 43.2 cm (12¹⁵⁄₁₆ × 17 in.)
Los Angeles, J. Paul Getty Museum
84.XP.259.11

5 **Baron Louis-Adolphe Humbert de Molard**
French, 1800–1874
Two Men and a Girl Seated under a Trellis, ca. 1848
Calotype negative
22.5 × 17.6 cm (8⅞ × 6¹⁵⁄₁₆ in.)
Los Angeles, J. Paul Getty Museum
2015.37

6 **Louis-Rémy Robert**
French, 1811–1882
Plow, ca. 1852
Waxed-paper negative
26.5 × 32.1 cm (10⁷⁄₁₆ × 12⅝ in.)
Los Angeles, J. Paul Getty Museum
2015.45.2

7 **Louis-Rémy Robert**
French, 1811–1882
Four Statues at Versailles, early 1850s
Waxed-paper negative
32.8 × 26.5 cm (12¹⁵⁄₁₆ × 10⁷⁄₁₆ in.)
Los Angeles, J. Paul Getty Museum
2015.45.1

8 **Comte Jean-François-Charles-André Flachéron**
French, 1813–1883
Colosseum, 1850
Salted paper print
24.8 × 33.3 cm (9¾ × 13⅛ in.)
Los Angeles, J. Paul Getty Museum
84.XP.677.43

9 **Comte Jean-François-Charles-André Flachéron**
French, 1813–1883
Colosseum, 1850
Waxed-paper negative
25.3 × 33.6 cm (9¹⁵⁄₁₆ × 13¼ in.)
Los Angeles, J. Paul Getty Museum
2015.34

10 **Charles Nègre**
French, 1820–1880
Plaster Cast of Venus de Milo, ca. 1849
Salted paper print
14.9 × 8.7 cm (5⅞ × 3⁷⁄₁₆ in.)
Los Angeles, J. Paul Getty Museum
84.XM.692.3

11 **Charles Nègre**
French, 1820–1880
Plaster Cast of Venus de Milo, ca. 1849
Waxed-paper negative
16.2 × 11 cm (6⅜ × 4⁵⁄₁₆ in.)
Los Angeles, J. Paul Getty Museum
84.XM.692.2

12 **Édouard Baldus**
French, born Prussia, 1813–1889
Arles (Bouches-du-Rhône)—Amphitheater, Interior View, 1851
Paper negatives
38.9 × 25.5 cm (15¼ × 10 in.);
36.7 × 32 cm (14½ × 12½ in.)
Paris, Musée d'Orsay
Purchased with funds from the Mission héliographique
DO 1982-538, DO 1982-539

13 **Gustave Le Gray**
French, 1820–1884
Auguste Mestral
French, 1812–1884
Tours (Indre-et-Loire)—West Facade, Cathedral of Saint-Gatien, 1851
Negative on dry waxed paper
34.2 × 25.2 cm (13.5 × 9.9 in.)
Paris, Musée d'Orsay
Purchased with funds from the Mission héliographique
DO 1982-561

14 **Henri Le Secq**
French, 1818–1882
South Porch, Central Portal, Left Jamb with Saints Matthew, Thomas, Philip, Andrew, and Peter, Chartres Cathedral, 1852
Waxed-paper negative
34 × 24 cm (13⅜ × 9⁷⁄₁₆ in.)
Los Angeles, J. Paul Getty Museum
2015.39.1

15 **Charles Nègre**
French, 1820–1880
Tarascon, 1852
Waxed-paper negative with selectively applied pigment
23.7 × 33.2 cm (9⁵⁄₁₆ × 13¹⁄₁₆ in.)
Los Angeles, J. Paul Getty Museum
2015.43.9

16 **Henri Le Secq**
French, 1818–1882
Jug, Pipe, and Mugs, ca. 1855
Waxed-paper negative
Paris, Bibliothèque nationale de France
Département des estampes et de la photographie, RESERVE EI-1-BOITE
FOL B - n° 31

17 **Henri Le Secq**
French, 1818–1882
Smoked Herring, ca. 1855
Waxed-paper negative
35 × 24 cm (13¼ × 9½ in.)
Paris, Bibliothèque nationale de France
Département des estampes et de la photographie, RESERVE EI-1-BOITE
FOL B - n° 17

18 Attributed to Henri Le Secq
Sailboats Docked at the Port of Dieppe,
France, ca. 1852–55
Waxed-paper negative
34.9 × 24 cm (13¾ × 9⁷⁄₁₆ in.)
Los Angeles, J. Paul Getty Museum
84.XP.492.24

19 Charles Nègre
French, 1820–1880
Saint-Honorat des Alyscamps, Arles, 1852
Waxed-paper negative
22.8 × 33.3 cm (9 × 13⅛ in.)
Los Angeles, J. Paul Getty Museum
2015.43.4

20 Charles Nègre
French, 1820–1880
Saint-Gilles, 1852
Salted paper print
32 × 23.2 cm (12⅝ × 9⅛ in.)
Los Angeles, J. Paul Getty Museum
2015.43.8

21 Charles Nègre
French, 1820–1880
Saint-Gilles, 1852
Waxed-paper negative with selectively
applied pigment
33 × 23.9 cm (13 × 9⁷⁄₁₆ in.)
Los Angeles, J. Paul Getty Museum
2015.43.7

22 Gustave Le Gray
French, 1820–1884
Pavillon Rohan, the Louvre, Paris, ca. 1857–59
Albumen silver print
50 × 36.3 cm (19¹¹⁄₁₆ × 14⁵⁄₁₆ in.)
Los Angeles, J. Paul Getty Museum
2015.38

23 Gustave Le Gray
French, 1820–1884
Pavillon Rohan, the Louvre, Paris, ca. 1859
Collodion-on-glass negative
53 × 42 cm (20⅞ × 16½ in.)
Paris, Bibliothèque historique de la ville
de Paris

24 Charles Nègre
French, 1820–1880
Notre-Dame, Paris, ca. 1853
Salted paper print
32.8 × 23.1 cm (12¹⁵⁄₁₆ × 9⅛ in.)
Los Angeles, J. Paul Getty Museum
2015.43.2

25 Charles Nègre
French, 1820–1880
Notre-Dame, Paris, ca. 1853
Waxed-paper negative
33.6 × 24 cm (13¼ × 9⁷⁄₁₆ in.)
Los Angeles, J. Paul Getty Museum
2015.43.1

26 John Beasly Greene
American, born France, 1832–1856
Tree at the Side of a Road, 1850s
Waxed-paper negative
30.9 × 23.9 cm (12³⁄₁₆ × 9⁷⁄₁₆ in.)
Los Angeles, J. Paul Getty Museum
2015.36

Prints

27 Hippolyte Bayard
French, 1801–1887
Chair and Watering Can in a Garden,
ca. 1843–47
Salted paper print from a paper negative
16.5 × 12.7 cm (6½ × 5 in.)
Los Angeles, J. Paul Getty Museum
84.XO.968.85

28 Hippolyte Bayard
French, 1801–1887
Self-Portrait of the Artist Seated in a Garden,
1843–47
Salted paper print
15.9 × 12.7 cm (6¼ × 5 in.)
Los Angeles, J. Paul Getty Museum
84.XO.968.20

29 Unknown French photographer
The Barrière de Clichy from in Front of
Le Gray's Studio, 1852–55
Salted paper print
10.9 × 15.2 cm (4⁵⁄₁₆ × 6 in.)
Los Angeles, J. Paul Getty Museum
84.XA.923.78

Unknown French photographer
Vicomte Odet de Montault, 1852–55
Salted paper print
15.9 × 13.7 cm (6¼ × 5⅜ in.)
Los Angeles, J. Paul Getty Museum
84.XA.923.79

30 Unknown French photographer
Madame the Vicomtesse de Montbreton,
1852–55
Salted paper print
22.2 × 16.5 cm (8¾ × 6½ in.)
Los Angeles, J. Paul Getty Museum
84.XA.923.74

31 Gustave Le Gray
French, 1820–1884
Auguste Mestral
French, 1812–1884
West Facade, Church of Saint-Jacques,
Aubeterre, 1851
Salted paper print
37.8 × 29.8 cm (14⅞ × 11¾ in.)
Los Angeles, J. Paul Getty Museum
90.XM.73.2

32 Gustave Le Gray
French, 1820–1884
Auguste Mestral
French, 1812–1884
End Pavilion of the Château de
Chenonceaux, 1851
Salted paper print from a waxed-paper
negative
43.9 × 33.9 cm (17⁵⁄₁₆ × 13⅜ in.)
Los Angeles, J. Paul Getty Museum
2005.4.2

33 Henri Le Secq
French, 1818–1882
Tower of the Kings at Reims Cathedral,
ca. 1853
Salted paper print
35.1 × 25.9 cm (13¹³⁄₁₆ × 10³⁄₁₆ in.)
Los Angeles, J. Paul Getty Museum
84.XP.370.25

34 Henri Le Secq
French, 1818–1882
Strasbourg (Bas-Rhin), Cathedral of
Notre-Dame, 1851
Waxed salted paper print
33.6 × 24 cm (13¼ × 9⁷⁄₁₆ in.)
Los Angeles, J. Paul Getty Museum
2015.39.2

35 Bisson Frères
French, active 1840–64
Amiens Cathedral, Main Facade,
Portal of the Virgin Mary, 1850s
Albumen silver print
45.6 × 36.6 cm (17¹⁵⁄₁₆ × 14⁷⁄₁₆ in.)
Los Angeles, J. Paul Getty Museum
2015.30.3

36 Édouard Baldus
French, born Prussia, 1813–1889
Cloister of Saint-Trophime, Arles, ca. 1851
Salted paper print
36.7 × 41.4 cm (14⁷⁄₁₆ × 16⁵⁄₁₆ in.)
Los Angeles, J. Paul Getty Museum
84.XM.641.22

37 Édouard Baldus
French, born Prussia, 1813–1889
Cloister of Saint-Trophime, Arles, ca. 1850
Salted paper print
37.1 × 42.3 cm (14½ × 16½ in.)
London, Wilson Centre for Photography
85:2025

38 Édouard Baldus
French, born Prussia, 1813–1889
Cloister of Saint-Trophime, Arles, ca. 1851
Salted paper print
20.7 × 23.2 cm (8⅛ × 9⅛ in.)
Los Angeles, J. Paul Getty Museum
84.XM.641.4

39 Édouard Baldus
French, born Prussia, 1813–1889
Cloister of Saint-Trophime, Arles, ca. 1861
Albumen silver print
32.8 × 41.2 cm (12¹⁵⁄₁₆ × 16¼ in.)
Los Angeles, J. Paul Getty Museum
84.XO.734.1.47

40 Édouard Baldus
French, born Prussia, 1813–1889
Cloister of Saint-Trophime, Arles, ca. 1861
Albumen silver print
33.7 × 42.9 cm (13¼ × 16⅞ in.)
Los Angeles, J. Paul Getty Museum
84.XO.734.1.46

41 Charles Nègre
French, 1820–1880
An Aisle of the Cloister of Saint-Trophime,
Arles, ca. 1852
Salted paper print
32.4 × 23.2 cm (12¾ × 9⅛ in.)
Los Angeles, J. Paul Getty Museum
84.XM.344.4

42 Charles Nègre
French, 1820–1880
Right Side of the Main Portal of Saint-Trophime, Arles, with Two Evangelists and the Damned, 1852–53
Salted paper print
31.6 × 23 cm (12⁷⁄₁₆ × 9¹⁄₁₆ in.)
Los Angeles, J. Paul Getty Museum
84.XP.1032.17

43 Édouard Baldus
French, born Prussia, 1813–1889
Church of Saint-Trophime, Arles, 1850s
Albumen silver print
28.1 × 22 cm (11¹⁄₁₆ × 8¹¹⁄₁₆ in.)
Los Angeles, J. Paul Getty Museum
84.XM.641.17

44 Charles Nègre
French, 1820–1880
Church of Saint-Gabriel, near Arles, 1852
Salted paper print
31.7 × 21.9 cm (12¹⁄₂ × 8⁵⁄₈ in.)
Los Angeles, J. Paul Getty Museum
2015.43.6

45 Charles Nègre
French, 1820–1880
Roman Ramparts, Arles, 1852
Salted paper print
23 × 32.4 cm (9¹⁄₁₆ × 12³⁄₄ in.)
Los Angeles, J. Paul Getty Museum
84.XM.344.14

46 André Giroux
French, 1801–1879
Square Courtyard of the Arles Amphitheater, 1850s
Salted paper print
34.6 × 27.2 cm (13⁵⁄₈ × 10¹¹⁄₁₆ in.)
Los Angeles, J. Paul Getty Museum
2015.35.1

47 Charles Nègre
French, 1820–1880
Roman Tower Restored under Francis I, Arles, 1852
Waxed-paper negative
16.5 × 20 cm (6¹⁄₂ × 7⁷⁄₈ in.)
San Francisco, Collection of Gary B. Sokol

48 Charles Nègre
French, 1820–1880
Roman Tower Restored under Francis I, Arles, 1852
Salted paper print
18.7 × 25.7 cm (7³⁄₈ × 10¹⁄₈ in.)
Los Angeles, J. Paul Getty Museum
2013.25

49 Charles Nègre
French, 1820–1880
Roman Tower Restored under Francis I, Arles, 1852
Salted paper print
17.1 × 17.1 cm (6³⁄₄ × 6³⁄₄ in.)
San Francisco, Collection of Gary B. Sokol

50 Charles Nègre
French, 1820–1880
Papal Palace, Avignon, 1852
Salted paper print
23.5 × 32.6 cm (9¹⁄₄ × 12¹³⁄₁₆ in.)
Los Angeles, J. Paul Getty Museum
2015.43.5

51 Édouard Baldus
French, born Prussia, 1813–1889
Papal Palace, Avignon, ca. 1861
Albumen silver print
33 × 42.2 cm (13 × 16⁵⁄₈ in.)
Los Angeles, J. Paul Getty Museum
84.XO.734.1.28

52 Henri Le Secq
French, 1818–1882
South Arm of the Transept of Notre-Dame, Paris, 1851
Salted paper print
32.7 × 23 cm (12.9 × 9.1 in.)
Paris, Bibliothèque des arts décoratifs

53 Charles Nègre
French, 1820–1880
The Angel of the Resurrection on the Roof of Notre-Dame, Paris, 1853
Salted paper print
32.9 × 23.3 cm (12¹⁵⁄₁₆ × 9³⁄₁₆ in.)
Los Angeles, J. Paul Getty Museum
84.XM.344.7

54 Charles Nègre
French, 1820–1880
Entrance to the Sacristy, Notre-Dame, Paris, ca. 1853
Salted paper print
32.1 × 22.9 cm (12⁵⁄₈ × 9 in.)
Los Angeles, J. Paul Getty Museum
84.XM.344.15

55 Henri Le Secq
French, 1818–1882
Demolitions in the Place de l'Hôtel de Ville, Paris, 1852
Salted paper print
32.3 × 22.7 cm (12.7 × 8.9 in.)
Paris, Bibliothèque des arts décoratifs

56 Édouard Baldus
French, born Prussia, 1813–1889
The Tour Saint-Jacques, 1852–53
Salted paper print
42.9 × 34 cm (16⁷⁄₈ × 13³⁄₈ in.)
Los Angeles, J. Paul Getty Museum
84.XM.348.4

57 Gustave Le Gray
French, 1820–1884
The Tour Saint-Jacques, ca. 1857–59
Albumen silver print
50 × 39.7 cm (19¹¹⁄₁₆ × 15⁵⁄₈ in.)
Los Angeles, J. Paul Getty Museum
84.XP.218.18

58 Henri Le Secq
French, 1818–1882
Print by
Louis Désiré Blanquart-Evrard
French, 1802–1872
Church of the Madeleine, 1851–53
Salted paper print
23 × 32.7 cm (9¹⁄₁₆ × 12⁷⁄₈ in.)
Los Angeles, J. Paul Getty Museum
84.XP.345.88

59 Bisson Frères
French, active 1840–64
Entrance to the Imperial Library, the Louvre Palace, Paris, ca. 1858
Albumen silver print
46 × 34.9 cm (18¹⁄₈ × 13³⁄₄ in.)
Los Angeles, J. Paul Getty Museum
84.XM.359.8

60 Charles Nègre
French, 1820–1880
Pavillon de l'Horloge, the Louvre, Paris, 1855
Salted paper print
70.2 × 53 cm (27⁵⁄₈ × 20⁷⁄₈ in.)
Los Angeles, J. Paul Getty Museum
2015.43.3

61 Gustave Le Gray
French, 1820–1884
Pavillon Mollien, the Louvre, Paris, 1859
Albumen silver print
36.7 × 47.9 cm (14⁷⁄₁₆ × 18⁷⁄₈ in.)
Los Angeles, J. Paul Getty Museum
90.XM.72

62 Édouard Baldus
French, born Prussia, 1813–1889
Pont de la Mulatière, ca. 1861
Albumen silver print
28.4 × 44 cm (11³⁄₁₆ × 17⁵⁄₁₆ in.)
Los Angeles, J. Paul Getty Museum
84.XO.401.5

63 Gustave Le Gray
French, 1820–1884
The Pont du Carrousel Seen from the Pont Royal, 1857
Albumen silver print
38.7 × 50.5 cm (15¹⁄₄ × 19⁷⁄₈ in.)
Los Angeles, J. Paul Getty Museum
84.XP.218.37

64 Charles Nègre
French, 1820–1880
Resting Chimney Sweeps, 1851
Salted paper print
16.2 × 19.7 cm (6³⁄₈ × 7³⁄₄ in.)
Los Angeles, J. Paul Getty Museum
84.XM.344.11

65 Charles Nègre
French, 1820–1880
Italian Street Musicians at Entrance to 21, Quai de Bourbon, Paris, 1851
Salted paper print
22.1 × 16.2 cm (8¹¹⁄₁₆ × 6³⁄₈ in.)
Los Angeles, J. Paul Getty Museum
84.XM.344.10

66 **Charles Nègre**
French, 1820–1880
Organ-Grinder at 21, Quai de Bourbon, Paris,
before March or May 1853
Salted paper print
10 × 8.3 cm (3¹⁵⁄₁₆ × 3¼ in.)
Los Angeles, J. Paul Getty Museum
84.XM.344.1

67 **Charles Nègre**
French, 1820–1880
*Licorice-Water Vendor at 21, Quai de Bourbon,
Paris*, ca. 1852
Waxed-paper negative
20.5 × 15 cm (8 × 6 in.)
Paula and Robert Hershkowitz

68 **Charles Nègre**
French, 1820–1880
*Licorice-Water Vendor at 21, Quai de Bourbon,
Paris*, ca. 1852
Salted paper print
20 × 14.3 cm (7¾ × 5½ in.)
Paula and Robert Hershkowitz

69 **Charles Nègre**
French, 1820–1880
*Licorice-Water Vendor at 21, Quai de Bourbon,
Paris*, ca. 1852
Oil on panel
21 × 16 cm (8½ × 6¼ in.)
The Israel Museum, Jerusalem,
Anonymous Gift to the American Friends
of the Israel Museum
B15.8831

70 **Charles Nègre**
French, 1820–1880
*Rachel Félix and Two Unidentified Men
on a Balcony*, 1853
Salted paper print
19.2 × 13.8 cm (7⁹⁄₁₆ × 5⁷⁄₁₆ in.)
Los Angeles, J. Paul Getty Museum
84.XM.344.8

71 **Gustave Le Gray**
French, 1820–1884
Victor Cousin, ca. 1856
Albumen silver print
20 × 15.2 cm (7⅞ × 6 in.)
Los Angeles, J. Paul Getty Museum
84.XM.343.3

72 **Nadar (Gaspard-Félix Tournachon)**
French, 1820–1910
Henri Murger, ca. 1855
Salted paper print
23.3 × 16.6 cm (9⅛ × 6½ in.)
Los Angeles, J. Paul Getty Museum
84.XM.436.316

73 **Nadar (Gaspard-Félix Tournachon)**
French, 1820–1910
Henri Murger, ca. 1855
Hand-painted salted paper print
23.3 × 16.6 cm (9⅛ × 6½ in.)
Los Angeles, J. Paul Getty Museum
84.XM.436.317

74 **Nadar (Gaspard-Félix Tournachon)**
French, 1820–1910
Alexandre Dumas, 1855
Salted paper print
23.5 × 18.7 cm (9¼ × 7⅜ in.)
Los Angeles, J. Paul Getty Museum
84.XM.262.4

75 **Nadar (Gaspard-Félix Tournachon)**
French, 1820–1910
Théophile Gautier, ca. 1856
Salted paper print
24.9 × 18.3 cm (9¹³⁄₁₆ × 7³⁄₁₆ in.)
Los Angeles, J. Paul Getty Museum
84.XM.436.37

76 **Nadar (Gaspard-Félix Tournachon)**
French, 1820–1910
*George Sand (Amandine-Aurore-Lucile
Dupin)*, ca. 1865
Albumen silver print
24.1 × 18.3 cm (9½ × 7¼ in.)
Los Angeles, J. Paul Getty Museum
84.XM.436.91

77 **Nadar (Gaspard-Félix Tournachon)**
French, 1820–1910
Émile Augier, ca. 1852
Graphite on paper
32.4 × 24.3 cm (12¾ × 9⁹⁄₁₆ in.)
Los Angeles, J. Paul Getty Museum
84.GG.790.117

78 **Nadar (Gaspard-Félix Tournachon)**
French, 1820–1910
Émile Augier, ca. August 1857
Salted paper print
23.7 × 18.7 cm (9⁵⁄₁₆ × 7⅜ in.)
Los Angeles, J. Paul Getty Museum
84.XM.262.3

79 **Nadar (Gaspard-Félix Tournachon)**
French, 1820–1910
Charles Philipon, 1856–58
Salted paper print
21.9 × 16.6 cm (8⅝ × 6½ in.)
Los Angeles, J. Paul Getty Museum
84.XM.436.142

80 **Nadar (Gaspard-Félix Tournachon)**
French, 1820–1910
Auguste Vacquerie, ca. 1865
Albumen silver print
19.7 × 15 cm (7¾ × 5⅞ in.)
Los Angeles, J. Paul Getty Museum
84.XM.436.21

81 **Nadar (Gaspard-Félix Tournachon)**
French, 1820–1910
Auguste Vacquerie, ca. 1865
Salted paper print with paint
26 × 20.7 cm (10¼ × 8⅛ in.)
Los Angeles, J. Paul Getty Museum
84.XM.436.449

82 **Nadar (Gaspard-Félix Tournachon)**
French, 1820–1910
Jean-François Millet, 1856–58
Salted paper print
26.3 × 19.7 cm (10⅜ × 7¾ in.)
Los Angeles, J. Paul Getty Museum
84.XM.436.40

83 **Nadar (Gaspard-Félix Tournachon)**
French, 1820–1910
Théodore Rousseau, 1857
Salted paper print
25.9 × 20.3 cm (10³⁄₁₆ × 8 in.)
Los Angeles, J. Paul Getty Museum
84.XM.436.186

84 **Charles Nègre**
French, 1820–1880
A Street in Grasse, 1852
Waxed salted paper print
32.7 × 23.2 cm (12⅞ × 9⅛ in.)
Los Angeles, J. Paul Getty Museum
Gift of Jay H. McDonald
2015.49

85 **Charles Nègre**
French, 1820–1880
Mill, Grasse, 1852
Albumen silver print
15.9 × 15.9 cm (6¼ × 6¼ in.)
Los Angeles, J. Paul Getty Museum
84.XM.344.3

86 **Charles Nègre**
French, 1820–1880
The Gate of the Chestnuts, Arles, 1852
Salted paper print
22.9 × 31.6 cm (9 × 12⁷⁄₁₆ in.)
Los Angeles, J. Paul Getty Museum
84.XM.344.13

87 **Henri Le Secq**
French, 1818–1882
Small Dwelling in Mushroom Cave, 1851
Salted paper print
35.1 × 22.7 cm (13¹³⁄₁₆ × 8¹⁵⁄₁₆ in.)
Los Angeles, J. Paul Getty Museum
84.XP.370.24

88 **Henri Le Secq**
French, 1818–1882
Three Peasants, 1853
Salted paper print
10.5 × 15.3 cm (4¼ × 6 in.)
Paris, Bibliothèque des arts décoratifs

89 **Henri Le Secq**
French, 1818–1882
Stairs of the Reine Berthe, Chartres, 1852
Salted paper print
32.3 × 22.5 cm (12.7 × 8.9 in.)
Paris, Bibliothèque des arts décoratifs

90 **André Giroux**
French, 1801–1879
Village Scene with Geese, ca. 1855
Salted paper print
21.5 × 27.5 cm (8⁷⁄₁₆ × 10¹³⁄₁₆ in.)
Los Angeles, J. Paul Getty Museum
2015.35.3

91 **André Giroux**
French, 1801–1879
*Thatched Cottage with Geese in Boursadière,
Allier*, ca. 1855
Salted paper print
21.4 × 27 cm (8⁷⁄₁₆ × 10⅝ in.)
Los Angeles, J. Paul Getty Museum
84.XP.776.13

92 **Édouard Baldus**
French, born Prussia, 1813–1889
Landscape with Stream and Stone and Wooden Bridge, 1854–55
Salted paper print
27.9 × 40.5 cm (11 × 15¹⁵/₁₆ in.)
Los Angeles, J. Paul Getty Museum
84.XM.348.21

93 **Henri-Victor Regnault**
French, 1810–1878
Print by
Alphonse-Louis Poitevin
French, 1819–1882
The Seine at Meudon, Sèvres, negative, ca. 1853; print, 1855–60
Carbon print
31.1 × 42.7 cm (12¹/₄ × 16¹³/₁₆ in.)
Los Angeles, J. Paul Getty Museum
92.XM.52

94 **Édouard Baldus**
French, born Prussia, 1813–1889
Millstream in the Auvergne, with Camera, 1854
Albumenized salted paper print
44.1 × 33.7 cm (17³/₈ × 13¹/₄ in.)
Los Angeles, J. Paul Getty Museum
84.XM.348.16

95 **Henri Le Secq**
French, 1818–1882
Study of the Head of a Woman with Closed Eyes, 1850s
Oil on canvas
8.8 × 7.7 cm (3¹/₂ × 3 in.)
Los Angeles, The Manfred Heiting Library

96 **Charles Nègre**
French, 1820–1880
Universal Suffrage: A Study, 1850s
Oil on canvas
24.5 × 19 cm (9¹/₂ × 7¹/₂ in.)
Private collection

97 **Charles Nègre**
French, 1820–1880
Nègre's Painting "The Strength of Man," after 1859
Albumen silver print
13.1 × 9.4 cm (5 × 3³/₄ in.)
Ottawa, National Gallery of Canada, Purchased 1968
32435

98 **Gustave Le Gray**
French, 1820–1884
Millet's Drawing of the "Mona Lisa," 1849
Albumen silver print
28.9 × 19.1 cm (11³/₈ × 7¹/₂ in.)
Los Angeles, J. Paul Getty Museum
85.XM.137

99 **Gustave Le Gray**
French, 1820–1884
Salon of 1852, Palais-Royal, 1852
Salted paper print
24 × 37.9 cm (9⁷/₁₆ × 14¹⁵/₁₆ in.)
Los Angeles, J. Paul Getty Museum
84.XA.412.9

100 **Gustave Le Gray**
French, 1820–1884
The Salon of 1850, 1850
Salted paper print
26.4 × 33.7 cm (10³/₈ × 13¹/₄ in.)
Los Angeles, J. Paul Getty Museum
84.XA.412.10

101 **Gustave Le Gray**
French, 1820–1884
Salon of 1852, 1852
Salted paper print
18.1 × 22.5 cm (7¹/₈ × 8⁷/₈ in.)
Los Angeles, J. Paul Getty Museum
84.XA.412.2

102 **Jean-Louis-Marie-Eugène Durieu**
French, 1800–1874
Possibly with
Eugène Delacroix
French, 1798–1863
Draped Model, ca. 1854
Albumen silver print
18.6 × 13 cm (7⁵/₁₆ × 5¹/₈ in.)
Los Angeles, J. Paul Getty Museum
85.XM.351.9

103 **Attributed to Félix Jacques Moulin**
French, 1802–1879
Female Nude, 1856
Albumen silver print
16.5 × 21.9 cm (6¹/₂ × 8⁵/₈ in.)
Los Angeles, J. Paul Getty Museum
84.XP.687.1

104 **Gustave Le Gray**
French, 1820–1884
Reclining Female Nude, ca. 1856
Albumen silver print
21.7 × 32.9 cm (8¹/₂ × 13 in.)
New York, Metropolitan Museum of Art
Gilman Collection, Purchase, The Horace W. Goldsmith Foundation Gift, through Joyce and Robert Menschel
2005.100.274

105 **Achille Devéria**
French, 1800–1857
Outdoor Portrait of a Young Lady, probably Cécile Devéria, 1854
Salted paper print with ink
14 × 10.8 cm (5¹/₂ × 4¹/₄ in.)
Los Angeles, J. Paul Getty Museum
84.XM.485.64

106 **Gustave Le Gray**
French, 1820–1884
Route de Chailly, Fontainebleau, paper negative, ca. 1852; glass negative for sky, ca. 1856; print, ca. 1856
Albumen silver print
25.6 × 35.4 cm (10¹/₁₆ × 13¹⁵/₁₆ in.)
Los Angeles, J. Paul Getty Museum
84.XM.347.3

107 **Gustave Le Gray**
French, 1820–1884
Curtain of Trees, Fontainebleau, 1849–50
Salted paper print
19.8 × 26.4 cm (7¹³/₁₆ × 10³/₈ in.)
Los Angeles, J. Paul Getty Museum
84.XM.637.6

108 **Gustave Le Gray**
French, 1820–1884
Forest Scene, Fontainebleau, 1849–52
Albumen silver print
29.7 × 37.6 cm (11¹¹/₁₆ × 14¹³/₁₆ in.)
Los Angeles, J. Paul Getty Museum
84.XM.637.11

109 **Eugène Cuvelier**
French, 1837–1900
Forest Scene, Fontainebleau, 1863
Albumen silver print
25.1 × 32.9 cm (9⁷/₈ × 12¹⁵/₁₆ in.)
Los Angeles, J. Paul Getty Museum
84.XP.687.52

110 **Eugène Cuvelier**
French, 1837–1900
Landscape Study, ca. 1862
Albumen silver print
25.6 × 34 cm (10¹/₁₆ × 13³/₈ in.)
Los Angeles, J. Paul Getty Museum
84.XP.218.51

111 **Eugène Cuvelier**
French, 1837–1900
Achicourt, near Arras, ca. 1860
Salted paper print
26 × 19.7 cm (10¹/₄ × 7³/₄ in.)
Los Angeles, J. Paul Getty Museum
2015.31

112 **Comte Olympe Aguado**
French, 1827–1894
Large Oak in the Bois de Boulogne, ca. 1855
Albumen silver print
40.2 × 28 cm (15¹³/₁₆ × 11 in.)
Los Angeles, J. Paul Getty Museum
84.XM.358.10

113 **André Giroux**
French, 1801–1879
The Ponds at Optevoz, Rhône, ca. 1855
Salted paper print
26.7 × 33.5 cm (10¹/₂ × 13³/₁₆ in.)
Los Angeles, J. Paul Getty Museum
84.XP.362.3

114 **Gustave Le Gray**
French, 1820–1884
The Beach at Sainte-Adresse, 1856
Albumen silver print
31.6 × 42.2 cm (12⁷/₁₆ × 16⁵/₈ in.)
Los Angeles, J. Paul Getty Museum
84.XM.637.25

115 **Gustave Le Gray**
French, 1820–1884
Lighthouse and Jetty, Le Havre, 1856–58
Albumen silver print
31 × 40.3 cm (12³/₁₆ × 15⁷/₈ in.)
Los Angeles, J. Paul Getty Museum
85.XM.153

116 **Gustave Le Gray**
French, 1820–1884
An Effect of Sunlight—Ocean No. 23, ca. 1858
Albumen silver print
32.1 × 41.8 cm (12⁵/₈ × 16⁷/₁₆ in.)
Los Angeles, J. Paul Getty Museum
84.XM.347.10

117 **Gustave Le Gray**
French, 1820–1884
The Sun at Its Zenith, Normandy, ca. 1858
Albumen silver print
32.5 × 41.6 cm (12¹³⁄₁₆ × 16³⁄₈ in.)
Los Angeles, J. Paul Getty Museum
84.XM.347.17

118 **Gustave Le Gray**
French, 1820–1884
The Brig, 1856
Albumen silver print
32.1 × 40.8 cm (12⁵⁄₈ × 16¹⁄₁₆ in.)
Los Angeles, J. Paul Getty Museum
84.XM.637.2

119 **Gustave Le Gray**
French, 1820–1884
Seascape with a Ship Leaving Port, 1856–58
Albumen silver print
31.3 × 40.3 cm (12⁵⁄₁₆ × 15⁷⁄₈ in.)
Los Angeles, J. Paul Getty Museum
84.XP.218.71

120 **Gustave Le Gray**
French, 1820–1884
The Breaking Wave, 1857
Albumen silver print
41.4 × 33.5 cm (16⁵⁄₁₆ × 13³⁄₁₆ in.)
Los Angeles, J. Paul Getty Museum
84.XM.347.11

121 **Henri Le Secq**
French, 1818–1882
Fantasies, ca. 1855
Cyanotype
36.7 × 26.8 cm (14.4 × 10.5 in.)
Paris, Bibliothèque des arts décoratifs

122 **Henri Le Secq**
French, 1818–1882
Romanesque Ornaments, ca. 1853–55
Salted paper print
33.4 × 25.3 cm (13¹⁄₈ × 9¹⁵⁄₁₆ in.)
Los Angeles, J. Paul Getty Museum
2014.24.3

123 **Louis-Rémy Robert**
French, 1811–1882
Still Life with Statuette and Vases,
negative, 1855; print, 1870s
Carbon print
32.4 × 26.2 cm (12³⁄₄ × 10⁵⁄₁₆ in.)
Los Angeles, J. Paul Getty Museum
84.XP.218.10

124 **Attributed to Henri-Victor Regnault**
French, 1810–1878
Louis Désiré Blanquart-Evrard
French, 1802–1872
*Still Life with Straw Basket, Rug,
and Potted Plant on Ladder*, ca. 1853
Albumen silver print
18.4 × 18.3 cm (7¹⁄₄ × 7³⁄₁₆ in.)
Los Angeles, J. Paul Getty Museum
84.XO.1279.39

125 **Henri-Victor Regnault**
French, 1810–1878
Louis Désiré Blanquart-Evrard
French, 1802–1872
*Still Life with Straw Baskets, Broom, Opened
Sack of Potatoes, and Potted Plants*, ca. 1853
Albumen silver print
19.1 × 25.4 cm (7¹⁄₂ × 10 in.)
Los Angeles, J. Paul Getty Museum
84.XO.1279.43

126 **Charles Marville**
French, 1813–1879
Rue au Lard, Paris, 1865–69
Albumen silver print
34.3 × 27.1 cm (13¹⁄₂ × 10¹¹⁄₁₆ in.)
Los Angeles, J. Paul Getty Museum
2015.40

127 **Henri Le Secq**
French, 1818–1882
In the Field of the Cossacks, Montmirail,
1852–53
Salted paper print
23.5 × 33.7 cm (9¹⁄₄ × 13¹⁄₄ in.)
Los Angeles, J. Paul Getty Museum
84.XP.370.26

128 **Gustave Le Gray**
French, 1820–1884
Factory, Terre-Noire, 1851–55
Salted paper print
24.61 × 32.7 cm (9¹¹⁄₁₆ × 12⁷⁄₈ in.)
Los Angeles, J. Paul Getty Museum
2002.13

129 **Bisson Frères**
French, active 1840–64
*After an Earthquake near Viège, Valais,
Switzerland*, July 25–26, 1855
Albumen print
35.5 × 44.7 cm (14 × 17⁵⁄₈ in.)
Los Angeles, J. Paul Getty Museum
2015.30.2

130 **Bisson Frères**
French, active 1840–64
*Destroyed House, after an Earthquake near
Viège, Valais, Switzerland*, July 25–26, 1855
Albumen silver print
35.9 × 43 cm (14¹⁄₈ × 16¹⁵⁄₁₆ in.)
Los Angeles, J. Paul Getty Museum
2015.30.1

131 **Édouard Baldus**
French, born Prussia, 1813–1889
Lyon (Floods), 1856
Salted paper print
33 × 43.4 cm (13 × 17¹⁄₁₆ in.)
Los Angeles, J. Paul Getty Museum
2015.29

132 **Édouard Baldus**
French, born Prussia, 1813–1889
Avignon (Flood of 1856), 1856
Salted paper print
31.9 × 44.3 cm (12⁹⁄₁₆ × 17⁷⁄₁₆ in.)
Los Angeles, J. Paul Getty Museum
84.XM.348.24

133 **Gustave Le Gray**
French, 1820–1884
Panorama of the Camp at Châlons, 1857
Albumen silver prints
Six photographs in three frames:
30.6 × 74.1 cm (12¹⁄₁₆ × 29³⁄₁₆ in.);
32.5 × 70.5 cm (12¹³⁄₁₆ × 27³⁄₄ in.);
30.6 × 68.9 cm (12¹⁄₁₆ × 27¹⁄₈ in.)
Los Angeles, J. Paul Getty Museum
84.XO.377.35–.40

134 **Gustave Le Gray**
French, 1820–1884
The French Fleet, Cherbourg, August 4–6,
1858
Albumen silver print
30.8 × 39.1 cm (12¹⁄₈ × 15³⁄₈ in.)
Los Angeles, J. Paul Getty Museum
2014.57

135 **Édouard Baldus**
French, born Prussia, 1813–1889
Bandol, ca. 1860
Albumen silver print
33.3 × 43 cm (13¹⁄₈ × 16¹⁵⁄₁₆ in.)
Los Angeles, J. Paul Getty Museum
Gift of Michael and Jane Wilson, The Wilson
Centre for Photography LLC
98.XM.173

136 **Édouard Baldus**
French, born Prussia, 1813–1889
Entrance to the Donzère Pass, ca. 1861
Albumen silver print
33.5 × 42.4 cm (13³⁄₁₆ × 16¹¹⁄₁₆ in.)
Los Angeles, J. Paul Getty Museum
84.XO.734.1.20

137 **Henri Le Secq**
French, 1818–1882
Statue of Christ, Reims Cathedral, ca. 1853
Salted paper print
34.3 × 24.5 cm (13¹⁄₂ × 9⁵⁄₈ in.)
Los Angeles, J. Paul Getty Museum
2014.24.1

138 **Henri Le Secq**
French, 1818–1882
Statue of Christ, Reims Cathedral,
negative, 1853; print, 1870s
Photolithograph
35 × 24.8 cm (13³⁄₄ × 9³⁄₄ in.)
Los Angeles, J. Paul Getty Museum
2014.24.2

139 **Henri Le Secq**
French, 1818–1882
Chartres Cathedral, negative, 1852;
print, 1870s
Photolithograph
33.3 × 23.8 cm (13¹⁄₈ × 9³⁄₈ in.)
Los Angeles, J. Paul Getty Museum
84.XM.832.3

140 Henri Le Secq
French, 1818–1882
North Transept, Chartres Cathedral,
negative, 1852; print, 1870
Photolithograph
33.3 × 22.9 cm (13⅛ × 9 in.)
Los Angeles, J. Paul Getty Museum
84.XM.832.1

141 Charles Nègre
French, 1820–1880
Italian Musicians (Pifferari) *at
21, Quai de Bourbon, Paris*, negative,
summer 1853; print, 1854
Photogravure
16.2 × 21.9 cm (6⅜ × 8⅝ in.)
Los Angeles, J. Paul Getty Museum
84.XP.446.26

142 Charles Nègre
French, 1820–1880
Mason Kneeling, negative, before September
1853; print, February–March 1854
Photogravure
5.7 × 4.9 cm (2¼ × 1¹⁵⁄₁₆ in.)
Los Angeles, J. Paul Getty Museum
84.XP.453.12

143 Charles Nègre
French, 1820–1880
*Royal Portal (The Incarnation Portal),
South Lateral Doorway, Chartres Cathedral*,
1857
Heliogravure
60.2 × 45.6 cm (23¹¹⁄₁₆ × 17¹⁵⁄₁₆ in.)
Los Angeles, J. Paul Getty Museum
84.XP.218.35

144 Lieutenant Louis Vignes
French, 1831–1896
Charles Nègre
French, 1820–1880
View of Sidon, negative, 1864; print, 1875
Heliogravure
19.5 × 25.6 cm (7¹¹⁄₁₆ × 10¹⁄₁₆ in.)
Los Angeles, J. Paul Getty Museum
84.XM.692.1

Chronology

Karlyn Olvido

1822

Joseph Nicéphore Niépce (born 1765) begins experiments with photography (which he names "héliogravure") at his home in Chalon-sur-Saône, France, and obtains his first images on metal plates with bitumen of Judea.

In Paris, Louis-Jacques-Mandé Daguerre (born 1787) opens the first Diorama, in collaboration with French academic painter Charles-Marie Bouton (1781–1853).

April 24
First exhibition of Romantic painter Eugène Delacroix (1798–1863) and academic painter Paul Delaroche (1797–1856) in the Salon, at the Louvre.

1827

Niépce and Daguerre meet through optician Charles Chevalier (1804–1859).

Hippolyte Bayard (born 1801 in Breteuil-sur-Noye, Oise) moves to Paris and becomes a clerk at the Ministry of Finance.

1829

Contract signed between Niépce and Daguerre to perfect the heliograph.

Honoré de Balzac (1799–1850) publishes his first novel, *The Last Chouan* (later titled *The Chouans* and published in *Scenes from Military Life*, part of Balzac's *The Human Comedy)*; it is set in Brittany in 1799 during the royalist uprising (the "Chouannerie") against the French Revolution and Republic.

1830

July monarchy of Louis-Philippe (r. 1830–48).

1831

Balzac's novel *The Magic Skin* is published; it is pioneering as it follows a contemporary character through the streets of Paris.

1832

December
Victor Hugo (1802–1885) publishes a new edition of *The Hunchback of Notre-Dame* (first published in March 1831), with three extra chapters. A note by the author to the new edition states: "Whatever may be the future of architecture, in whatever manner our young architects may one day solve the question of their art, let us, while waiting for new monuments, preserve the ancient monuments. Let us, if possible, inspire the nation with a love for national architecture. That, the author declares, is one of the principal aims of this book; it is one of the principal aims of his life." Two years earlier, in 1830, François Guizot, minister of the interior under Louis-Philippe, had established the post of inspector general of historical monuments; in 1837, as minister of public education, Guizot will create the Commission des monuments historiques, which in 1851 will sponsor the Mission héliographique.

1833

July 5
Niépce dies suddenly.

1837

Charles Nègre (born 1820 in Grasse) takes drawing lessons with Sébastien Pezetti from Aix-en-Provence.

Balzac's novel *Lost Illusions* is published.

1838

Eduard Baldus (born 1813 in Grünebach, Prussia) arrives in Paris to study painting. He changes the spelling of his first name to the French "Édouard."

The future portrait photographer Gaspard-Félix Tournachon (born 1820 in Paris) takes the name Nadar.

1839

Nègre moves to Paris to take courses at the École des beaux-arts and joins Paul Delaroche's studio.

January 7
François Arago (1786–1853), secretary of the Académie des sciences, announces the daguerreotype process at the weekly meeting of the academy.

January 25
William Henry Fox Talbot (1800–1877) exhibits some of his photogenic drawings at the Royal Institution in London.

February 1
Bayard begins his experiments with direct positives on paper.

August 19
Arago announces the invention of the daguerreotype before a joint session of the Académie des sciences and the Académie des beaux-arts.

1840

October
Henri Le Secq (born Jean-Louis-Henri Le Secq Destournelles in 1818, in Paris) becomes a student of Paul Delaroche and meets Nègre.

1840–41

Gustave Le Gray (born Jean-Baptiste Gustave Le Gray in 1820, in Villiers-le-Bel, outside Paris) is a clerk in the notary office of Edme Lechat in Villiers-le-Bel.

1841

Balzac decides on the title *The Human Comedy* for the future compilation of his writings that will explore multiple facets of Parisian and provincial life from the time of the French Revolution.

Baldus submits four paintings to the annual Salon; all are rejected.

February 5
Talbot announces his calotype process in the *Literary Gazette* (London) and, three days later, files a patent for his process. He will present the calotype to the Royal Society in June.

April 8
Nègre is admitted to the École des beaux-arts as a student in painting and sculpture.

1841–42

Nadar associates with a group of artists gathered around Henri Murger (1822–1861) who call themselves the Water Drinkers.

1842

Le Secq exhibits his paintings for the first time at the annual Salon, at the Louvre, where Baldus shows his painting *Virgin and Child*.

Le Gray leaves Villiers-le-Bel and moves to 170, rue du Faubourg-Saint-Denis, in Paris. He joins Delaroche's studio, where he meets Le Secq and Nègre. He requests a copyist's pass to the Louvre.

1842–43

Nadar meets Charles Baudelaire (1821–1867) and begins working at the Republican daily newspaper *Le commerce*.

1843

Champfleury (Jules-François-Félix Husson) (1821–1889)—who in 1850 will write a pamphlet for a private exhibition by Gustave Courbet (for which the artist himself will produce a manifesto on Realism), and in 1857 will publish *Le réalisme*—moves to Paris and meets Baudelaire.

Le Gray leaves for Italy. Shortly thereafter, Delaroche officially closes his painting studio in Paris and departs for Rome. Le Secq moves to Rome the following year.

Nègre exhibits a portrait at the Salon for the first time and briefly apprentices with Michel-Martin Drolling (1789–1851). He later works in the studio of Jean-Auguste-Dominique Ingres (1780–1867), until about 1848.

1844

Champfleury begins working as an art critic for the weekly illustrated journal *L'artiste*.

Nègre begins to make daguerreotypes.

1844–45

First installment of Murger's *Scènes de la vie de Bohème* (later turned into the play *La vie bohème*, which will inspire Puccini's 1895 opera *La bohème*) appears in the journal *Le corsaire*.

1845

Hugo begins writing *Les misères*, published as *Les misérables* in 1862.

Nègre exhibits his painting *The Voyage to Cythera* at the Salon, at the Louvre. Le Secq receives a medal at the Salon for *The Sleep of the Models*, which he had sent from Italy; the work is purchased by the state.

Delaroche returns to Paris from Rome.

1846

Le Secq returns to Paris from Rome.

Nadar begins his career as a caricaturist, working for the satirical journals *Le corsaire* and *La silhouette*.

Louis Désiré Blanquart-Evrard (born 1802 in Lille) sends a document including his paper-negative process to the Académie des sciences; correspondence between Jean-Baptiste Biot (1774–1862) and Talbot.

1847

Léon de Laborde (1807–1869) becomes curator of antiquities at the Louvre; in 1848, he will become curator of works from the Middle Ages and the Renaissance.

François Guizot, minister of the interior, commissions from Nègre a copy of the portrait of Louis-Philippe by Franz Xaver Winterhalter (1805–1873) for the mayor of Grasse.

During the summer, Le Gray and Arago attempt to make daguerreotypes of sunspots in Paris; in October, they make a daguerreotype of an eclipse.

In June, Blanquart-Evrard publishes his method of photography on paper, building on that of Talbot. A commission is assembled to test Blanquart-Evrard's process.

Le Secq travels to London.

1847–48

Claude-Félix-Abel Niépce de Saint-Victor (1805–1870), cousin of Joseph Nicéphore Niépce, develops a method for making photographic negatives on glass coated with albumen.

1848

In an article in *Le pamphlet*, Champfleury is one of the first art critics to promote the work of Courbet.

Le Gray attempts for the first time to make photographic prints with collodion on paper. He also submits two paintings to the Salon (both are rejected) and makes daguerreotype portraits of Le Secq's parents.

Nègre is sympathetic to the Republican cause during the insurrection of 1848 and volunteers for the National Guard to protect the Louvre. He shows *The Death of Saint Paul* at the Salon; he paints *Universal Suffrage* for a competition, but his work is not selected. By the end of the year, he begins to practice photography on paper.

Louis-Philippe is overthrown. The Second Republic (1848–52) is proclaimed and the National Workshops for the Unemployed are established. The director of the Louvre decides that all work submitted to the Salon jury should be accepted, including two paintings by Le Gray. Universal suffrage is decreed. In April and May, the National Constituent Assembly makes a conservative turn.

June–July
Hugo becomes a member of the new assembly and speaks for freedom of the press and against the death penalty. The National Workshops are abolished, leading to the June Days of uprisings and to new laws restricting freedom of the press.

Le Secq, with the help of Le Gray, begins to experiment with photography on paper. Le Gray, Le Secq, and Mestral photograph one another.

November
The new constitution, written by the National Constituent Assembly, is adopted.

December
Louis-Napoléon is elected president.

1849

Nadar submits first work for the *Journal pour rire* of the lithographer, caricaturist, and journalist Charles Philipon (1800–1862); they will collaborate closely until 1862.

June
Nègre shows the painting *Universal Suffrage* at the Salon, at the Palais des Tuileries.

August
Théophile Gautier (1811–1872) critiques Nègre's *Universal Suffrage* in *La presse*.

September–October
Le Gray takes his first photographs in the forest of Fontainebleau, in the company of Nègre.

Le Gray receives a bronze medal for his prints on paper shown in the photography section of the eleventh Exposition nationale des produits de l'industrie.

1850

Taking photographs of the Salon, Le Gray experiments with collodion on glass. At the Salon, Nègre exhibits paintings of nudes derived from photographs, dated 1850, and the painting *The Bean Seller*.

Summer
Le Gray publishes his treatise on the dry waxed-paper process, *Traité pratique de photographie sur papier et sur verre*. Nadar is imprisoned in Clichy for debts.

August 18
Balzac dies in Paris.

September
Le Secq and Nègre experiment with Le Gray's paper-negative process.

December
The Salon rejects a group of nine photographs mounted in a single frame submitted by Le Gray; Courbet shows his painting *The Stone Breakers*.

1851

Nadar begins planning his *Panthéon*, lithographs with caricatures of prominent contemporaries.

January
Champfleury, Delacroix, Le Gray, and Le Secq, among others, establish the Société héliographique, on the rue des Arcades, near the Bourse.

Le Secq shows examples of his photographs of architecture to the Commission des monuments historiques and is appointed to the Mission héliographique.

February 9
The Société héliographique circulates the first issue of its weekly journal, *La lumière*, which lists the founding members and describes the group's mission.

February
Le Gray sends a description of his waxed-paper process to the Académie des sciences in a sealed envelope.

Baldus, Bayard, and Le Secq are appointed to the Mission héliographique.

Bayard photographs sites in Normandy and Brittany using glass plates.

March
Laborde, Le Gray, and Le Secq establish a group within the Société héliographique to enquire into the creation of a photographic printing company. Blanquart-Evrard founds the Imprimerie photographique in Lille, and the Imprimerie Fontenay is founded in Paris.

April
Le Gray reveals his waxed-paper process to the Société héliographique.

May
The Great Exhibition opens in London's Crystal Palace. There Le Gray exhibits two sets of nine prints each, mounted in two frames, and Le Secq presents two portfolios, each containing six views of the cathedrals of Amiens, Chartres, and Reims. The jury finds his distortion of perspective "highly unpleasing."

Le Gray and Mestral are added to the Mission héliographique and depart in July.

La lumière announces the five Missions héliographiques.

July
Le Secq travels on his Mission héliographique.

The second edition of Le Gray's 1850 treatise is published as *Nouveau traité théorique et pratique de photographie sur papier et sur verre*.

July 10
Daguerre dies in Bry-sur-Marne.

Late September–October
Le Gray and Mestral return to Paris, and their first prints for the Mission héliographique appear.

November
Le Gray deposits a sealed envelope containing a text about "positive prints on paper with extremely varied coloration and greater stability" with the Académie des sciences.

December 2
Coup d'état by Louis-Napoléon. Hugo tries, unsuccessfully, to organize a movement against him.

December 8
Le Gray applies for a patent for his invention of "a kind of prepared paper for photography." The sealed envelopes deposited by Le Gray in February and November are opened and the texts are read to the members of the Académie des sciences.

Dissolution of the Société héliographique.

1852

January 9
A decree is issued exiling Hugo from France.

Spring
Le Gray submits a painted portrait of Le Secq and three photographs to the Salon; all are rejected. Accompanied by John Beasly Greene (1832–1856), Le Gray photographs in the forest of Fontainebleau.

Courbet exhibits *Young Ladies of the Village* at the Salon, at the Palais-royal.

April–May
Baldus shows photographs of the south of France to Ernest Lacan (1828–1879) at one of Lacan's informal soirées at his home. Le Gray, Le Secq, Nègre, Niépce de Saint-Victor, Victor Plumier, François-Auguste Renard, and Jules Claude Ziegler are also present.

Baldus publishes *Concours de photographie*, and describes his variation of the paper negative. In a letter to the comte de Persigny, minister of the interior, Baldus proposes that the government subscribe to twenty copies of *Villes de France photographiées*.

Summer
Le Gray makes a photographic portrait of Louis-Napoléon, and in the fall he photographs ceremonies held in Paris, at the porte Saint-Martin and the place de la Concorde, to mark Louis-Napoléon's return to power.

Napoléon le Petit by Hugo is published in Brussels.

Fall
Le Gray and Mestral invoice the Commission des monuments historiques for 120 negatives and 120 prints for the Mission héliographique.

The third edition of Le Gray's 1850 treatise is published, with the title *Photographie: Traité nouveau théorique et pratique des procédés et manipulations sur papier et sur verre*.

Louis-Napoléon becomes emperor, as Napoléon III, and the Second Empire (1852–70) is established.

Le Gray's work (including prints made from the Mission héliographique negatives) is shown in the exhibition of the Society of Arts in London.

1853

May 24
Le Gray shows large-scale prints to an audience at Lacan's residence.

Fall
Lacan writes about Baldus's views of Paris, in which he discerns "rare perfection," "tonal beauty," and "incredible fineness of detail." Baldus photographs facsimiles of the sixteenth-century illuminated *Grandes heures d'Anne de Bretagne*. For the Office of Fine Arts, Baldus makes twenty negatives of Jean Le Pautre's ornamental architectural designs; he will present them as photogravure plates in March 1854. He also contributes portraits and photographs of artworks to Théophile Silvestre's *Histoire des artistes vivants*. Baldus travels and photographs in the Midi for *Villes de France photographiées*.

December
La lumière features an article about the studio and activities of Le Gray.

1854

Nadar opens his first portrait studio, in his apartments at 113, rue Saint-Lazare in Paris.

Le Gray is listed in the annual trade directory (*Bottin*): "History painter and photographer, portraits on paper, reproductions of paintings, views of France and art objects, photography lessons, chemin de ronde de la barrière de Clichy, 7."

January
At the exhibition of the Photographic Society of London, Mestral shows views, notably of the staircase at the château de Blois, made for the Mission héliographique, and Baldus exhibits prints from the Midi, made in the fall of 1853, which attract the attention of Queen Victoria and Prince Albert.

Summer
Le Gray's *Photographie: Traité nouveau théorique et pratique des procédés et manipulations sur papier, sec—humide, et sur verre, au collodion— à l'albumine* (the fourth and final edition of his 1850 treatise) is published. The chapter about collodion is especially detailed. Le Gray joins a commission assigned to draft statutes for the Société française de photographie (SFP), which will be established on November 15.

1855

Le Gray opens a studio at 35, boulevard des Capucines and establishes the firm Gustave Le Gray et Cie. Le Gray keeps the laboratory and residence at 7, chemin de ronde, de la barrière de Clichy.

January 10
The SFP decides to install an exhibition of photographs.

May 15
First Exposition universelle, held in the Palais de l'industrie. The fine-arts section takes the place of the Salon for this year (Courbet opens an exhibition of his work across the street, in the

Pavillon du réalisme). Le Gray shows his work in the photography section, which includes 126 exhibitors, and receives a first-class silver medal. Baldus shows *Lake Chambon*, a mountain-landscape panorama made from three negatives that is more than four feet wide.

August 1
The SFP's first exhibition opens at rue Drouot, with the prints on display for sale.

1856

Madame Bovary by Gustave Flaubert is published in six installments in the literary journal *Revue de Paris*. The following year, the novel causes Flaubert to be prosecuted, unsuccessfully, on moral grounds.

Summer
Le Gray creates his first seascapes and sky studies in Normandy.

August–December
Le Gray's works are included in an exhibition sponsored by the Association pour l'encourage-ment et le développement des arts industriels at the Musée des beaux-arts in Brussels, where they win a medal.

November 6
The Brig by Le Gray is shown during a meeting of the Photographic Society of London.

1857

Champfleury publishes *Le réalisme*.

Early January
The second exhibition of the SFP opens and Le Gray exhibits *The Brig*, in addition to a positive print on glass of this work.

Spring
Le Gray photographs the inauguration of the Toulouse-Sète section of the Bourdeaux-Sète railway line and produces views of the Sète port and seascapes. Three of his seascapes are featured in the Exhibition of the Art Treasures of the United Kingdom, in Manchester, inaugurated by Prince Albert.

September
Le Gray is commissioned by Napoléon III to photograph the inauguration of the military camp at Châlons-sur-Marne.

1858

Le Gray's works are shown in an exhibition of the Photographic Society of London and at the Crystal Palace in Sydenham.

January 13
Le Gray provides information about the gold-chloride process for toning albumen prints in a sealed envelope given to the Académie des sciences. The envelope will be opened by the academy in January 1859.

August 5–8
At the invitation of Napoléon III, Le Gray makes photographs of a meeting of Queen Victoria and Prince Albert with Napoléon III and Empress Eugénie in the harbor of Cherbourg, in Normandy.

1859

Le Gray's photographs of Paris are shown in an exhibition hosted by the British Association for the Advancement of Science in Aberdeen, Scotland. The exhibition of the Photographic Society of Glasgow includes Le Gray's seascapes.

April 15
Opening of the Salon, at the Palais de l'industrie. The third exhibition of the SFP opens in the same building but with a separate entrance.

1860

The firm of Le Gray et Cie closes. In May, Le Gray joins Alexandre Dumas on a voyage to the Mediterranean and Middle East and, after being put ashore by Dumas in Malta, departs for Syria. He eventually lands in Egypt, where he will stay until his death in 1884.

1862

Hugo publishes *Les misérables*.

1867

Le Gray is appointed professor of drawing at the Military Schools of Cairo. His photographs made for Ismail Pasha, and manuscripts and books that are supposedly his, are shown in the Egyptian division of the Exposition universelle in Paris. In 1869, Le Gray will teach drawing at the preparatory school for the Polytechnic School of Cairo, remain a professor there until about 1875.

1870

Hugo returns to France from exile.

1871

Paris Commune

1872

Champfleury is the chief of collections at the Sèvres porcelain factory and will retain the position until his death in 1889.

1880

Nana and *The Experimental Novel* by Émile Zola (1840–1902) are published.

January 16
Nègre dies in Grasse.

1882

December 26
Le Secq dies in Paris.

1884

July 29
Le Gray dies in Cairo.

1886

The Masterpiece by Zola is published.

1887

May 14
Bayard dies in Nemours.

1900

Nadar's memoirs are published in his book *Quand j'étais photographe*.

1910

March 21
Nadar dies in Paris.

Index

Contributors

Sylvie Aubenas is director of the Department of Prints and Photographs at the Bibliothèque nationale de France, Paris. She has published several catalogues and essays on French photographers of the nineteenth century and is coauthor of *Gustave Le Gray: 1820–1884* (Getty Publications, 2002) and, with Paul-Louis Roubert, *Primitifs de la photographie: Le calotype en France, 1843–1860* (BnF, 2010).

Sarah Freeman is associate conservator of photographs in the Department of Paper Conservation at the J. Paul Getty Museum. She recently contributed technical notes to the exhibition publication *Light, Paper, Process: Reinventing Photography* (Getty Publications, 2015) and has published with the International Council of Museums Committee for Conservation and the American Institute for Conservation of Historic and Artistic Works.

Karen Hellman is assistant curator in the Department of Photographs at the J. Paul Getty Museum. Her work focuses on the early history of photography, primarily in Europe. She is the author of *The Window in Photographs* (Getty Publications, 2013) and coauthor of *Landscape in Photographs* (Getty Publications, 2012).

Anne de Mondenard is curator at the Centre de recherche et de restauration des musées de France, Paris. Her area of expertise is in the history of photography, and she has published widely on early French photography. She recently coauthored the exhibition catalogue *Modernisme ou Modernité: Les photographes du cercle de Gustave Le Gray* (Petit Palais, 2012) and contributed to *Charles Marville: Photographer of Paris* (National Gallery of Art, 2013).

Karlyn Olvido is a former research assistant at the J. Paul Getty Museum and currently a graduate student in the history of photography at the University of California, Riverside.

Paul-Louis Roubert is assistant professor at Université Paris 8 and president of the Société française de photographie, Paris. He is a specialist in the history, exhibition, and critique of photography in nineteenth-century France. With Sylvie Aubenas, he coauthored *Primitifs de la photographie: Le calotype end France, 1843–1860* (BnF, 2010). He publishes frequently on early French photography and is a founder of the journal *Études photographiques*.